20TH CENTURY WOMEN SERIES

The Remarkable Lives of

100 WOMEN ARTISTS

BROOKE BAILEY

BOB ADAMS, INC.
Holbrook, Massachusetts

For Bryn

Acknowledgments

Thanks are due to Brandon Toropov, Jen Most, Gigi Ranno, Peter Gouck, Janet Anastasio, Erica Jorgensen, Tami Monahan, and Susan Moffatt for ideas and helpful criticism. Sarah Scheffel and Melissa Geisler offered useful suggestions.

The collections of the Boston and Cambridge Public libraries and the Harvard-Radcliffe library system—particularly the Schlesinger Library—were instrumental in the research for this book.

Special thanks go to Cristina Paglinauan, Carolyn Sporn, Rachel and Craig Lewis, and my family for their support and aid in research.

Published by Bob Adams, Inc., 260 Center Street, Holbrook, MA 02343

ISBN: 1-55850-360-9

Printed in the United States of America.

J I H G F E D C B A

Library of Congress Cataloging-in-Publication Data
Bailey, Brooke.
 The remarkable lives of 100 women artists / Brooke Bailey.
 p. cm. — (20th century women series)
 Includes bibliographical references.
 ISBN 1-55850-360-9 : $12.00
 1. Women artists—United States—Biography—Encyclopedias. 2. Arts, American—Encyclopedias. 3. Arts, Modern—20th century—Encyclopedias. I. Title. II. Title: Remarkable lives of one hundred women artists. III. Series.
 NX504.B3 1994
 700'.92'273—dc20 94-8435
 [B] CIP

This book is available at quantity discounts for bulk purchases. For information, call 1-800-872-5627.

Cover Painting: Leonid Mysakov/Irmeli Holmberg Representative

Introduction

The one hundred women in this collection share a common choice to dedicate themselves somehow to their art. All of their lives were shaped by this choice—but the sheer range of experience here is astonishing.

Although this collection of accounts of women's lives is intentionally broad, it cannot begin to cover the full range of women's experience in art in the twentieth century. What it can do is to give a sampling of the rich variety of women who dedicated their lives to an art. Sculptor Elizabeth Prophet bought materials instead of food, and filled her diary with daydreams of sumptuous feasts. Illustrator Blanche Ames used her talent to further her botanist husband's career by illustrating his books. Painter Frida Kahlo carried out her fight with physical pain in her work.

Of course, many interesting stories have been excluded from this book. Painter Grandma Moses, for instance, was passed over because her story is already well known. Many of the artists not included here were more commercially successful than, say, blues performer Mother Scott or sculptor Janet Scudder—but to include them because of their well-known achievements would be, it seemed to me, to de-emphasize the difficulties that have faced women of talent over the past century.

The lives of the one hundred women in this book illustrate some of the obstacles and triumphs of women who, for better or for worse, committed their energy and talent to an art. The stories inspired me, and I hope they do the same for you.

—Brooke Bailey

Blanche Ames, 1878–1969

Botanical illustrator Blanche Ames didn't shape the visual ideas of a generation of artists, or pioneer a new art form. Instead, she did something many women in the early part of the century did: she used her talents to support her husband's far more famous career. And within her own small field, she set new standards for excellence.

Ames was born and raised in Lowell, Massachusetts, the fourth of six children of parents from old New England families. Her father had been a Civil War general, a United States senator, and a governor of Mississippi during the Reconstruction, and invested profitably in flour mills. Her mother's family's wool mills also contributed to the family income. Ames was an athlete at an early age, learning tennis, golf, yachting, and even football at home. Her parents expected her to excel, and she easily obliged them.

In 1895 Ames enrolled at Smith College, where she developed her artistic talent, played on the basketball team, and was elected president of her class. A year after her graduation with an A.B. in 1899, she wedded Oakes Ames, then a botany instructor at Harvard University. They had four children over the next ten years and raised them on their large estate in North Easton, Massachusetts.

Meanwhile, Blanche Ames began to apply her artistic talent to her husband's work. He was becoming increasingly prominent in the study of orchids, and Blanche illustrated the species he identified with precision and an artist's flair. Over a period of seventeen years the couple published a definitive seven-volume series, *Orchidaceae: Illustrations and Studies of the Family Orchidaceae*. Oakes Ames stayed at Harvard and eventually became the Arnold Professor of Botany, the director of the Botanical Museum, and the supervisor of the Arnold Arboretum. He was considered the leading orchidologist of his day.

In addition to her growing interest and involvement in her husband's career, Ames became a staunch crusader for women's rights. She drew prosuffrage cartoons, cofounded the Birth Control League of Massa-

chusetts, and wrote and illustrated pamphlets that described methods for making your own diaphragm and spermicidal jelly. According to her husband's diary, she danced around the library table when an antisuffrage senator was defeated in a 1918 election. Oakes Ames joined her in her political work, heading a men's suffrage league and lobbying at the 1914 Republican National Convention for suffrage.

Ames was an incredibly active woman. She invented and patented several devices, including an antipollution toilet, a hexagonal lumber cutter, and snares for catching low-flying enemy planes during World War II. She painted for pleasure and her own projects as well as for her husband's work. Some of her oil works hang at Phillips Exeter Academy, Columbia University, and Dartmouth College. She wrote a book about her father's career, which she published in 1964. "For her to have an idea was to act," wrote her daughter Pauline, "no matter how difficult or how impossible."

Her work and her husband's work both benefited from their commitment to each other. In a letter to Blanche before their marriage, Oakes Ames wrote, "You and I are forming a contract . . . we have an equal voice." They managed not only to pursue their own very different careers, but also to enrich each other's work by their collaboration. Oakes Ames died in 1950; Blanche Ames outlived him by nineteen years, dying at their home in North Easton at the age of ninety-one.

> **Ames drew prosuffrage cartoons and founded the Birth Control League of Massachusetts.**

TO FIND OUT MORE . . .

- Plimpton, Pauline. *Oakes Ames: Jottings of a Harvard Botanist, 1874–1950.* Cambridge, MA: Botanical Museum and the Arnold Arboretum of Harvard University; distributed by Harvard University Press, 1980.

- Sicherman, Barbara, and Carol Hurd Green, eds. *Notable American Women: The Modern Period. A Biographical Dictionary.* Cambridge, MA: The Belknap Press of Harvard University Press, 1980.

- Ames's papers are in the Schlesinger Library at Radcliffe College.

Marian Anderson, 1902–1993

Heralded as the greatest contralto of her generation, Marian Anderson was the first African-American singer to break the longstanding color barrier at the Metropolitan Opera when she made her debut there in 1955. Her warm contralto voice opened doors for her and for other performers; she made it an irresistible force. It is said that the composer Toscanini was once moved to say to her: "A voice like yours is heard only once in a hundred years." A voice like hers, it seems, could not be ignored.

Anderson first sang at age six in her South Philadelphia church choir. Her mother laundered clothes and her father sold ice and coal to support Anderson and her two younger sisters. Anderson worked to save up enough money to buy herself a $3.45 violin from a pawnshop, scrubbing neighbors' steps and running errands. But her voice was always her favorite instrument. She briefly attended school to train for a business career that would support her family, but a stranger who had heard her sing talked the school principal into letting Anderson switch from her commercial course to an academic one that would allow her to study music. Anderson thrived, giving concerts more for the joy of it than for the often small or nonexistent fees.

The prejudice that would hamper her professional career was a problem early on; she was once ignored and humiliated by a clerk at a prestigious music school who informed her that "we don't take coloreds." Her voice, however, captivated others. She soon began to attract critical notice, touring for respectable fees. Despite the critical acclaim she was beginning to win in her own country, major engagements were only available to her in Europe, and in the early 1930s she accepted a Julius Rosenwald Fellowship to sing and study in Europe.

She became a star of the European circuit, performing a program of arias and spirituals in Berlin, Oslo, Stockholm, Helsinki, Paris, Vienna, Geneva, and the Soviet

Union. Her rendition of "They Crucified My Lord, and He Never Said a Mumblin' Word" reduced an audience of powerful opera figures, including Toscanini and soprano Lotte Lehmann, to awed silence. The impresario Sol Hurok gave her a contract, and with her new European experience and backing, she returned to the States to crack the top levels of the tough American concert world.

In 1935 and 1936, Anderson seemed to be well on her way to her goal, with acclaimed performances in New York's Town Hall and Carnegie Hall. In 1939, however, she found herself at the center of a highly public controversy when the Daughters of the American Revolution canceled her contract to sing at Constitution Hall in Washington, D.C., when they found out that she was black. The immediate outcry from public figures like Eleanor Roosevelt, who resigned from the DAR in protest, prompted Secretary of the Interior Harold Ickes to invite her to sing at a public performance at the Lincoln Memorial on Easter Sunday.

When Anderson sang before a Washington crowd of over seventy-five thousand and a radio audience of millions, the response—and the effect on her career—was overwhelming. Critics raved. She sang at Carnegie Hall to thunderous applause. She was catapulted to the very top of her profession, where she would stay until her retirement. In 1955 she became the first black soloist to sing at the Metropolitan Opera House in New York. She sang for presidents, kings and queens; she was decorated and honored by several countries and many universities.

Anderson was the first African-American singer to break the longstanding color barrier at the Metropolitan Opera.

Despite her many groundbreaking achievements, Anderson was quick to point out that her career did not really "pave the way" for others. Those who followed in her footsteps, she said, "deserve a great deal of credit for what they have achieved. . . . if they didn't have it in them, they wouldn't be able to get it out."*

TO FIND OUT MORE . . .

- Anderson, Marian. *My Lord, What a Morning: An Autobiography.* New York: Viking Press, 1956.

- Lanker, Brian. *I Dream a World: Portraits of Black Women Who Changed America.* New York: Stewart, Tabori & Chang, 1989.

- Patterson, Charles. *Marian Anderson.* New York: Watts, 1988.

* Quote reprinted from *I Dream a World: Portraits of Black Women Who Changed America.* Copyright ©1989 Brian Lanker. Reprinted by permission of Stewart, Tabori & Chang, Publishers.

Diane Nemerov Arbus, 1923-1971

Diane Arbus was a photographer of peculiar power who shot her subjects—physical "freaks," misfits, transvestites, and addicts—in the starkest possible way, never posing or manipulating them. To the casual observer, her images may seem grotesque, but Arbus found in her subjects a particular dignity all their own, which she tried to capture with a minimum of technique.

Arbus, born Diane Nemerov to a well-off Manhattan family, had a comfortable childhood. Her family owned Russeks, a successful department store on Fifth Avenue. She and her siblings attended prestigious schools and wanted for nothing, but Arbus was a restless, pensive child. One account tells of episodes in which she would stand on the window ledge of her parents' eleventh story apartment, gazing out across upper Manhattan, until her mother pulled her back into the apartment. She believed that she came from "a family of Jewish aristocrats." To Arbus, the word "aristocrat" signified not wealth or social cachet but a courage of spirit and nobility of mind. It was a quality she would later work to capture on film.

In 1941, when Diane was eighteen, she married Allan Arbus. The couple had two daughters—Doon and Amy—and went to work for Diane's father as fashion photographers, a career that occupied Arbus for nearly twenty years. At thirty-six, she abruptly shifted gears to study with photographer **Lisette Model**. She began to refine a straightforward style of photography that, at its most striking, demonstrates an implicit consent between photographer and subject that nevertheless avoids artifice. Her sometimes macabre choice of subjects makes her images all the more startling—her more extreme subjects were considered taboo.

Arbus struggled as an artist. She won the prestigious Guggenheim Fellowship at

forty, and she had a fairly successful business relationship with several magazines, but her work was not well known when, at age forty-eight, she committed suicide in her West Village apartment. In 1972, however, when the Museum of Modern Art staged a major retrospective of her work and Aperture came out with a monograph of her photography, she became the object of a cult. Today she is considered a major influence on modern photography.

Arbus once told her mentor, "I want to photograph what is evil." Her daughter, Doon, commented on the statement years after Arbus's death: "I think what she meant was not that it was evil, but that it was forbidden, that it had always been too dangerous She was determined to reveal what others had turned their backs on." Arbus called the "freaks" who often let her photograph them "aristocrats," saying, "they've already passed their test in life." Her photographs have the remarkable ability to reveal both the dignity and the pathos of her more sensational subjects, and also to bring out those qualities in her more ordinary ones.

Arbus found in her subjects a particular dignity all their own.

TO FIND OUT MORE . . .

- Munsterberg, Hugo. *A History of Women Artists.* New York: Clarkson N. Potter, Inc., 1975.
- Livingston, Jane. *The New York School: Photographs 1936–1963.* New York: Stewart, Tabori & Chang, 1992.
- Bosworth, Patricia. *Diane Arbus: A Biography.* New York: Alfred A. Knopf, Inc., 1984.

Lillian (Lil) Hardin Armstrong, 1898–1971

Lillian Armstrong's career in jazz was somewhat overshadowed by that of her hugely famous husband, gravel-voiced Louis Armstrong. Before she met him, however, she was an early jazz pianist with her own reputation. Jazz was the main driving force in her life. "It caught me way back in Memphis and it looks like it won't ever let go," she once told an interviewer.

Memphis was Lillian Hardin's birthplace, but she wasn't much encouraged to learn jazz there. Her strictly religious mother and grandmother strongly disapproved of popular music and forbade Lillian to play it. Talent and drive made her defiant. She sneaked sheet music of popular songs into the house, and once played "Onward Christian Soldiers" in church with a sassy rhythm.

After several years of piano and organ lessons at home, Hardin moved to Chicago with her family when she was nineteen. She studied at Fisk University for the next seven years. At the same time, she began work as a song promoter at Jones's Music Store on South State Street in Chicago. She demonstrated all the music sold at the store under the title "the Jazz Wonder Child." As jazz legend has it, one day jazz heavyweight Jelly Roll Morton came into the store and played a series of popular tunes with Hardin. Thereafter she adapted his strongly rhythmic style for her own use.

In the twenties, Hardin made a name for herself in appearances with bands. Her first, the Original New Orleans Creole Jazz Band, played at the De Luxe Cafe. She later said that they started out without any instructions—they didn't even choose a key to start in—and she had to wing it from the first chord. Apparently she was a good improvisor, because other jobs soon followed. She played with the famous King Oliver's Creole Jazz Band in the early twenties, where Louis Armstrong then played the cornet. These were the heady early days of jazz

in Chicago, and King Oliver's band was a groundbreaking group.

After two years of musical collaboration in the band, Lil Hardin and Louis Armstrong were married. She became his promoter, encouraging him to make breakthrough moves in New York and Chicago. His career became enormously successful soon after their marriage, but the couple drifted apart, divorcing in 1938. In the waning years of her marriage, Lil Armstrong managed to maintain her own career, despite the ravages of the Depression. She fronted an all-woman group, the Harlem Harlicans, in the mid-thirties, and recorded as a session pianist for Decca Records in the late thirties.

> *Legend has it that she played with Jelly Roll Morton as a young woman.*

In the 1940s Lil Armstrong returned to Chicago to play locally. With occasional tours of the United States and Europe, she kept playing for literally her whole life. She died on stage at a 1971 memorial concert for Louis Armstrong.

TO FIND OUT MORE . . .

- Dahl, Linda. *Stormy Weather: The Music and Lives of a Century of Jazzmen.* New York: Pantheon Books, 1984.

- Placksin, Sally. *American Women in Jazz, 1900 to the Present.* New York: Seaview Books, 1982.

- Smith, Jessie Carey, ed. *Notable Black American Women.* Detroit, MI: Gale Research Inc., 1992.

Margaret Frances (Peggy) Bacon, 1895–1987

The multitalented painter, illustrator, and writer Peggy Bacon followed in her parents' footsteps–to a point. Both her parents were artists, but her father did not consider himself a very successful one. When Peggy was eighteen, Charles Bacon, depressed about his stalled career, committed suicide. Peggy made sure while still a student that she could support herself with her illustrations. Her prudence paid off during the Depression, when she was able to pay the bills with her work.

Peggy Bacon's parents had met while studying at the Art Students' League in New York. Their daughter Peggy grew up surrounded by their paints and brushes, so her ambition to be an artist must not have been a surprise. Her parents mourned the hardships they envisioned for their daughter but allowed her to take classes at the School of Applied Arts for Women. After her father's death, her landscape teacher, Jonas Lie, helped her to sell a number of her early works. The sale financed her illustration classes over the next two years.

During her late teens and early twenties, Bacon studied at the Art Students League in New York and spent summers in Provincetown, Massachusetts, absorbing a wide range of influences. At the League she experimented with drypoint, in which a hard steel needle is used to carve lines in a softer metal (often copper) plate, and the plate used to make prints. It was the perfect medium for the sharp caricatures of her friends and teachers that she began to produce. She used the technique to illustrate her first book, *The True Philosopher and other Cat Tales* (1919).

Like her mother, Peggy Bacon met and married a fellow student at the League, the painter Alexander Brook. Soon after their marriage in 1920, they had two children. They lived on the exciting cutting edge of art in the 1920s, living in the art colony in Woodstock, New York, and later in Green-

wich Village. Bacon continued to produce her well-received drypoints, but she stopped painting because her husband, whom she considered a superior painter, was critical of her work in "his" medium.

Both artists enjoyed a fair amount of success and recognition in New York. Their work sold well commercially in magazines and children's books, and they were part of the group of artists promoted by the influential Whitney Studio (later the Whitney Studio Club), which eventually grew into the Whitney Museum of American Art (see **Gertrude Vanderbildt Whitney**). Bacon's work from this period is ebulliently satirical, black and white drypoints rich with humorous detail.

> *Bacon began to feel uncomfortable with caricature when she saw that it was often painful to its targets.*

In 1934 a Guggenheim Foundation Fellowship funded Bacon's book *Off With Their Heads!*, which skewered thirty-nine luminaries of the art world (including Georgia O'Keeffe) in Bacon's incisive drypoint. The book was a great success for her and resulted in a great demand for her caricatures. Bacon began to feel uncomfortable with caricature, however, when she saw that it was often painful to its targets. She shifted her attention to less personal subjects.

In 1940 Bacon divorced her husband. She began to paint again almost a decade after the divorce. She also taught and continued to write; her 1953 mystery novel *The Inward Eye* won her an Edgar Allen Poe Mystery Award for best novel of the year. She moved to Cape Porpoise, Maine, to be near her son Alexander, and lived out the rest of her long life there, continuing to paint despite failing health and fading eyesight. She died in 1987 at the age of ninety-two.

TO FIND OUT MORE . . .

- Bacon, Peggy. *Off With Their Heads.* New York: Robert M. McBride & Co., 1934.

- Rubenstein, Charlotte Streifer. *American Women Artists: From Early Indian Times to the Present.* New York: Avon, 1982.

- Tarbell, Roberta. *Peggy Bacon: Personalities and Places.* Washington, D.C.: National Collection of Fine Arts, Smithsonian Institution Press, 1975.

Mildred Bailey, 1907–1951

The mercurial jazz soprano Mildred Bailey lived dramatically. An emotional presence both on and offstage, Bailey broke barriers both as the first white singer to master jazz and as a crossover artist who could switch back and forth between her take on Southern jazz and a warm popular Broadway-influenced style. Her personal life, however, was volatile, and her health was increasingly shaky throughout her short life. She died at forty-four from complications of diabetes, exacerbated by an excessive lifestyle.

Mildred was born Mildred Rinker in Tekoa, Washington, to a musical family with both Irish and Coeur d'Alene Indian roots. Mildred's mother taught Mildred and her little brother, Al, ragtime piano, and Mildred grew up warbling in a light soprano that landed her a job in her teens—ten dollars a week for singing in a Seattle dime store. That job led to others, including a stint in a nightspot called Charlie Dale's Cabaret. While still in her teens, Mildred made an unfortunate marriage to a man named Bailey. By eighteen, however, she had di-

vorced him, keeping only his name, and was heading for Los Angeles to sing.

In Los Angeles she sang in a speakeasy, married a bootlegger, and was soon secure enough to help her brother Al and his partner, crooner Bing Crosby, get their start as a duo. Both men got a later break in Paul Whiteman's Rythmn Boys, the top popular band of the twenties. Al repaid his sister's favor by inviting Whiteman to a party at her house. The bandleader was won over by her rendition of "Sleepy Time Gal," and signed her up at the party for a spot on his radio show. In a year her salary went from $75 a week to $1,250 a week, and she became a popular headliner. Crosby later cited Bailey as one of his main influences during this period, when they sang together in Whiteman's band. Her clear, jazz-styled phrasing and warm tones are related to Crosby's later distinctive style.

The band's xylophonist, Red Norvo, became her third husband. Fans nicknamed them "Mr. and Mrs. Swing." Offstage they had violent ups and downs, swerving quickly into pointless quarrels. One fight re-

portedly started when Norvo took a two-night fishing trip. Bailey waited until they were at a dinner party to express her rage by flinging his hat into a handy fireplace. He retaliated with something of hers, and soon the fire—and the argument—had grown out of control.

Her extrovert emotions offstage were better controlled onstage. She could move easily between her jazz and popular songs, sometimes blurring the boundary between the two. Light Broadway tunes were injected with rich jazz styling; nightclub jazz was brightened for a more mainstream, white audience. She had a talent for drawing her listener in no matter what she was singing. Her professional success, however, was not enough to keep her happy.

Bailey and Norvo divorced, childless, in 1945. By this time her diabetes was physically debilitating. She was careless about her medically supervised diet, which worsened her condition, and despite her many friends, including Norvo, she was lonely. She continued, however, to lead a fairly extravagant lifestyle, shopping heavily for clothes and jewelry and lavishing gifts on friends.

Bailey was soon financially as well as physically debilitated. She sang less and less often, retiring in the late 1940s to an upstate New York farm with her many pet dogs and a parrot. After her last nightclub date in 1951, she collapsed, dying less than three weeks later. Her finances were so depleted that friends, including Bing Crosby and Frank Sinatra, had to cover her final hospital bills for her.

> *Bailey was the first white singer to master jazz.*

TO FIND OUT MORE . . .

- Balliet, Whitney. *Such Sweet Thunder: 49 Pieces on Jazz*. Indianapolis: The Bobbs-Merrill Company, Inc., 1966.

- Gourse, L. *Louis' Children: American Jazz Singers*. New York, 1984.

- Kernfeld, Barry, ed. *The New Grove Dictionary of Jazz, Vol. I*. London: Macmillan Press Ltd., 1988.

Amy Marcy Cheney Beach, 1867–1944

A my Beach was America's first well-known woman composer. A talented pianist with only one year of technical training, she composed 150 opuses in her long and successful career.

The Cheneys traced their roots back to early New England colonists. Their daughter Amy, born in Henniker, New Hampshire, was expected to learn the arts as a young gentlewoman. At private school in Boston she studied piano with Ernest Perabo and Carl Baermann and harmony with Junus W. Hill. She excelled at her early training, becoming a bit of a prodigy; by sixteen she was playing on the stage in Boston.

When Amy Cheney was eighteen, she married a much older man, the forty-three-year-old surgeon H.H.A. Beach. As a young wife, she turned her musical energies to composition. At first her compositions were small-scale pieces for piano, but she soon produced an ambitious Mass in E-Flat, published under the name Mrs. H.H.A. Beach.

In 1892 the Boston Handel and Hayden Society performed the Mass—the first composition composed by a woman that the Society had ever played. During her fifteen-year marriage, she also composed her *Gaelic Symphony*, based on Irish folk songs. It was the first composition by a woman played by the Philadelphia Philharmonic Orchestra.

Many of Bach's compositions—especially the simpler songs—had a nostalgic flavor, hearkening back to the late-nineteenth-century Romantic style that was a hallmark of the "Boston School." Her work is marked by inventive melodies and complex harmonies, and often makes use of folk songs. She was one of the first truly American composers of either sex in the sense that, unlike most of her musical contemporaries, she trained only in the United States.

Toward the end of her marriage Beach became more interested in performing. When the Boston Symphony Orchestra played her Piano Concerto (1900), she

played the central piano part. H.H.A. Beach died in 1910 at age sixty-eight, and Beach left for a three-year performing tour in Europe.

Beach was a great success on the European tour, especially in Leipzig and Berlin. The "Gaelic Symphony" was very well received as a composition, and Beach made a name for herself as both a pianist and a composer. She returned to the United States in 1914, moving to New York. After a period of touring and some composing, she began to produce more major works in the late 1920s.

> Her work is marked by inventive melodies and complex harmonies.

Much of her new composing was done during her summers at the peaceful Mac-Dowell Colony. Both her opera, *Cabildo* (1932), and her 1938 *Piano Trio* were products of her time there. These later works reflected new influences, including Debussy and the late MacDowell. By her death at seventy-six in 1944, she was considered America's premier woman composer.

TO FIND OUT MORE . . .

- Macksey, Joan, and Kenneth Macksey. *The Book of Women's Achievements*. New York: Stein and Day, 1975.

- Sadie, Stanley, ed. *The New Grove Dictionary of Music & Musicians*. London: Macmillan Publishers, Ltd., 1980.

- Slonimsky, Nicolas. *Baker's Biographical Dictionary of Musicians, 8th Edition*. New York: Maxwell MacMillan International, 1992.

Isabel Bishop, 1902–1988

Painter Isabel Bishop grew up isolated by the twin pressures of her family's poverty and education. Forbidden to play with other neighborhood children, she spent a lonely childhood watching other people's camaraderie with sadness and frustration. As a painter she celebrated the friendships she had missed in intimate studies of New Yorkers interacting on the streets near her Union Square studio.

Bishop was born in Cincinnati and grew up in Detroit, where her father was a school principal. His salary did not allow the family to live near neighbors they considered their intellectual peers, and Isabel's nearest sibling was thirteen years older, so she grew up quite lonely. Art lessons led to her enrollment at the age of eighteen in classes at New York's School of Applied Design for Women, and then to further study at the Art Students League in the early 1920s.

In the early 1930s, working with government funding, Bishop hit on the style that would characterize her work for the rest of her long career. She became interested in the hurrying figures she saw near her studio in downtown Manhattan, people on their way to work or preparing for some encounter. There is often a sense that time is of the essence in Bishop's work. Shopgirls chat on their lunch hour; a businessman gets a shine while reading a newspaper; students make intersecting beelines to class. Bishop is never a participant but always a loving observer.

Bishop married neurologist Harold G. Wolff in 1934. They moved to Riverdale, New York, and had a son together. Bishop began commuting to her studio, working five days a week even while raising her child. She remained distant from the hustle and bustle she painted, completing her works slowly and carefully at the rate of only three or four a year.

Bishop was particularly interested in painting young women, especially upwardly mobile working women. She was sensitive to the small, everyday preparations they made both in public and in private. In *Nude #2* (1954), a chunky young woman carefully trims her toenails. In *Tidying Up* (1938), a

girl checks her teeth for lipstick in a small mirror. Later she began to incorporate elements of abstract painting in her otherwise representational work, veiling her figures with an intricate haze of dots and lines.

The Whitney Museum gave a major retrospective of Bishop's paintings in 1975. Her very personal work had long been recognized as a major contribution to American art. Isabel Bishop died at the age of eighty-six.

There is often a sense that time is of the essence in Bishop's work.

TO FIND OUT MORE . . .

- Fine, Elsa Honig. *Women & Art: A History of Women Painters and Sculptors from the Renaissance to the 20th Century.* Montclair, NJ: Allanheld, Osmun & Co and Abner Schram Ltd., 1978

- Harris, Ann Sutherland, and Linda Nochlin. *Women Artists: 1550–1950.* New York: Alfred A. Knopf, 1976.

- Heller, Nancy G. *Women Artists: An Illustrated History.* New York: Abbeville Press, 1987.

- Lunde, Karl. *Isabel Bishop.* New York: Harry N. Abrams, 1975.

- Rubenstein, Charlotte Streifer. *American Women Artists: From Early Indian Times to the Present.* New York: Avon, 1982.

Beatrice Romaine Goddard Brooks, 1874–1970

The portraitist Beatrice Romaine Goddard Brooks had a horrific childhood. Her mother, a wealthy Pennsylvania woman of questionable sanity, dragged the family around Europe in search of a cure for her even less stable eldest son. Romaine was born in a hotel in Rome on one of these trips; soon afterward, her father deserted the family. As she grew older, Romaine was made to care for her brother, since she seemed best able to manage him. Unfortunately, he was sometimes sexually predatory toward her. Her mother was little better, ranting of demons and accusing Romaine of having "devil's eyes."

When she was seven, Beatrice was left to live with the family washerwoman for four years. After another tour with the family, during which her brother threw a knife at her, her mother put her in a convent. Romaine doodled caricatures of the priest, refused to kiss the crucifix, and otherwise failed to fit in. After several years at a finishing school and a short career as a professional singer, she finally won her freedom—and a sort of financial independence—thanks to a guaranteed monthly stipend from her mother.

Newly optimistic, she went to Rome to study art. As the only woman student there to draw a nude model, she was the object of cruel attention from her male peers, who left obscene drawings on her bench. She went from Rome to the island of Capri, where she spent a happy time painting portraits of the arty inhabitants including Somerset Maugham, Compton Mackenzie, and Axel Munthe. Her happiness there was interrupted by the deaths of first her brother and, soon afterward, her mother, who tried until the last to bring her deranged son back through séances. Although their deaths made her a wealthy heiress, she would be haunted by the memory of their unreasoning malice for the rest of her life.

Goddard married for convenience, hop-

ing that she would have more freedom as a married woman, but John Ellingham Brooks turned out to be a leech with designs on her money. She eventually rid herself of him by paying him a substantial allowance. Free—and alone—once more, she returned to portrait painting. In London and in Paris she earned a name for herself with her often harsh portraits that employed a subtle palette of grays. Some of her subjects begged her not to exhibit her portraits of them.

Brooks herself began to cut a public figure, dressing in masculine clothing and decorating her Paris apartment in black, gray, and white. She painted a series of emaciated female nudes, using Ballet Russe ballerina Ida Rubenstein as her muse. When surrealism and abstract painting became popular in the forties, Brooks began to work on a series of moody, abstract line drawings, disturbing works that seem to recall her traumatic childhood. She drew images of mayhem and imprisonment, and signed them with a wing in chains.

In 1915, Brooks fell in love with a fellow American expatriate, Alice Pike Barney. Barney was a horsewoman and essayist who championed androgyny and ran a famous salon, which included Colette, Marcel Proust, and Ranier Maria Rilke. Brooks painted her as an Amazon, including a small figure of a horse to symbolize her free spirit. Although toward the end the relationship would turn tempestuous, Barney would be the great love of Brooks's life. She encouraged Brooks in her art long after her paintings went out of vogue; with Barney's prodding, Brooks sent a number of paintings and drawings to the National Collection of Fine Arts in Washington, D.C. In 1971 the National Collection exhibited a retrospective show of Brooks's work, renewing interest in her work.

> *As the only woman student in her class to draw a nude model, she was the object of cruel attention from her male peers, who left obscene drawings on her bench.*

TO FIND OUT MORE . . .

- Breeskin, Adelyn. *Romaine Brooks: "Thief of Souls."* Washington, D.C.: National Collection of Fine Arts, Smithsonian Institution Press, 1971.

- Rubenstein, Charlotte Streifer. *American Women Artists: From Early Indian Times to the Present.* New York: Avon, 1982.

- Secrest, Meryle. *Between Me and Life: A Biography of Romaine Brooks.* New York: Doubleday, 1974.

- Werner, Francoise. *Romaine Brooks.* Paris: Plon, 1990.

Rosalind Bengelsdorf Browne, 1916–1979

R osalind Browne was a founding member of the American Abstract Artists, and continued to expound upon the significance of the group's artistic breakthroughs almost until her death. She asserted that the abstract artists of the 1960s and 1970s were going over ground already staked out in the 1930s and 1940s, and that the only difference between the two groups of artists was that the pioneering abstract artists had made no money with their work.

Rosalind Bengelsdorf was a New Yorker all her life. She was born in the city, and her first forays into painting were made there. She studied at the Art Students League with realist, not abstract teachers; indeed, she did not much like the first painting by Picasso shown her by an influential abstract artist, Arshile Gorky, at the Museum of Modern Art.

At eighteen, however, she had a more thorough introduction to abstract art at the Annot School. After a year there she studied at Hans Hoffmann's newly established school on 57th Street. Hoffman was very influential in the growth of the Abstract Expressionist movement in the 1940s and 1950s because of his contact early on with younger artists like Bengelsdorf. He urged his students to use color to create spaces on a canvas that balanced each other out while establishing a sense of movement and tension. With color, he taught, you can bring some forms "forward" out of the painting and push others into deeper lanes within it. Bengelsdorf absorbed his ideas and integrated them with great verve into her own innovative compositions.

In 1936 the twenty-year-old Bengelsdorf threw herself into the difficult task of winning acceptance for abstract art. A founding member of the American Abstract Artists, she contributed in many ways to the struggling organization. Her lithograph was one of the thirty-nine in the printed folio the artists sold for thirty-nine cents to help to

pay for their first exhibition in 1937. In 1938 she wrote a statement of intent for the organization, in which she argued that abstraction was not an escape from reality but a new way to look at the world in terms of spatial relationships.

That same year she was one of the sadly few abstract artists to win funding from the Federal Art Project, which usually shunned the pariah new art form. At only twenty-two years old she painted an impressive mural for the Central Nurses Home that, like many other government-funded projects, was eventually destroyed. Her oil-on-canvas *Study for Mural for Central Nurses Home* (1937–38), which hangs at the University Art Museum at the University of New Mexico, gives an impression of the sweep of the lost work. Its large, straight-edged forms and edge-to-edge lines intersect curving forms. Small circular shapes suggest the audience's staring eyes.

Bengelsdorf's intensely creative period ended with her marriage to fellow abstract artist Byron Browne in 1940, after which she only painted part-time. As a critic, teacher, and writer, however, she continued to speak out for abstract art until her death in 1979.

She did not much like the first painting by Picasso shown her by an influential abstract artist, Arshile Gorky, at the Museum of Modern Art.

TO FIND OUT MORE . . .

- Marling, Karal Ann. *7 American Women: The Depression Decade.* Poughkeepsie, NY: Vassar College Art Gallery and A.I.R. Gallery (NY), 1976.

- Rubenstein, Charlotte Streifer. *American Women Artists: From Early Indian Times to the Present.* New York: Avon, 1982.

Elizabeth Burchenal, 1876–1959

Elizabeth Burchenal, folk dancer and educator, was one of those artists whose work touched lives in a non-artistic arena. She introduced folk dancing to the general public and made it a part of many public school athletic programs.

Elizabeth Burchenal was born in Richmond, Indiana, the second of six Burchenal children. Her father was a judge with early Colonial roots, her mother a Europhile musician. Elizabeth had her mother's interest in other cultures. She went with her on long field trips to visit rural mountain dwellers, absorbing the mountain music and dance traditions. The Burchenal house was one where visitors—especially foreign ones—were encouraged to join in dancing and singing with the enthusiastic Burchenal clan. Burchenal's earliest training in folk dance came from these experiences.

After earning an A.B. in English from Richmond's Earlham College, Burchenal moved to Boston in 1896 to study and teach physical education. She received her diploma from Dr. Sargeant's School of Physical Training in 1898 and taught for the next five years in Boston and Chicago. Her interest was piqued during this time by the ideas of dance educator Melvin Gilbert, who proposed combining dance and physical education. In 1903 she moved to New York City to take a job at Columbia University and begin applying this theory to her work.

Early 1900s New York, with its diverse immigrant population, was the perfect place for Burchenal to explore the folk dancing of different ethnic populations. She soon switched jobs; working for the city's public schools allowed her to have an impact on more people. Her pioneering programs for girls centered on dancing, allowing them to participate in vigorous physical activity without violating turn-of-the-century standards of decorum.

Her position as executive secretary of the New York Public Schools Athletic

League (Girls' Branch), and later as Inspector of Athletics for the New York Department of Education, made her ideas extremely influential. By the early 1910s she was organizing performances of thousands of students for a delighted public audience. One of these performances attracted the admiration of the visiting Irishwoman Lady Aberdeen. She brought Burchenal home with her to spend a short time training Irish public school teachers to teach Irish folk dancing.

In 1916 Burchenal retired from the New York Public School System and founded the American Folk Dance Society. She lectured and taught for the society, spreading her opinion that folk dance was an ideal way to bridge cultural and social gaps. Burchenal was appointed in 1918 to the National Recreation Association as a representative of the War Workers Community Service, where she worked to smooth over ethnic and racial problems with folk dance.

In 1928, Burchenal went to Prague to represent American folk dance at the first International Congress of Folk Arts. A year later, her American Folk Dance Society joined the National Committee of Arts. Burchenal directed the larger organization almost until her death in 1959. She contin-

> *For Burchenal, folk dance was an ideal way to bridge cultural and social gaps.*

ued her work for dance, establishing an Archive of American Folk Dance that includes her own authoritative works, fifteen volumes of collected folk dances. She died in Brooklyn at age eighty-three. She would have been happy to know that her friends and admirers danced at her funeral.

TO FIND OUT MORE ...

- Gerber, Ellen W. *Innovators and Institutions in Physical Education.* 1971.

- Read, Phyllis J., and Bernard L. Witleib. *The Book of Women's Firsts.* New York: Random House, 1992.

- Sicherman, Barbara, and Carol Hurd Green, eds. *Notable American Women: The Modern Period. A Biographical Dictionary.* Cambridge, MA: The Belknap Press of Harvard University Press, 1980.

Maria Callas, 1923–1977

The acclaimed soprano Maria Callas fought insecurity all her life. She saw her singing talent as her ticket to love and recognition from childhood onward; her mother, who had been hoping for a boy, was said to have been disappointed with her fat, homely daughter. "Only when I was singing did I feel loved," Callas later reflected.

Callas was born only months after the eldest child in the family, a boy, had died. Her mother refused to look at the infant Callas for four days after her birth, and Callas never felt completely accepted. She spent her childhood in New York City, but moved to Greece with her family when she was thirteen. There she began training her already impressive voice. Maria's teacher at the Athens Conservatory, Elvira de Hidalgo, remembers their first encounter: "The very idea of that girl wanting to be a singer was laughable! She was tall, very fat, and wore heavy glasses." However, when Callas sang, de Hidalgo heard "violent cascades of sound, not yet fully controlled but full of drama and emotion. I listened with my eyes closed and imagined what a pleasure it

would be to work with such material, to mold it to perfection."

Callas debuted at age fifteen at the Olympia Theater in Athens as Snatuzza in Mascagni's *Cavalleria Rusticanna*, but it was her later starring appearance in *La Gioconda* at the Arena Verona that launched her professional career. She began taking on notoriously difficult roles, like Brunhilde, Turandot, and Isolde, often at the risk of her vocal cords. Her voice took the punishment unwaveringly for the early, glorious years of her career, and earned her adulation and respect. She used her growing clout to resurrect the then-neglected bel canto repertoire, which has since enjoyed wider circulation.

Later, however, the strain of her demanding early roles began to affect her performances. Much to her frustration, the sharp precision of her high notes began to slip. Her career was further impeded by her affair with the Greek shipping magnate Aristotle Onassis, for which she broke off her marriage to her manager, Giovanni Battista Meneghini. One of her favorite stage direc-

tors, Franco Zeffirelli, ascribed the affair to Callas's "stupid idea of becoming a great lady of cafe society." Whatever her motivation, the affair proved a destructive one. Onassis, who had no appreciation for opera or Callas's talent, belittled her. He made her walk behind him and his children, who hated and tormented her, and once said in public: "What are you? Nothing. You just have a whistle in your throat that no longer works." Eight months after their ten-year affair broke up, Onassis married Jackie Kennedy.

Although her voice was increasingly frayed, Callas was still one of the best sopranos in the world, and continued to tackle difficult roles with some of the abandon that had led her to take on radically different roles as little as ten days apart early in her career. She refused to back down from either difficult notes or difficult audiences. In 1961, when she was hissed by the gallery while singing *Medea* she shocked them into silence by furiously screaming the opera's next lines directly at her audience: "Crudel! Ho datto tutto a te." ("Cruel! I have given you everything.")

Throughout her career, Callas battled weight problems. At one particularly low point, a photo of the diva at three hundred pounds was used in an advertisement for pasta. At another point, she dieted herself down to, in the words of one critic, "the approximate width of Audrey Hepburn." Her hard-won slimness was good for her image as a celebrity, but it further handicapped her singing, and perhaps her health.

Callas left the operatic stage in 1965, but continued to sing in recitals until her death in her Paris apartment in 1977. She was fifty-three.

She used her growing clout to resurrect the then-neglected bel canto repertoire, which has since enjoyed wider circulation.

TO FIND OUT MORE . . .

- Drinkel, Sophie. *Music & Women: The Story of Women in Their Relationship to Music.* New York: Coward-McCann, Inc. 1978.

- Scott, Michael. *Maria Meneghini Callas.* Boston: Northeastern University Press, 1992.

- Stancioff, Nadia. *Maria: Callas Remembered.* New York: Dutton, 1987.

Emily Carr, 1871–1945

Emily Carr was Canada's premier woman artist. Her dark and imposing landscapes reflect Fauvist influences and the artist's own formidable vitality.

Carr grew up in Victoria, British Columbia, under the thrall of her businessman father. He doled out his love parsimoniously, and Emily, as the robust youngest child (except for her sickly younger brother), got an inordinate amount of his attention. His petty rules dominated her childhood: no fairy tales; either jam or butter with tea but never both (except on Sundays); teeth with cavities must be pulled, not filled (ouch). Meanwhile, her mother dwindled and, when Emily was fourteen, died of tuberculosis.

As she grew older, Carr's relationship with her authoritarian father grew more troublesome. She left Victoria for San Francisco to study for two years at the Mark Hopkins School of Art when she was twenty. After this training, she saved her earnings as a teacher in Victoria to finance a trip to study in London at the Westminster School of Art. In 1902, however, Carr had a physical and nervous breakdown, and

the nursing of her older sister, whom she regarded as stuffy and overbearing, did not help. Her trouble was vaguely diagnosed as "hysteria"—the blanket description for many women's widely differing mental problems, including schzophrenia and depression.

The prescribed cure stipulated that Emily stay away from her sister—and, unfortunately, her painting as well. She endured the cure at a sanatorium in the English countryside and spent the next six years in Vancouver, painting, teaching, saving her money, and absorbing the indigenous culture and gorgeous landscapes. By 1910, Carr decided that her skills were not up to the task of capturing the natural grandeur of Vancouver, so she set out for Paris.

She knew no French and remained oblivious to the political issues of the day, but she readily absorbed the ideas of modern artists. Unfortunately, the hard work got the better of her in less than a year, and renewed "hysterical" symptoms forced her to take a rest from her studies at the infirmary of the American Student Hostel. She eventually fought off her illness to produce the first

of her striking, brightly colored abstract paintings.

Back in Canada to apply her hard-won knowledge, Carr struggled with obscurity. She also cast about for a way to support herself and her art. She won recognition, however, with dramatic Canadian landscapes like *Forest, British Columbia* (1932). Carr had always felt an affinity with Canada's native peoples, and was as much influenced by their art as by the daringly new art she had studied in Paris. She often included striking figures inspired by their carvings in her paintings.

> *Carr's dramatic Canadian landscapes won her a measure of recognition in the 1930s.*

Her paintings were ever more inventive and daring; viewers often assumed that they had been done by a man. But even as she mastered her art and gained critical recognition, she developed heart trouble, and she was forced to abandon painting. She took up writing instead, and (ever self-centered) began a series of remarkable autobiographical works. She was able to write for nearly ten years before poor health finally caught up with her in 1945, and she died at the age of seventy-four.

TO FIND OUT MORE . . .

- Blanchard, Paula. *The Life of Emily Carr*. Seattle, WA: The University of Washington Press, 1987.
- Carr, Emily. *Growing Pains*. Toronto: Oxford University Press, 1946.
- Heller, Nancy G. *Women Artists: An Illustrated History*. New York: Abbeville Press, 1987.
- Tippett, Maria. *Emily Carr: A Biography*. Toronto: Oxford University Press, 1979.

Minna Wright Citron, 1896–1991

Minna Citron's painting is a testament to her courage and persistence. She first began to attend art classes as a twenty-eight-year-old middle-class mother of two; ten years later, in the middle of the Depression, she divorced her husband and moved with her children to Union Square in Manhattan, where she succeeded both in supporting her small family and significantly developing her work. She was a versatile artist who moved from pointed caricature to commissioned murals to innovative, abstract techniques.

Minna Wright grew up an only child in Newark, New Jersey. Her father died when she was very young. Wright followed a fairly conventional path to marriage and motherhood in a comfortable Brooklyn neighborhood. She began taking commercial art classes at the New York School of Applied Design for Women with the idea of developing a business skill, but did so well there that she decided to take her talent more seriously.

Citron began to commute to Manhattan to take classes at the Art Students League. It was there that she began to develop her own style, inspired by the sly, satirical work of Honoré Daumier and shaped by her exposure to other artists at the league. She developed a tough—at times unforgiving—critical eye in her art, which perhaps played a role in her decision, at age thirty-eight, to divorce her husband, whom she later described as a selfish materialist.

She packed up her belongings and her children and moved to Union Square, where she was surrounded by the buzz and bustle of Manhattan and the company of several other professional artists. A year after Citron began divorce proceedings, she had her first solo exhibit at the Midtown Galleries Cooperative.

In the show at the Cooperative, Citron demonstrated the harsher side of her satirical skills. *Feminanities* was a series of paintings that skewered the stereotypical female,

in works like *She Earns "An Honest Living."* Later, she said that she had wanted to "hold a mirror to the unlovely facets of a woman's mind," and that she had been working out her own view of gender roles.

Citron taught for the Federal Art Project until 1937, in the meantime taking inspiration from whatever surroundings she found herself in. When she finalized her divorce in Reno, Nevada, she recreated the casinos and their inhabitants in pointed detail. In the early 1940s Citron went on a government-funded trip to Tennessee to paint murals. As she had as a teacher in New York, she spent her spare time working on her own paintings. After her return to Manhattan from Tennessee, she exhibited these smaller works at the Midtown Galleries.

Beginning in 1942 she worked with artists transplanted from Paris during World War II, including abstract artists Marc Chagall, Jacques Lipchitz, and André Masson. Inspired, she turned to abstract painting and began to experiment with her materials, thickly slathering paint onto her canvas and texturizing it with whatever came to hand. In one work, a plastic wrapper patterns the surface.

Minna Citron died at the age of ninety-five.

> *Citron's style was inspired by the sly, satirical work of Honoré Daumier.*

TO FIND OUT MORE . . .

- Harris, Ann Sutherland, and Linda Nochlin. *Women Artists: 1550–1950.* New York: Alfred A. Knopf, 1976.
- Fine, Elsa Honig. *Women & Art: A History of Women Painters & Sculptors from the Renaissance to the 20th Century.* Montclair, NJ: Allanheld, Osmun & Co. Publishers, Inc. and Abner Schram Ltd., 1978.
- Rubenstein, Charlotte Streifer. *American Women Artists: From Early Indian Times to the Present.* New York: Avon, 1982.

Elizabeth (Libba) Cotten, 1892–1987

At age eleven, guitarist, composer and musical innovator Elizabeth Cotten worked as a housemaid for seventy-five cents a month. The money went to the price of her first guitar, a $3.75 Sears and Roebuck model. She taught herself to play by ear, developing a new and influential style of three-fingered picking called "Cotten picking."

Elizabeth Nevills was the youngest of five children born in Chapel Hill, North Carolina, to Louisa Price Nevills and George Nevills. Her parents both worked, her father as a dynamite setter in the iron mines and her mother as a midwife. Banjo blues was then popular in Chapel Hill, and Elizabeth's older brother's banjo was her first instrument. She taught herself to play the right-handed instrument left-handed, with the bass strings on the bottom instead of the top. At eleven, she quit school to earn her guitar. That year she composed her well-known classic "Freight Train," which was much later recorded by the Grateful Dead and Peter, Paul, and Mary.

At fifteen, Nevills's improvisational home concerts with her family came to an abrupt halt when she eloped with Frank Cotten after their first date. She had a daughter, Lillie, the next year. Elizabeth had always been a churchgoer, singing in the choir at an early age, but her involvement grew as she became immersed in her new role as a wife and mother. The Cottens moved to New York, where Frank, a chauffeur, established his own business, and Elizabeth was a domestic servant. They divorced when Cotten was in her mid-fifties, and Elizabeth Cotten moved to Washington, D.C.

She found a job in Landsburgh's Department Store. One day she found a lost little girl in the toy department whose mother turned out to be the composer **Ruth Crawford Seeger**. Seeger offered Cotten a job cooking and cleaning for her large family in Chevy Chase, Maryland. It

was in the Seegers' busy, musical home that Cotten rediscovered the guitar. Charles Seeger was an ethnomusicologist, and Ruth Seeger was then compiling a huge collection of folksongs. Of the seven children they raised, three—Pete Seeger, Peggy Seeger, and Mike Seeger—grew up to be folk singers.

At age sixty-seven, Libba joined Mike Seeger on stage at Swarthmore College. It was her first professional concert. She would give many more, performing at blues and folk festivals until her death in 1987, nearly thirty years later. She cut several records on the Folkways label from 1957 to 1983, most notably *Elizabeth Cotten Live!* (1983), which won her a Grammy award. Her upside-down style of playing left-handed on a guitar strung for right-handed players gave her an innovative—and much-analyzed—sound. The upper strings, instead of the bass strings, provide the rhythm.

In an interview with Brian Lanker shortly before her death, Cotten said, "I just love to sing. I love to get up before people and let 'em hear what I can do I love to entertain people, sing to 'em, talk, tell little things about me, what all I used to do. That was my pleasure to do that."*

> *She taught herself to play by ear, developing a new and influential style of three-fingered picking.*

TO FIND OUT MORE . . .

- Harris, Sheldon. *Blues Who's Who.* New York: Da Capo Press, 1979.

- Lanker, Brian. *I Dream A World: Portraits of Black Women Who Changed America.* New York: Stewart, Tabori & Chang, 1989.

- Smith, Jessie Carey, ed. *Notable Black American Women.* Detroit, MI: Gale Research Inc., 1992.

* Quote reprinted from *I Dream a World: Portraits of Black Women Who Changed America.* Copyright ©1989 Brian Lanker. Reprinted by permission of Stewart, Tabori & Chang, Publishers.

Imogen Cunningham, 1883–1976

Imogen Cunningham's sensitive photographic close-up studies of flowers and plants prefigured Georgia O'Keeffe's paintings of the same subjects by almost a decade. Art historian Hugo Munsterberg, in his book *A History of Women Artists*, suggests that they inspired O'Keeffe, who would have had access to them through her photographer husband, Alfred Steiglitz. Whether or not Cunningham's photographs had any effect on O'Keeffe's work, however, they stand alone as innovative works of art.

Although Cunningham's work drew national attention, she lived all her life on the West Coast. She was born in Portland, Oregon, and moved to Seattle when she was six years old. She attended college locally, at the University of Washington, majoring in chemistry. In 1901, she decided—against her father's wishes—on a career in photography, inspired by the work of **Gertrude Käsebier**.

Despite her father's forcefully expressed objections, Cunningham took a job in Edward S. Curtis's studio, where she learned commercial platinum printing techniques and watched Curtis work on his renowned collection of historical photographs of Native Americans, financed by millionaire J.P. Morgan. After further grounding her technique with a year of study of photographic chemistry in Germany, she was ready to branch out on her own.

In 1910 Cunningham opened her own portrait studio in Seattle. Her portraits, like Käsebier's, relied on hazy soft focus, but they had a distinctive straightforwardness that carried over into her later work. In 1915 she married artist Roi Partridge, with whom she had three boys. The family moved to San Francisco, then to Oakland, California. Wherever they were, Cunningham continued to work for the pleasure of it, refining her style to new levels by 1920.

In her late forties, as her children grew older and more independent of her, Cun-

ningham returned full-time to photography. Her involvement in West Coast photography made her a founding member of the "f/64" group, along with Ansel Adams and Edward Weston. As a group they rejected the formerly popular lyrical, soft-focus photography of pre-World War I days in favor of crisp, clearly focused work.

Cunningham's closeup studies of plant life fit into the group's style. She used sharp focus and zoomed in close to minutely examine the textures of the flowers and other plants she studied; but could also use the technique to explore the repetitive patterns formed by her subjects. In *Plant Forms* (1923), she takes advantage of clear, slanting sunlight to play up the cabbage-rose shapes of her plants, which are emphasized by the sharply defined shadows.

> In 1901, she decided—against her father's wishes—on a career in photography.

Cunningham was also known for her close-ups of expressive hands and her penetrating portraits of prominent contemporaries, including Alfred Steiglitz, Gertrude Stein, Herbert Hoover, Upton Sinclair, and dancer/choreographer Martha Graham. In 1967, Cunningham and Graham were the only two women elected to fellowship in the National Academy of Arts and Sciences.

Active and prominent into her nineties, Cunningham's work has been much honored and exhibited on both coasts. She declined to comment on her work in later years, suggesting instead that her audience decide for themselves what her photographs have to say. She died at age ninety-three in 1976.

TO FIND OUT MORE . . .

- Dater, Judy. *Imogen Cunningham: A Portrait*. Boston, MA: New York Graphic Society, 1979.

- Lorenz, Richard. *Imogen Cunningham: Ideas Without End: A Life in Photographs*. San Francisco: Chronicle Books, 1993.

- Munsterberg, Hugo. *A History of Women Artists*. New York: Clarkson N. Potter, 1975.

Natalie Curtis, 1875–1921

L ike folk matriarch **Ruth Crawford Seeger** and Creole artist **Camille Nickerson**, Natalie Curtis was committed to preserving indigenous American forms of music. Her work was mostly done among Native Americans in the Southwest. With her accurate ear and careful transcriptions, she was able to preserve hundreds of songs from a range of tribes and tongues.

Curtis was the child of prominent New Yorkers who counted Theodore Roosevelt among their friends. Natalie trained as a concert pianist in New York and Berlin, but in her early twenties her attentions shifted when, on a trip to Arizona, she was seized by the conviction that Native American culture was fast disappearing. Alarmed by the apparent state of affairs, she took on the challenge of recording Native American songs and chants for posterity.

In this project she had the help of family friend Theodore Roosevelt. Native Americans living on reservations were then expected to slough off their primitive ways so that they could cleanly adjust to Anglo society. One rule laid down to help enforce this policy restricted native songs from being sung in government schools. At Curtis's request, Roosevelt abolished the rule. She was able to move about the reservations without restrictions.

Over a decade, Curtis visited eighteen tribes all over North America, including some in Maine and British Columbia. She started out using a phonograph to record the songs, but soon found that a pencil and her own musically trained ear were just as accurate. She was a welcome guest at the reservations, where she sometimes sang songs from other tribes for her hosts. In 1907 she published her collection of two hundred songs in *The Indians' Book*. The ever-helpful Roosevelt wrote the introduction. The collection was reissued in 1923 and 1935.

Curtis's concern for authenticity led her to study African-American songs, which she felt were being contaminated by new arrangements and popular styling. Bringing her skills as an accurate transcriber to this new field, she presented a four-volume study of folk songs in 1918–1919, *Hampton*

Series Negro Folk-Songs. A smaller study in the same vein, done from her study of the songs of two African students, was published under the rather pejorative title of *Songs and Tales from the Dark Continent (1920)*.

At forty-two she married artist Paul Burlin, with whom she had a son. Young Paul was still a baby when Natalie Burlin was struck and killed by a Parisian taxi on a trip to lecture on art history at the Sorbonne.

Curtis's recordings survive, but they are not, as she had originally thought, the only remaining relics of Native American culture. Thanks in part to the efforts of advocates like her, government-enforced policies designed to assimilate Native Americans by stripping them of their cultural heritage were phased out. Many of the songs she so carefully recorded are still sung today.

> *Curtis got family friend Theodore Roosevelt to abolish a rule that forbade the singing of native songs by Native American children.*

TO FIND OUT MORE . . .

- Eaglefield-Hull, A., ed. *Dictionary of Modern Music and Musicians.* New York: E.P. Dutton Co., 1924.

- James, Edward T., ed. *Notable American Women 1607–1950: A Biographical Dictionary.* Cambridge, MA: The Belknap Press of Harvard University Press, 1971.

- Obituary. *The New York Times,* October 29, 1921.

Mabel Wheeler Daniels, 1878–1971

. .

Mabel Daniels wanted to be known for her music, not her gender. Music, she declared, must be judged on its merits, "[no] difference whether written by a man or a woman or a Hottentot or a Unitarian." In the early 1900s, that was not a particularly easy goal, but Daniels was in fact declared "one of our finest composers" by American composer Randall Thompson. Many of her compositions explore the less dominant instruments, including flute, harp, and voice.

Daniels was born in Swampscott, Massachusetts, the only child of Sarah Wheeler and George Frank Daniels, both from old New England families. George Daniels was a businessman with musical leanings; he was the vice president of the Boston Board of Trade and the president of the Handel and Haydn Society. Her mother encouraged Mabel in her piano lessons as it became obvious that she had considerable talent.

Daniels attended Radcliffe College in Cambridge, Massachusetts, from 1896 to 1900. She thrived there, composing and conducting operettas and singing in the Glee Club. She became increasingly serious about composition, and, on her Cum Laude graduation in 1900, decided to pursue it as a career. It would never be a terribly lucrative career choice, but financial support from her family made it possible for her to pursue it. She studied orchestration at the New England Conservatory of Music and traveled in 1902 to Munich to study at the city's Royal Conservatory. She published a book on her experiences there after her return, *An American Girl in Munich* (1905).

Boston's rich musical culture suited Daniels, and after her Munich training, she immersed herself in music in Cambridge. She was the musical director at Simmons College, directed the Radcliffe Glee Club, and sang in the Cecilia Society. Her thorough understanding of the human voice, developed in her work both directing and

singing, was much praised in her later compositions.

Daniels helped her friend **Marian MacDowell** develop the MacDowell Colony in Peterborough, New Hampshire. She also took advantage of its peaceful location to work on her own composition. Her 1913 cantata *The Desolate City*, one of her more popular works, was first performed at the Colony. Daniels always remembered her wonderful experiences as a student and worked to support young rising musicians and composers. She donated lavishly to Radcliffe, which named a hall for her, and founded a scholarship at the New England Conservatory.

> *Daniels stressed "a strong constitution" and "perseverance" as qualities a composer might need.*

Although she considered herself a political and musical conservative (she voted Republican and disliked experimental atonal music), she was a suffragist and felt strongly about women's rights. She felt that her own career as a composer was hampered by her gender, and stressed "a strong constitution" and "perseverance" in her list of qualities a composer might need. Dedicated to her work, she continued to compose into her eighties. She died, in her ninety-third year, of pneumonia in Cambridge, Massachusetts.

TO FIND OUT MORE . . .

- Ammer, Christine. *Unsung: A History of Women in American Music.* Westport, CT: Greenwood Press, 1980.
- Macksey, Joan, and Kenneth Macksey. *The Book of Women's Achievements.* New York: Stein and Day, 1975.
- Sicherman, Barbara, and Carol Hurd Green, eds. *Notable American Women: The Modern Period. A Biographical Dictionary.* Cambridge, MA: The Belknap Press of Harvard University Press, 1980.

Dat-So-La-Lee (Datsolalee) (Louisa Kayser), 1850–1925

Native American basket weaver Dat-So-La-Lee worked as a maid until she was about sixty years old. Abe Cohn, the son of a former employer, was so impressed with her intricately woven baskets that he became her business manager, introducing her work to others. Her work was featured in the St. Louis Exposition of 1919, and she lived out the rest of her life devoting her energies to her baskets.

Dat-So-La-Lee came from the Washo people around Lake Tahoe, situated near the border between California and Nevada. Basket weaving was a practical skill for her, as it was for all Washo women and girls; and she learned it as a child. Her life was changed forever by the invasion of white miners and settlers as the Gold Rush swept the West, and she survived by working for some of them as a washerwoman or a maid.

After a lifetime of menial work, Dat-So-La-Lee's life abruptly changed. Abe Cohn, who had grown up in a household cleaned by Dat-So-La-Lee, discovered her basketwork. Cohn, a successful businessman in Carson City, Nevada, brought Dat-So-La-Lee and her husband, Charles Kayser, to Nevada, placed them in a small house near his own, and paid all their bills in return for Dat-So-La-Lee's creations.

Dat-So-La-Lee's baskets are a testament to her patient craftsmanship. The "threads" she used were actually plant fibers: the pale, creamy inner bark of a willow twig, red birch bark, and bracken fern root, blackened by mud. Each material had to be scraped down to the desired thickness with a piece of broken glass and woven into a pattern. The threads in Dat-So-La-Lee's baskets are extremely fine—about .03 inches—and densely packed. Her designs are precise, fine, and meticulously spaced, her forms rounded and self-contained.

Cohn carefully catalogued each of Dat-So-La-Lee's creations, organizing them ac-

cording to date. She devoted a considerable amount of time to each basket, sometimes several months, and her emotions came out in her work. She wove a disturbed-looking, irregular basket when her husband Charles was thrown in jail. Like any artist, she experimented for a while before settling on her orderly designs, in which repeated motifs are arranged in rows on the surface of the basket.

No written record exists of her birth, so it is uncertain how old Dat-So-La Lee was when she died in 1925. Estimates place her somewhere between seventy-five and ninety. Examples of her work can be found at the National Museum of the American Indian in New York City.

> *Like any artist, she experimented for a while before settling on her orderly designs, in which repeated motifs are arranged in rows on the surface of the basket.*

TO FIND OUT MORE . . .

- Cohodas, Marvin. "Dat So La Lee's Basketry Design." *American Indian Art*, 1, no. 4 (Autumn 1976): 22–31.

- Munsterberg, Hugo. *A History of Women Artists.* New York: Clarkson N. Potter, 1975.

- Rubenstein, Charlotte Streifer. *American Women Artists: From Early Indian Times to the Present.* New York: Avon, 1982.

Maya Deren, 1917–1961

The avant-garde filmmaker Maya Deren was one of the most influential figures in the artier circles of American filmmaking in the 1940s and 1950s. Her works focused on dark and magical themes—dreams, witchcraft, Chinese martial arts. She was deeply devoted to her art; her personal life and her films were always intertwined. In her brilliant career she helped American experimental filmmaking gain respect in the international art world.

Maya Deren was born Eleanora Derenkowsky in 1917 in Kiev, Russia. Her father had been a medical corpsman in the Russian army, and her mother had graduated from an exacting program at an arts conservatory. Solomon and Marie Derenkowsky moved to the United States with their only child in 1922, and the family shortened its name to Deren. Solomon redid his medical training in the United States and soon established himself in Syracuse, New York as a lecturer in mental hygiene and a physician at the Syracuse State School for Mentally Defective Children. Marie Deren taught.

Encouraged by her mother to seek out the best possible education, Eleanora Deren studied at L'École Internationale in Geneva, Syracuse University, New York University, the New School for Social Research, and Smith College, where she recieved an A.M. in literature in 1939. During her student years, she was a socialist, writing for left-wing periodicals and marrying a labor reformer. (They divorced in 1938, after three years of marriage.) A year after her graduation, Deren became the personal secretary of Katherine Dunham, the great African-American dancer and choreographer.

Deren's work with Dunham inspired her first published article, "Religious Possession in Dancing," which ran in *Educational Dance* in 1942. Dunham's island-inspired dances struck a chord in Deren; she would return again and again to Haiti in her films for creative material. Her repertory of artistic tools grew with her second marriage, this time to Alexander Hammid, a Czechoslovakian cinematographer. He taught her, in her words, "the mechanics of film expression and . . . the principle of infinite pains." They divorced after five years of marriage,

but first they coproduced her film *Meshes of the Afternoon* (1943), the best-known of her works.

Deren's films often incorporated dance, which helped to evoke the mystical world of her imagination. In *Witch's Cradle*, she enlisted Marcel Duchamp to help infuse some of the artist's surrealism into the film; she saw a link between his work and her interest in medieval magic. Her bold *Study in Choreography for Camera* (1945), starring the dancer Talley Beatty, broke new ground in cinedance. In her 1946 *Ritual in Transfigured Time*, Deren herself starred in a film that contemplates her status as a creator and a manipulator: In it, she metamorphoses from widow to bride.

By late 1946, when she published *An Anagram of Ideas on Art, Form, and Film*, she was well established as one of the leading lights of experimental film. Less than a year later, she became the first woman *and* the first American to win the Cannes Grand Prix Internationale for Avant-Garde Film for her first four films. She continued her pursuit of Haitian mysticism, publishing a well-received book, *Divine Horsemen: The Living Gods of Haiti*, in 1953. She completed another film on ritual metamorphosis, *The Very Eye of Night*, in 1954. It would be her last, and it pushed Deren to her creative peak, "out in space about as far as I can go," as she put it.

Her third marriage, in 1960, was to the composer Teiji Ito, a colleague in some of her later work. It lasted only a year; in 1961 Deren died of a stroke. Her work remains, proof that she pushed the creative boundaries of film forward about as far as she could go.

> Deren helped American experimental filmmaking gain respect in the international art world.

TO FIND OUT MORE . . .

- Brakhage, Jane. *From the Book of Legends*. New York: Granary Books, 1989.

- Clark, Veve A. *The Legend of Maya Deren*. New York: Anthology Film Archives/Film Culture, 1984.

- Sicherman, Barbara, and Carol Hurd Green, eds. *Notable American Women: The Modern Period. A Biographical Dictionary*. Cambridge, MA: The Belknap Press of Harvard University Press, 1980.

Katherine Sophie Dreier, 1877–1952

. .

Painter and art patron Katherine Sophie Dreier had a strong activist streak. Her early commitment to community service and feminism extended to her less-well-off peers in the art world, and her work in supporting art and backing innovative new talent benefited such struggling artists as Kandinsky, Klee, and Piet Mondrian.

Katherine Dreier, the fifth child of Dorothea and Theodor Dreier, was born in their Brooklyn home. Her German-born father had moved to New York, married his cousin, and made a comfortable living as a manager for an iron and steel distribution company. Katherine attended private school and took art classes in Brooklyn. Her parents' death when Dreier was in her late teens left Dreier with a substantial inheritance and the freedom to pursue a nonlucrative career in art and public service.

Dreier spent most of her twenties studying painting and undertaking a huge load of public-service work. A year at the Pratt Institute was followed by two in Europe. Back in New York in 1925, she earned her first commission, a painting for the altar of St. Paul's School's chapel in Garden City, New York. During this time she also spent nine years working for a program her mother had founded, the German Home for Recreation for Women and Children; cofounded and headed Brooklyn's Little Italy Neighborhood Association; and worked in the suffrage movement.

She moved in 1909 to the arty Chelsea section of London, where she painted and became friendly with other artists. A 1911 marriage to another American artist, Edward Trumbull, was quickly annulled when it was discovered that Trumbull had another wife and children. After more study in London and Munich, Dreier moved back to New York in late 1912.

She exhibited two paintings in the Armory Show of 1914. She was thrilled by the new ideas she saw in the other show en-

tries, particularly *Nude Descending a Stair-case* by Marcel Duchamp, but was disappointed by the audience's mostly befuddled response. Along with Duchamp and Man Ray, she formed the new Société Anonyme, an organization dedicated to promoting "the progressive in art" in America.

When the Société opened in a rented gallery in downtown Manhattan in 1920, it was the first American museum of modern art, featuring works selected by artists—not curators. And modern art was, at that time, in full swing. Duchamp had just had his notorious sculpture *Fountain* banned (it was a urinal). Joan Miró, Kurt Schwitters, and Paul Klee had not yet come to prominence. They were among the many innovative young artists who got their start at the Société. The organization also acted as a kind of cultural center, sponsoring readings and lectures by the likes of Marsden Hartley and Alfred Steiglitz.

> *Along with Duchamp and Man Ray, she formed the new Société Anonyme, an organization dedicated to promoting "the progressive in art" in America.*

Dreier herself lectured frequently at the Société and published prolifically, often under its aegis. The New York Museum of Modern Art, which opened in Midtown Manhattan in 1929, somewhat eclipsed the smaller Société, which permanently do-nated its collection to Yale University in 1941. But it seems plain that the organization had more than served its purpose; its impressive midtown successor speaks for the success of the stated goals of the Société Anonyme.

Dreier continued to paint, write, and lecture for the rest of her life. Her three years in Paris mark her work as belonging to the Abstraction-Création Group. In later years, she broadened her artistic interest to the performing arts, befriending pioneer modern dancer Ted Shawn (see **Ruth Denis**) and painting *40 Variations* on musical themes. She died in 1952.

TO FIND OUT MORE . . .

- Rubenstein, Charlotte Streifer. *American Women Artists: From Early Indian Times to the Present.* New York: Avon, 1982.

- Sicherman, Barbara, and Carol Hurd Green, eds. *Notable American Women: The Modern Period. A Biographical Dictionary.* Cambridge, MA: The Belknap Press of Harvard University Press, 1980.

Isadora Duncan, 1878–1927

Isadora Duncan, America's first modern dancer, leapt impulsively from project to project and continent to continent. Unable to win recognition in her own country and restlessly going through a series of brief, passionate affairs, Duncan poured her emotions into her innovative dancing, which prefigured America's modern dance movement by several decades.

After leaving her husband Joseph, whose indiscriminate affairs and questionable business dealings ended the marriage when Isadora was still an infant, Dora Duncan moved her four children from San Francisco to Oakland, California, and tried to support her brood by teaching piano.

Dora Duncan considered "culture" more important than money or formal education, and Isadora dropped out of school at age ten. She had already made a name for herself in her neighborhood with her free-spirited dancing, and with her sister Elizabeth, she began to teach other children for fees. The lessons soon attracted the children of wealthy San Franciscans, and Isadora's little school was soon turning a tidy profit. Although she took private ballet lessons as a girl, Duncan found them as confining as she had elementary school and focused instead on developing her own style of "natural movement." By the time Isadora was in her late teens, the family had begun to perform for paying audiences, with Dora on piano, the girls improvising dances, and the boys acting out playlets.

At nineteen Duncan suffered her first romantic disappointment. Determined to leave California, she talked her family into following her out to Chicago, where, she was sure, she would become a star. Instead, she found only indifference and another heartbreaking affair with a man who turned out to be married. She moved the family to New York and began a series of unsatisfying jobs in stage shows and pantomimes. Unable to win her directors over to her idiosyncratic style of dance, Duncan began dancing in private performances for New York's wealthiest families. Despite her popularity, the income from these and from her sister's dance classes in Carnegie Hall scarcely paid the bills. A fire wiped the Duncans out, and they traveled together to Europe in 1899.

London was not ready for her innova-

tions, but Paris welcomed her with open arms. Her dancing sought to evoke primitive emotion in its audience, and Paris's artistic movement toward simplicity was perfectly timed for Duncan's arrival. From 1902 until 1908 she developed a following all over Europe. She became a noted personality, openly disdaining the institution of marriage and dancing in scanty clothing that scandalized her American audience. In 1908, after an initially disappointing tour, she finally gained the recognition she sought in her home country. She was never, however, accepted by mainstream American audiences, who considered her scandalous, and even her mother eventually despaired of Isabella's ever becoming "respectable."

> *Unable to win her directors over to her idiosyncratic style of dance, Duncan began dancing in private performances for New York's wealthiest families.*

In 1913, Duncan's two children, fathered by two different men, drowned with their nanny in a freak accident when a taxi rolled into the Seine river in Paris. Another son, conceived in an effort to fill the emotional hole that their deaths had left in Duncan, died in infancy. She achieved moderate success in the United States, but she seemed unable to settle down romantically or professionally. By 1920 she had fled to Europe once more, where she married the mentally unstable Russian poet Sergei Yessenin. Their violent, furniture-smashing tantrums earned them a terrible reputation in America and Europe. Yessenin became increasingly volatile and left Duncan for a Russian woman within only a few years. He committed suicide in 1925.

In Paris at forty-eight, Duncan fought loneliness and the knowledge that she was considered passé by the art world. She maintained her flamboyant image with overdone hair dye and makeup, and wrote a candid autobiography, *My Life*, in 1926. In 1927, she hopped into a sports car driven by a dashing young Italian fellow and cried out, "Adieu, mes amis. Je vais à la gloire." ("Goodbye, friends, I'm off to glory.") She was killed instantly when the car took off; her long red scarf, caught in the car's wheel, broke her neck. After years fighting obscurity, she was finally back in the headlines. Her funeral in Paris was attended by more than ten thousand mourners.

TO FIND OUT MORE . . .

- Baxter, Annette K. "Isadora Duncan." *Notable American Women 1607-1950: A Biographical Dictionary*, edited by Edward T. James. Cambridge, MA: The Belknap Press of Harvard University Press, 1971.

- Blair, Fredrika. *Isadora: Portrait of the Artist as a Woman*. New York: McGraw–Hill, 1986.

- Richey, Elinor. *Eminent Women of the West*. Berkeley, CA: Howell-North Books, 1975.

Mabel Dwight, 1876–1955

Artist and satirist Mabel Dwight never felt she had to go out of her way to find humor in everyday life. Modern life in the city seemed to her to be so full of absurdities, all she felt she was doing was capturing it in ink. Her lithographs do have that feel of a common situation wryly observed, and the quiet smile lurking behind her images makes them classics.

Mabel Dwight grew up in big cities, first Cincinnati and then New Orleans, and was accustomed to their hustle and bustle when she left for art school in San Francisco. She studied at the Hopkins Art School there and lived a rather bohemian life.

Many of her fellow art students were socialists, and their radical ideas were a great early influence. She upset her more conservative parents with her new ideas. She identified strongly with the poor and underfed, considering poverty an unnecessary evil in the modern age. Eventually Dwight became more moderate in her political views, but her early empathy for the poor was the flip side of her darkly funny work on city life. It influenced some of her

less humorous prints, like *In the Crowd* and *Derelicts* (both 1936).

Mabel Dwight's art remained undeveloped for many years while she traveled in the great cities of Europe and Asia. In 1927, however, at the age of fifty-one, she began producing the lithographs that established her reputation. Her first lithographs depicted Paris in the late 1920s, but in 1928, she returned to the United States, where her 1928 *In the Subway* was the first of her hundreds of lithographs pointing out the oddities in modern urban life.

A classic example of her work is her 1936 *Queer Fish*. In an indoor aquarium, a small crowd gathers to observe a tank of oddly shaped fish. A roundish bald man with popping eyes and a downturned mouth stares at a grouper with popping eyes and a downturned mouth. Their expression is one of mutual horror.

The Federal Art Project sponsored her from 1935 to 1939. During this period, Dwight's work was exhibited at New York's Weyhe Gallery. The Federal Art Project's requirements mandated that every artist on

their payroll punch a clock in Manhattan every morning. Dwight was in her sixties and hard of hearing by the time she worked for the Project. She also lived a fair trip away from the clock in Manhattan. She lived in fear of sleeping through her alarm and missing her daily clock punch, even though her work was done in her Staten Island studio.

Dwight wrote an essay, "Satire in Art," for the Federal Art Project. In it, she crisply analyzes the elements of satire, looking for inspiration to the work of other satirists, like Honoré Daumier and Francisco Goya. Her

> *She captured the poignancies of urban life with her quiet style and eye for humor.*

own work shows none of the shrillness she criticizes in the essay, even in her more socially conscious works like *Derelicts*. Instead, she captured the poignancies of urban life with her quiet style and eye for humor.

TO FIND OUT MORE . . .

- Henkes, Robert. *American Women Painters of the 1930s and 1940s: The Lives and Work of Ten Artists.* Jefferson, N.C.: McFarland, 1991.

- Rubenstein, Charlotte Streifer. *American Women Artists: From Early Indian Times to the Present.* New York: Avon, 1982.

Emma Hayden Eames, 1865–1952

Soprano Emma Hayden Eames made her name on stage in Paris and New York with her performance of the role of Juliette, the doomed ingenue from Charles Gounod's opera *Roméo and Juliette*. Her versatile voice and her proud bearing quickly made her an international favorite. Later, when her prickly dignity made work in the highly competitive world of international opera difficult, her devoted public fueled a second brilliant career as a concert singer.

Emma's father, Ithama Bellows, was a lawyer. He worked in the international courts in Shanghai, China, where Emma was born. Shanghai did not suit the poor health of Emma's mother (also named Emma Hayden Eames), so the Eames family moved to Bath, Maine. In Bath, Emma grew up in the care of her mother's parents. She absorbed her grandmother's prickly dignity and later gained a reputation for her professionally cool demeanor.

Emma began training with her mother in Portland, Maine, as a teenager. At seventeen she went to Boston to sing for pay in churches, and when she was twenty, she traveled to Paris with her mother to complete her training. In Paris she polished her style under the well-known teacher Mathilde Marchesi. Marchesi was as strict as Eames's grandmother had been, and the young singer went through the *maestra's* regime of classes in voice and stage skills, including languages and mime.

International opera was extremely competitive, even at Emma's early age. Fellow student Nellie Melba became a lifelong rival when she blocked Eames's planned debut at the Théâtre la Monnaie in Brussels. In 1889 Charles Gonoud arranged another debut for her, starring in his opera *Roméo and Juliette*. Eames left the Paris Opéra a year later, when her archrival joined the company. A successful season at Covent Garden in London and at the Metropolitan

Opera in New York launched a twenty-year career in international opera.

Eames's flourishing career took her all over Europe. She established homes abroad for herself—a townhouse in Paris and a castle in Tuscany. She married Julian Story, a fellow American artist, a painter and the son of an eminent New England clan. They were divorced in 1907; the marriage was not a happy one after the first couple of years. She developed a reputation, for which she was admired onstage and resented offstage, for her icy, regal bearing. One reviewer said of her performance in *Aïda*, set in Egypt, "There was skating on the Nile last night." Eventually the headstrong diva encountered an immovable object: the administration of the Metropolitan Opera in the 1908–1909 season.

Rather than struggle with opposing forces in opera, she built a new, equally successful career on the concert stage. She was briefly married to her stage partner, Brooklynite singer Emilio de Gogorza, following a flurry of notoriety brought on by de Gogorza's legal troubles with his previous wife. This publicity did not deter her devoted public, and Eames was a concert star for the six years until her retirement. She was even able to leave opera on her own terms, with performances in the Boston Opera's *Tosca* and *Otello*. She retired permanently from performing in 1916, at the age of fifty-one.

Eames spent twenty years shuttling between Europe and America before settling in New York at age seventy-one, where she embarked upon a third career as a voice teacher. She died in 1952, two months short of her eighty-seventh birthday.

> *She developed a reputation, for which she was admired onstage and resented offstage, for her icy, regal bearing.*

TO FIND OUT MORE . . .

- Eames, Emma Hayden. *Some Memories and Reflections.* New York: D. Appleton, 1927.

- Sicherman, Barbara, and Carol Hurd Green, eds. *Notable American Women: The Modern Period. A Biographical Dictionary.* Cambridge, MA: The Belknap Press of Harvard University Press, 1980.

Mary Abastenia St. Leger Eberle, 1878–1942

The style of the sculptor Mary Eberle has much in common with that of a photojournalist. She worked in New York's Lower East Side when that part of the city was jammed with new immigrants and new social problems, and she recorded the lives of its inhabitants with the eye of a reporter. This factual style made her socially conscious sculptures, like her 1913 *White Slave*, about the exploitation of poor immigrant women, powerfully moving.

Eberle was born in Webster City, Iowa, and grew up mostly in Canton, Ohio. Her father was a physician who sometimes took her along on his house calls. On one of these trips, Eberle and her father visited the studio of a local sculptor. Eberle was immediately captivated by the idea of becoming a sculptor. Luckily her parents were supportive, and she began sculpture lessons with Frank Vogan, a nearby artist and teacher. When she was about twenty years old, Eberle's family moved to Puerto Rico,

where her father was sent as an army surgeon during the Spanish-American War. She found subjects for her sculpture among the people in the streets, and began to develop her factual style.

In 1899 Eberle won admittance to the Art Students' League in New York, where she took classes taught by sculptor George Grey Barnard. She shared an apartment with the successful animal sculptor **Anna Vaughn Hyatt**. The two became good friends and collaborators, working together on sculptures in which Hyatt molded the animal figures and Eberle shaped the human ones. One of their joint works, *Men and Bull*, won a bronze medal at the 1904 St. Louis Exposition.

After a period of study in Naples, Italy, where she learned both from the people in the street and the celebrated sculpture there, Eberle moved to Manhattan in 1908. She began to make forays into the East Side to search for subjects. The early small

pieces she did in bronze of slum life bring the vibrancy of the city to their audience. One particularly joyful sculpture, *Roller Skating* (1906), has a small girl on roller skates, arms open wide, hair and dress blown back, and mouth open wide in a shout of surprised delight. Her realistic portraits of slum life place her in the group of painters and sculptors of the early 1900s called the Ash Can School.

Despite her eye for small joys in the city, Eberle couldn't avoid its darker side, and she soon began to document the evils she saw in her trips to the East Side of Manhattan. She was developing a social conscience tinged with her own feminist ideas, which are visible in her controversial 1913 sculpture, *White Slave*. The plaster sculpture, which has since been destroyed, was first captured on the cover of the periodical *The Survey*. In it, a leering man seems to auction off a barely pubescent girl, who hangs her head in shame. The sculpture is a sharp comment on prostitution's exploitation of the immigrant population.

By 1914 Eberle had moved to the Lower East Side to be closer to her subjects. Children played in an area near her studio,

> *Eberle's controversial 1913 sculpture, White Slave, attacked prostitution's exploitation of the immigrant population.*

which she set up in order to observe them. She was never terribly successful in winning commissions—her work was a bit too gritty for the current tastes—but she was able to maintain her sculpture until she was forty, when she became ill and unable to work. Her studies of day-to-day life in the slums were not recognized until relatively recently as early examples of an important school of art.

TO FIND OUT MORE . . .

- Armstrong, Tom, ed. *200 Years of American Sculpture*. New York: David R. Godine, Publisher, 1976.

- Edwards, James T., ed. *Notable American Women: 1607-1950*. Cambridge, MA: The Belknap Press of Harvard University Press, 1970.

- Heller, Nancy G. *Women Artists: An Illustrated History*. New York: Abbeville Press, 1987.

- Rubenstein, Charlotte Streifer. *American Women Artists: From Early Indian Times to the Present*. New York: Avon, 1982.

Geraldine Farrar, 1882–1967

Geraldine Farrar, soprano, was a prima donna in the best sense: She always refused to be undersold. Determined from the first to be a star, while still in her teens she turned down several invitations to sing at the Metropolitan Opera in New York—simply because she had been invited to sing in *minor* roles. Her finickiness paid off: By age twenty-four she was singing major roles in Berlin.

Farrar's parents were both natural performers. Her mother was the lead soprano in her church choir, and her father was a professional baseball player and an amateur singer in his wife's choir and at local concerts. Their Melrose, Massachusetts, home was filled with music, and Geraldine started young. She picked out tunes by ear on the piano as soon as she could walk, sang a solo in church at three, and began taking lessons not long afterward. Her first paid singing performance was at fourteen. She received ten dollars. Five months later she gave her first recital, in Boston.

Farrar had seen Emma Calvé sing the role of Carmen in Bizet's opera and re-

solved to become an opera singer. Her recital had attracted the attention of an associate of the famous voice teacher Luisa Cappiani, and she was encouraged to audition with her. Although her audition was successful, Farrar turned down the offer to study with Cappiani, since she would have to sign an exclusive three-year contract in order to do so. Instead, she studied in New York with another teacher and hungrily watched performances at the Metropolitan Opera House.

Farrar's talent gained her admirers and artistic contacts, but when no major soprano roles were offered her quickly enough in New York, she accepted a loan of thirty thousand dollars and sailed for Paris. After two years studying there, she moved to Berlin, where she was offered a three-year contract—and the coveted major soprano roles—by Karl Muck, the principal conductor of the Berlin Royal Opera. Her debut, at the tender age of twenty, was in the role of Marguerite in *Faust*. She was a leading soprano for the orchestra, singing roles that included Juliet in *Romeo and Juliet*, Violetta

in *La Traviata*, Zerlina in *Don Giovanni*, Gilda in *Rigoletto*, and Leonora in *Il Trovatore*. Massenet's *Manon* was revived in order that she could play the title role, and the composer himself coached her for the performance.

She continued her string of successes in Europe, playing lead roles in Paris, Warsaw, and Monte Carlo, where she starred in *La Bohéme* with Enrico Caruso. She made her triumphant return to New York with a contract to sing starring roles at the Metropolitan Opera House, and opened the 1906 season there as Juliet. Her work there was renowned; she was considered a charismatic dramatic actress as well as an important singer. For her most famous role, as Cio-Cio-San in Puccini's *Madama Butterfly*, Farrar spent several weeks working with a Japanese actress, learning how to act the perfect Japanese lady. Puccini, however, had different ideas about how the role should be played, and the composer and singer clashed so strongly that Puccini went so far as to criticize her publicly.

Despite—or perhaps because of—her headstrong ways, Farrar was a huge success at the Metropolitan Opera, where she sang for sixteen years. Her retirement from the Met at age forty (as she had always declared it would be) brought her enormously successful career more or less to an end. She would never again sing at the Met, although she toured infrequently; she preferred to rest on her remarkable laurels. Her later years were spent in satisfied quiet, working for the Red Cross and other philanthropical organizations.

> *Although Farrar's role in Puccini's* **Madama Butterfly** *brought her great fame, her conflicts with the composer made life difficult for them both.*

TO FIND OUT MORE . . .

- Ewen, David. *Musicians Since 1900: Performers in Concert & Opera.* New York: The H. W. Wilson Company, 1978.

- Nash, Elizabeth. *Always First Class: The Career of Geraldine Farrar.* Washington, D.C.: University Press of America, 1981.

- Sadie, Stanley. *The New Grove Dictionary of Opera,* vol. 2. London: Macmillan Press Ltd., 1992.

Perle Fine, 1908–1988

Perle Fine strove to convey a sense of gentle order in her abstract paintings and collages. A critic once compared one of her paintings to a Calder mobile, citing its bright shapes and black lines. Like Calder's mobiles, Fine's works achieve harmony and inspire peace in their audience.

Fine was raised near Boston on her parents' dairy farm. She followed through on her early artistic leanings, moving to New York City in her late teens to take classes at the Art Students' League with drawing master Kimon Nicoläides. While still a student, she met Maurice Berezov. Both became abstract artists, and when they married, Fine kept her own name. They were careful always to keep their artistic selves quite separate, and Fine managed to escape many of the obstacles that faced women artists like **Frida Kahlo** and **Lee Krasner**.

Around age thirty, Fine studied with abstractionist Hans Hofmann. She gained much from the experience, but often disagreed with Hofmann's artistic philosophy. Uneasy with his ideas, she continued to search for her own form of expression. She eventually found a home at the Guggenheim Museum. **Hilla Rebay** made her one of the recipients of the Guggenheim Foundation's funds, and Fine began to bring her work in for show.

In 1945 Fine had her first one-woman exhibition at the Willard Gallery. In her paintings she balanced lines and solid shapes on mostly flat surfaces. One of these was *Polyphonic*, which was compared to Calder's mobiles. Other works from this period, like *Taurus* (1946), similarly suggest harmony in their mix of geometric curves and angles, solid forms and connecting lines. One of her paintings was bought by the Guggenheim's architect, Frank Lloyd Wright, although he reportedly hated most painting.

It was at the Guggenheim that Fine met Jackson Pollock, who was then working as a museum guard. Fine, a new member of the American Abstract Artists in the mid-forties, proposed Pollock for membership in the organization. Her colleagues, who favored the kind of structured, cubist-inspired

work they themselves were doing, objected violently. When the Abstract Expressionist movement gained momentum a decade later, Fine welcomed its loosening influence.

In 1954 Fine was hired as an associate professor of art by Hofstra University. She moved from her huge loft to the Springs, an art colony near East Hampton, Long Island. Teaching became a major focus for her, one that she described as a "creative commitment." Around a period of illness in the late sixties, Fine ended her twelve years of teaching at Hofstra and began to construct minimalist collages in a series she called "Accordment."

These later collages and several series of paintings, also dubbed "Accordment," came closest to achieving total harmony. She gave paintings in these series names like *Gently Cascading*, *The Dawn's Wind*, and *A Woven Warmth*. In these, color became a major element. She continued to paint in this vein into her late seventies at her house on East Hampton, and died in her eightieth year.

> *One of her paintings was bought by the Guggenheim's architect, Frank Lloyd Wright, although he reportedly hated most painting.*

TO FIND OUT MORE . . .

- Deichter, David. *Perle Fine: Major Works, 1954-1978 (A Selection of Drawings, Paintings and Collages)*. East Hampton, NY: Guild Hall of East Hampton, 1978. Exhibition catalog.

- Rubenstein, Charlotte Streifer. *American Women Artists: From Early Indian Times to the Present*. New York: Avon, 1982.

Meta Vaux Warrick Fuller, 1877–1968

The sculpture of Meta Vaux Warrick Fuller, with its exploration of African-American roots and its strong social commentary, marks her as an important forerunner of the Black Renaissance. Her emotion-packed images led a contemporary critic to label her a "sculptor of horrors." Her work was evocative, but never as sensational as the critic's quip might suggest; her pieces were designed to stir both emotion and thought.

Her early interest in art was supported by her comfortable Pennsylvania family. With their encouragement, she won a scholarship to the Pennsylvania School of Industrial Art in 1894, and graduated with an award for her *Crucifixion of Christ in Agony* and another scholarship, this time for study in Paris. She was met there with an unpleasant surprise: The American Girls Club, which had arranged to provide her with lodgings, changed its plans when they came face to face with the young African-

American student. She was forced to find a small room in a hotel. Happily, the Paris art world would prove more hospitable.

In Paris she further developed her craft at the Académie Colarrossi and at the École des Beaux-Arts. Auguste Rodin was an admirer of her work, particularly an emotional sculpture called *Secret Sorrow (Man Eating His Heart)*. She became known for her powerful, haunting figures. A prestigious art gallery, L'Art Nouveau, exhibited her work. Sculptures from this period include *The Wretched, Man Carrying a Dead Comrade,* and *The Thief on the Cross.*

After Warrick's glowing success in Paris, the return to her native America, in 1904, must have been a letdown for the young artist. Despite the acclaim her work had received abroad, art dealers in the United States studiously ignored her. In 1907, however, she gained a toehold when *The Progress of the Negro in North America* won a gold medal at the Jamestown Ter-

centennial. And in 1922, her piece *Awakening Ethiopia* was shown in the 1922 New York Making of America Exposition. But her work would never be popular in the America of her time; its themes were too tough and its images too somber for the tastes of her contemporaries.

In 1909, Warrick married a neurologist/psychologist from Liberia, Dr. Solomon Fuller. They settled happily in Framingham, Massachusetts, where they raised three sons together. But soon after their marriage her career suffered another setback when a 1910 fire ravaged the Philadelphia warehouse that held most of her early work. Only a few pieces remained. Fuller pressed on, continuing to sculpt smaller pieces that now more often depicted African-American subjects.

> *Fuller death explicitly with troublesome subjects like race and death.*

She would continue to create such sculptures until a few years before her death in 1968. One particularly haunting piece, *The Talking Skull*, shows a young black man kneeling in front of a skull that rests on the ground, gazing intently at it as if to ask a question. His thinness and the sharp outlines of his face suggest vulnerability and link him to the skull. Perhaps it was the way Fuller dealt so explicitly with subjects like death that disturbed her critics. Whatever their reasons, they panned her work, judging it dark and grim. But she never backed off from making a statement with her sculpture, and her works are now seen as prefiguring the wave of African-American art known as the Black Renaissance.

TO FIND OUT MORE . . .

- Rubenstein, Charlotte Streifer. *American Women Artists: From Early Indian Times to the Present.* New York: Avon, 1982.

- Lewis, Samella S. *Art: African American.* New York: Harcourt Brace Jovanovitch, 1978.

Ruth Gikow, 1915–1982

Ruth Gikow's paintings usually have a comment to make. Whether they express her solidarity with the working man in the 1930s or examine the effects of marijuana on young people in the late sixties, they work to communicate with their audience. Her childhood experience of fleeing Russia over a frightening two-year period may have contributed to this strong social feeling that comes through so clearly in her paintings.

Gikow was born in 1915 in the Ukraine. The pogroms against Jewish people prompted her family's long period of flight when she was only five years old. Until she was seven, she lived a sort of half-existence on her way out of a country that was no longer hers. Once the guides who were leading her through a swamp lost track of her. Eventually the family made it to the United States, where they moved into the immigrant-filled Lower East Side of New York City.

Ruth's father had been a photographer in his homeland, and Ruth set her sights on a career as a fashion artist. She worked part-time at Woolworth's for twenty-eight dollars a month and took art classes at Washington Irving High School. On her graduation at age seventeen from high school, however, she found that there were no fashion jobs for her. Undaunted, she kept her job at Woolworth's and enrolled in more art classes at the Cooper Union Art School.

An exhibit in Greenwich Village of her early paintings, in which she identified strongly with the working man, led to a position with the Federal Art Project, which paid a princely $95.44 per month. She painted murals for the Project and at the Flushing Meadows World's Fair. When Federal Art Project funds dried up, Gikow worked for a time as art director of an advertising agency. Advertising did not suit her. She wanted more time to devote to her own work, and had already decided to quit when she married the expressionist painter Jack Levine in 1946.

The change did her good. The Weyhe Gallery gave a solo show of her work that year, and the Grand Central Galleries gave

another after she and her husband returned from a trip to Italy in 1948. The travel gave Gikow material for later paintings of Italy, in which she recalled the burnt-out buildings and beggars in the aftermath of the war.

With a daughter growing up in the fifties and the sixties, Gikow turned her attention to American popular culture. She explored the passionate world of young people in the turbulent sixties, from the adoration of rock stars to studies of crowds of protestors for civil rights and peace.

TO FIND OUT MORE . . .

- Josephson, Matthew. *Ruth Gikow.* New York: Random House, 1970.
- Rubenstein, Charlotte Streifer. *American Women Artists: From Early Indian Times to the Present.* New York: Avon, 1982.

An exhibit in Greenwich Village of her early paintings led to a position with the Federal Art Project, which paid a princely $95.44 per month.

Dorothea Schwarcz Greenbaum, 1893–1986

Dorothea Schwarcz Greenbaum displayed her love for humanity in her art and in her work for the arts. In sculptures like *Drowned Girl*, a life-size marble head, she evokes an almost spiritual peacefulness. *Drowned Girl* contrasts the smooth texture of the girl's closed eyelids with her coarsely etched hair, which seems to be reverting to the rough stone or the swirling sea whose waves and shells it echoes. In her work for The Sculptors Guild and Artists Equity, she strove to make life easier for other artists—even though she herself was financially well-off.

Greenbaum was born in comfortable circumstances in Brooklyn, New York, to an importer and his wife. When she was twenty-two, her father was drowned in the sinking of the *Lusitania*. Dorothea, nicknamed "Dots," joined the group of artists who worked at the Art Students' League in the 1920s. She shared studio space in downtown Manhattan's busy Union Square with painter **Betty Parsons**. Like Parsons, Greenbaum was a painter at this early stage in her career.

It wasn't until she was in her late thirties that she tried sculpture. In 1925, at age thirty-two, she married Edward Greenbaum. Greenbaum was a lawyer who later became a brigadier general during the Second World War. Dorothea Greenbaum had already given birth to two young sons when she began to experiment with clay modeling. She soon turned to sculpture in bronze and marble, often trying to convey a political message through her work. She took advantage of the sheer weight and bulk of her material in her sculptured bronze head, *Fascist* (1938), to communicate her negative opinion of fascism.

Even in the financially strapped thirties, Greenbaum was able to devote time to her art without worrying about finding money for food or art supplies. This was in sharp contrast to the plight of many other artists

of the time, who relied on grants from the Federal Art Project and other organizations for the bare essentials. She took advantage of her relatively comfortable position to contribute to the running of artistic organizations like the Sculptors Guild, an avant-garde sculptors' group. Greenbaum was made secretary, and joked that the group was so opposed to traditional modes of administration that she ran the group in absence of a president.

Even after World War II ended the period of desperate need for many artists, Greenbaum continued to work to improve the situation of the professional artist. She was one of the founders of Artists Equity, and fought the deportation of sculptor William Zorach (husband of **Marguerite Zorach**) during the McCarthy Era.

Meanwhile she continued her own work, for which she was much recognized. Her 1928 *Sleeping Girl* was exhibited in the 1933 Chicago Century of Progress Exposition. She had her first one-woman show at the Weyhe Gallery in Manhattan. Later, during the war, another one-woman show was headlined as the show of a "General's Wife." The American Academy of Arts and Letters recognized her accomplishments with a grant in 1947, citing her "warm and sensitive appreciation of the human spirit."

Greenbaum learned to work in carved stone after mastering clay modeling, and also created some unique works in hammered lead. She died in 1986 at the age of ninety-three.

> *She was one of the founders of Artists Equity, and fought the deportation of sculptor William Zorach during the McCarthy Era.*

TO FIND OUT MORE . . .

- Corlette, Suzanne. *Paintings by Bishop; Sculpture by Dorothea Greenbaum.* Foreword by Kenneth Prescott. Trenton: New Jersey State Museum, 1970.

- Rubenstein, Charlotte Streifer. *American Women Artists: From Early Indian Times to the Present.* New York: Avon, 1982.

Gertrude Glass Greene, 1904–1956

The painter and sculptor Gertrude Greene was an idiosyncratic free spirit. She lived her life with a cheerful disregard for convention. The same blithe inventiveness is apparent in her work, which some critics find astonishingly forward-looking. Peter Walch (as quoted by Charlotte Streifer Rubenstein) said of Greene's *Construction Grey* (1939), "One feels confronted with an odd time-warp sensation of ideas taken up by even more recent artists."

Gertrude Glass grew up in New York. She was born in Brooklyn and attended art classes at the Leonardo da Vinci Art School in the city in her early twenties. When she was twenty-two, she married a fellow artist and free spirit, the painter Balcomb Greene. The couple spent the next five years traveling wherever they though they might be able to learn more about anything that was new in art.

In 1931, after their quest had taken them to Paris and to Vienna, the Greenes returned to New York City. Gertrude chose to take a studio in busy Greenwich Village, where she sculpted for the next fifteen years. In 1936, Greene was one of a group of artists who worked with abstract, non-representative forms. There were few forums in New York at the time for this kind of groundbreaking art, so Greene and several other artists organized the American Abstract Artists Association, which later embraced such artists as **Lee Krasner** and **Irene Rice Pereira**. Later, Greene helped to establish other organizations to promote art, including the Artists Union and the Sculptors Guild.

Around that time, Gertrude Greene began to work with wood reliefs, wall-hung sculptures that she pieced together from carefully shaped, sometimes painted wood forms. The solid colors and blocky shapes suggest that Greene had been influenced by Cubism in her travels to Europe. These works, including *Construction in Blue*

(1935) and *White Anxiety* (1943-44), are the pieces cited by critics who find that her work predicts more recent innovations in art.

The Greenes undertook an ambitious project in the 1940s when they decided to build their own summer home. They found a site they liked on a lonely Long Island cliff and spent the first summer sleeping in a small shelter dug into their land while they built the first room of the house. Friends pitched in over the next few years to complete the structure, and were rewarded with the Greenes' hospitality when the house, with its clear, wide view of the ocean, was completed.

> *Greene was one of the founding members of the American Abstract Artists Association.*

Gertrude Greene shifted some of her artistic energy to painting in the late forties. Her sculpture already incorporated painting, and her painting was somewhat sculptural. She used a palette knife to give her abstract paintings a textured look. Her early death at fifty-two cut off this new avenue of creativity.

TO FIND OUT MORE . . .

- Armstrong, Thomas, et al. *200 Years of American Sculpture.* New York: Whitney Museum of American Art and David R. Godine, Publisher, 1976.

- Rubenstein, Charlotte Streifer. *American Women Artists: From Early Indian Times to the Present.* New York: Avon, 1982.

Marion Greenwood, 1909–1980

M uralist Marion Greenwood, like many artists around 1940, painted several murals funded by the government. When her funders began to meddle with the design of her work, however, Greenwood became an outspoken advocate of artistic freedom. Her expansive murals, like those of her onetime employer Diego Rivera, are imbued with a spirit of social activism.

Greenwood spent her childhood in Brooklyn, but her talent drew attention early, and at fifteen she quit high school in favor of art classes at the Art Students' League. While still a teenager she had the privilege of working at Yaddo, the artists' retreat in Saratoga Springs, New York, where a small number of artists, writers, and composers may work undisturbed. She painted portraits of many of her famous companions at Yaddo, including the composer Aaron Copland.

A portrait of an affluent patron paid her way to Paris before she was twenty. With the grounding of her study at the Académie Colarossi, she returned briefly to New York. Illustrations for the theater section of the *New York Times* helped fund her trip the next year, in 1931, to the Southwest and later to Mexico.

Greenwood was encouraged to paint murals by Pablo O'Higgins, whom she met in Taxco. She had begun what would become a long career of painting people of different ethnicities with a study of the Navajos in the Southwest, and in 1932 she finished her first government-commissioned mural. She was twenty-three years old. The project, which covered seven hundred square feet at the University of San Hidalgo, reflected a year of close study of the Tarascan Indians.

Mexican muralist Diego Rivera, impressed with Greenwood's work, hired her and her sister Grace to work on a huge group mural of vital peasant figures in Mexico City's Mercado Rodriguez. Greenwood

returned to the United States in 1936 to undertake another commission for the Treasury Relief Art Project. The next year she was hired by Columbia University to teach fresco painting, a technique in which the pigment is applied to fresh, moist plaster and dries as part of the wall.

Greenwood continued to paint for government projects in the late thirties and early forties, even though she had a bad experience with the Treasury Department of Fine Arts in 1938. Her mural was marred by changes her funders forced upon her, and thereafter Greenwood regarded government projects with a good amount of (regularly expressed) resentment.

> *Her expansive murals, like those of her onetime employer Diego Rivera, are imbued with a spirit of social activism.*

Greenwood spent World War II as one of the only two women selected to be war correspondents. She painted recuperating casualties of battle. After the war ended, she continued to travel, studying and painting different ethnicities wherever she found them—in India, North Africa, Hong Kong, and the West Indies. On her return to the United States, she began once more to paint large-scale murals. She painted her last mural in 1965, an homage to women from all over the world that she painted at Syracuse University.

Marion Greenwood spent many of her later years at the art colony in Woodstock, New York, with her husband Robert Plate. She was seventy-one when she died.

TO FIND OUT MORE . . .

- Fine, Elsa Honig. *Women & Art: A History of Women Painters & Sculptors from the Renaissance to the 20th Century.* Montclair, NJ: Allanheld, Osmun & Co. Publishers, Inc. and Abner Schram Ltd., 1978.

- Henkes, Robert. *American Women Painters of the 1930s and 1940s: The Lives and Work of Ten Artists.* Jefferson, N.C.: McFarland, 1991.

- Marling, Karal Ann. *7 American Women: The Depression Decade.* Poughkeepsie, NY: Vassar College Art Gallery and A.I.R. Gallery (NY), 1976.

- Rubenstein, Charlotte Streifer. *American Women Artists: From Early Indian Times to the Present.* New York: Avon, 1982.

Marion Lucy Mahony Griffin, 1871–1961

Architect Marion Griffin is best remembered for the work she did with the celebrated architect Frank Lloyd Wright at his studio in Oak Park, Illinois. After her fourteen-year professional relationship with Wright came to an unpleasant end, she worked behind her husband's name, going mostly uncredited for her collaborations with him. After his death, however, she reestablished herself as an independent architect at the age of sixty-seven.

Marion Lucy Mahony was one of five children born in Chicago, Illinois to educators Clara and Jeremiah Mahony. Her father, who had grown up in County Cork, Ireland, died when Marion was eleven. Clara Mahony took over the support of her young family, working (as had her husband) as a school principal. When she was nineteen, a prominent Chicago citizen helped pay for Marion's tuition at the Massachusetts Institute of Technology's architecture course. In 1894 she became only the second woman to graduate from the program.

She returned to Chicago to work with her cousin, architect Dwight Perkins, also an alumnus of MIT. After a year in his office, Mahony began working with Frank Lloyd Wright at his studio in Oak Park. During the time she worked there, Wright's studio developed a style of architecture known as the "Prairie School." Houses designed in this mode echoed the flat prairie landscape in their low, sleek lines and horizontally jutting eaves. The Prairie School has been called the most important indigenous movement in American architecture.

Mahony's contributions to the work at Wright's studio are strikingly visible in the drawings she did there. She executed most of the drawings of the designs that brought him international recognition for the first time, a group of plans called the Wasmuth Portfolio (*Ausgefürte Bauten und Entwürfe von Frank Lloyd Wright*, 1910). Her delineations were always carefully rendered in im-

THE REMARKABLE LIVES OF

peccable detail, down to her beautifully sketched trees and trademark monogram.

Wright, planning a trip abroad in 1909, asked Mahony to direct the studio in his absence. She declined, and architect H.V. von Holst took his place instead on the condition that Mahony would act as the studio's designer. Wright left several commissions unfinished when he left rather abruptly. During his long absence, Mahony designed at least three projects: a house, never built, for automobile magnate Henry Ford; the David Amberg house in Grand Rapids, Michigan (1909–1911); and a third house built in 1910 in Decatur, Illinois, for Adolph Mueller. On his return, Wright falsely accused Mahony of stealing his projects and clients, and Mahony, livid, permanently broke off the relationship.

> *Griffin executed most of the drawings of the group of designs that first brought Frank Lloyd Wright worldwide recognition.*

At forty, Mahony married architect Walter Burley Griffin and began her long uncredited professional collaboration with him. Her artistic fingerprints are on his 1912 designs for Canberra, the capital city of Australia. Marion Griffin followed her husband to Australia in 1914, where they set up practice together. In 1935, the practice was moved to Lucknow, India, but Walter Griffin died in 1937. Marion finished up their business in Lucknow, revisited Australia, and settled permanently in Chicago with her own private practice. She continued to work into her seventies and eighties, finally under her own name.

TO FIND OUT MORE . . .

- Brooks, H. Allen. *The Prairie School: Frank Lloyd Wright and His Midwest Contemporaries.* Toronto: University of Toronto Press, 1972

- Manson, Grant Carpenter. *Frank Lloyd Wright to 1910, the First Golden Age.* 1958.

- Sicherman, Barbara, and Carol Hurd Green, eds. *Notable American Women: The Modern Period. A Biographical Dictionary.* Cambridge, MA: The Belknap Press of Harvard University Press, 1980.

- Drawings are at the Northwestern University art department, the New York Historical Society, Avery Library at Columbia University, and the Burnham Library at the Art Institute of Chicago.

Emma Azalia Smith Hackley, 1867–1922

S inger and choral director E. Azalia Hackley was a constant advocate of African-Americans in music. Through her People's Chorus, she helped to launch the careers of gifted young singers like contralto **Marian Anderson** and tenor Roland Hayes.

Azalia Smith was born in Murfreesboro, Tennessee, where her mother ran a school for the children of freed slaves. The locals did not take kindly to her efforts to educate the population, however, and she moved her family to Detroit when Azalia was three. Azalia took after her mother, who had grown up in relative wealth as the daughter of a successful freed businessman, and who taught her daughter that education was of paramount importance.

Azalia took this advice to heart and graduated from high school with honors. She had first played the piano soon after she learned to walk, and supplemented her mother's earnings by performing at dances throughout high school. For eight years after her graduation, she taught grade school and showed off her lovely singing voice in a Detroit choir and in occasional solo performances. When concert managers tried to convince her to "pass" as white in performances, she turned them down.

At twenty-seven she married Denver attorney Edwin Henry Hackley, despite the disapproval of her mother. She moved with him to Denver and earned a bachelor's degree in music at the University of Denver. Meanwhile, she continued her singing and began working as the director of her church choir and the assistant director of a large Denver choir. In 1901 she bowed to her growing unease with her marriage and left her husband, moving to Philadelphia. They were officially separated in 1909.

In Philadelphia she quickly developed a reputation as a skilled choral director at the helm of the African-American choir at the Episcopal Church of the Crucifixion. In 1904

she launched her own venture, the one-hundred-member People's Chorus. It was a critical and popular success, and the proceeds allowed her to study briefly in Paris. Soon the choir became an instrument for Hackley's work toward the recognition of African-American singers. Marian Anderson was one of the young singers she featured.

The concerts raised money for an annual scholarship for other promising African-American students to study in Europe. Around 1910 she began to lecture on tour, addressing subjects that ranged from African-American beauty (intended to boost listeners' self-esteem) to musical technique. She published a book on the former in 1916, *The Colored Girl Beautiful*.

That same year she was stricken by an illness that left her weakened and disoriented. She fought her disability to produce a pioneering series of folk concerts across the United States, which helped restore some respect for the older forms of music. She was also successful in introducing African-American sounds to listeners in Tokyo in 1921, but within a year she had suffered first a mental, then a physical collapse. She died in Detroit in 1922.

> *When concert managers tried to convince her to "pass" as white in performances, she turned them down.*

TO FIND OUT MORE . . .

- Cuney—Hare, Maud. *Negro Musicians and Their Music.* Washington, D.C.: The Associated Publishers, Inc., 1936.

- Davenport, M. Marguerite. *Azalia.* Boston: Chapman & Grimes, 1947.

- James, Edward T., ed. *Notable American Women 1607-1950: A Biographical Dictionary.* Cambridge, MA: The Belknap Press of Harvard University Press, 1971.

 - Hackley's papers are at the E. Azalia Hackley Collection at the Detroit Public Library.

Hazel Lucille Harrison, 1883–1969

L ike **Philippa Schuyler**, concert pianist Hazel Harrison's success with mainstream American audiences was severely hampered by the color of her skin. One favorable review of a 1922 recital lamented, "It seems too bad that the fact that she is a Negress may limit her future plans." Unlike Schuyler, who was never comfortable with her mixed parentage, Harrison eventually settled into the avenues open to her—the European circuit and African-American audiences—and enjoyed great popularity.

Hazel Harrison was born in La Porte, Indiana, to Hiram Harrison, the tenor and accompanist of his local church choir, and Olive Woods Harrison, a manicurist and hairdresser. All her father's musical nurturing was focused on his only child, and Hazel's talents developed at an astonishing rate. She began formal training in piano at four, and was performing for pay at eight. According to one story, the eminent German musician Victor Heinze heard her play at a private party and offered to tutor her.

Heinze became Harrison's longtime mentor, and his name helped establish her reputation as a young pianist of note in Chicago. She studied with him after graduating from high school in 1902, and taught the children of wealthy La Porte families in her free time. In 1904, an invitation came to play as a soloist with the Berlin Philharmonic Orchestra. That fall, at the age of twenty-one, she performed the E minor concerto by Chopin and the concerto in A minor by Grieg under conductor August Scharrer in Berlin. The performance marked the first time a completely American-trained soloist had appeared with a European orchestra. German critics applauded the young pianist's virtuosity in a series of gushingly favorable reviews.

After this initial triumph, Harrison returned to her routine of studying and teaching in La Porte. She had no resources for

further study abroad. A Chicago recital in 1910 brought her situation to the attention of local philanthropists, who financed Harrison's three years of blissful existence in Berlin. As a favorite student of Italian composer-pianist Ferruccio Busoni, she had an immediate circle of friends. At his urging, Harrison acquired a broad artistic education, studying philosophy, literature, and the fine arts. Sadly, this idyllic period came to a close with the outbreak in 1914 of World War I.

Back in the United States, Harrison moved permanently to Chicago, and in 1919 married businessman Walter Bainter Anderson. The marriage lasted less than a decade. Meanwhile, she had limited success on the American stage in the 1920s and 1930s. Although she appeared repeatedly in recitals in major cities, she never had another appearance with a major orchestra in its regular season after her 1904 triumph in Berlin. Nevertheless, her reviews were consistently excellent, and critics praised both her technical expertise and the drama of her performances.

The Depression years marked a necessary shift toward more teaching. She became a faculty member at Tuskegee

> *One favorable review of a 1922 recital lamented, "It seems too bad that the fact that she is a Negress may limit her future plans."*

Institute in 1931, and the head of the piano faculty at Howard University in 1937. She established a piano scholarship in her mother's name at Howard, and oversaw the fundraising for it. After twenty years of distinguished service, Harrison resigned from Howard at the age of seventy-four. After eight years in New York, she moved to the warmer South and finally to Washington, D.C., where a devoted former student cared for her until she had to be moved to a nursing home. She died there at the age of eighty-six.

TO FIND OUT MORE . . .

- Cazort, Jean E. *Born to Play: The Life and Career of Hazel Harrison.* Westport, CT: Greenwood Press, 1983.
- Hare, Maud Cuney. *Negro Musicians and Their Music.* 1936.
- Sicherman, Barbara, and Carol Hurd Green, eds. *Notable American Women: The Modern Period. A Biographical Dictionary.* Cambridge, MA: The Belknap Press of Harvard University Press, 1980.

Eva Hesse, 1936–1970

This German-American sculptor's life was marked by tragedies that included her early childhood in Nazi Germany, her parents' divorce, her mother's suicide, a failed marriage, and her early death of a brain tumor. Yet she went at her abstract figures with courage and vision, using bland industrial materials like fiberglass and surgical tubing to create figures of an odd beauty. During the year before her death, she produced an amazing series of works from a wheelchair.

When Hesse was two years old, her Jewish family sent her and her sister Helen on a train to Amsterdam to get them out of Germany. They arrived safely in Amsterdam, but the uncle who was to meet them there never got there. They were separately placed in foster care. The Hesses were able eventually to find both children, and the family finally escaped to New York, but they were never quite able to escape the terror of their early years in World War II Germany. In a twisted reminder of their past, their Washington Heights home happened to be across the street from the headquarters of the local Nazi party.

Eva's mother never recovered; she killed herself when Eva was still young. Her father remarried and made a living in the insurance business. Eva, a brilliant student, won a scholarship to Yale University Art School. She graduated in 1959, determined to make her mark as an artist in New York. She had not yet found her medium, however, and spent her early years in the city drawing unexceptional pictures that were still skillful enough to win her places in small exhibitions.

In 1961 Hesse married the abstract sculptor Tom Doyle. She quickly found herself in an uncomfortable position: her work was seen as the dabbling of the artist's wife; it was not taken seriously in its own right. The artistic anxieties this engendered in Hesse were complicated when, in 1964, Doyle won a commission to work in Germany for a year. Hesse had nightmares. She read Simone de Beauvoir's *The Second Sex* and tried to work in her small section of the empty weaving factory that was theirs for the year.

Out of her oppression in the country of her earliest traumas, Hesse began to develop her own mode of expression. Using cord scrounged in the factory, she made collages and reliefs based on her abstract drawings. In 1965 she exhibited a series of these pieces, including *An Ear in a Pond* and *Ring Around Rose*. Feeling more sure of herself, she separated from her husband and returned to New York to sculpt in earnest.

Her 1965–1966 *Hang Up*, a wall-hung carefully wrapped wooden frame with a thin, free-form metal loop protruding from it, was "the most ridiculous structure . . . I ever made," said Hesse, "and that is why it is really good. It has . . . the kind of depth of soul or absurdity of meaning . . . or feeling . . . that I want to get." Hesse had found her niche in expressing extreme emotions with mysterious forms. She was very successful with pieces like *Addendum* (1967), and won recognition with her strangely powerful forms.

Terrible headaches interrupted this period of productivity, and when in 1969 Hesse was diagnosed with cancer, she poured herself into her work with new intensity. She directed many of her constructions from her wheelchair, creating

> *Hesse found her niche in expressing extreme emotions with mysterious forms.*

sculpture of latex, wire, and fiberglass that play with the idea of order. After her death in 1970, the Guggenheim museum gave a posthumous exhibition of her work.

TO FIND OUT MORE . . .

- Heller, Nancy G. *Women Artists: An Illustrated History.* New York: Abbeville Press, 1987.

 - Lippard, Lucy. *Eva Hesse.* New York: New York University Press, 1976.

 - Nemser, Cindy. *Art Talk: Conversations With 12 Women Artists.* New York: Charles Scribner's Sons, 1975.

 - Rubenstein, Charlotte Streifer. *American Women Artists: From Early Indian Times to the Present.* New York: Avon, 1982.

Natalie Hinderas, 1927–1987

Classical pianist Natalie Hinderas had a successful international career on the concert stage. As an African-American performer in a field that was resistant to non-whites, she had a difficult time gaining recognition in the earlier phases of her career. Later on, however, she used her position as a recognized performer to give a boost to African-American composers, compiling an early large anthology of their music in 1971.

Natalie Leota Henderson (her given name) was a child prodigy. Natalie was born in Oberlin, Ohio, the child of professional musicians. Her father, a jazzman, toured Europe with his own band; her mother, a pianist, was her first teacher. Henderson began to play the piano at age three; at eight she had her first recital. That same year she was accepted at the Oberlin School of Music.

Around her seventeenth birthday, Natalie Henderson became the youngest student ever to earn a bachelor of music degree from Oberlin. Henderson next went to the Julliard School of Music in New York City, where her mentor was Olga Samaroff. It was Samaroff, whose given name was Lucy Mary Olga Agnes Hickenlooper, who encouraged Henderson to change her professional name to Hinderas.

Natalie Hinderas made her New York debut at twenty-seven with a performance at Town Hall. On the program were Chopin's Ballade in F-minor and Mozart's Sonata in F. Reviewers noted her impressive technique and predicted success for Hinderas. 1954, however, was not the easiest time for an African-American performer to gain success in the overwhelmingly white world of classical music, and Hinderas's career was slow to take off.

Like so many other African-Americans in classical music, Hinderas had better luck in Europe. As a United States Cultural Ambassador in 1959 and 1964, she toured all over the world, including most major European cities and wider-flung parts of the world like Singapore, Yugoslavia, the Phillipine Islands, the Middle East, and Hong Kong. In the 1960s she joined the faculty at Philadelphia's Temple

University, where she served as professor of piano until her death.

In 1972 Hinderas finally gained respect as a pianist of stature, receiving rave reviews for her performances as a soloist with the Philadelphia Orchestra and the New York Philharmonic. Finally hailed as "one of the great pianists of our era" (*San Francisco Chronicle*), she began performing with major orchestras all over the country and recording with major labels.

Once firmly established, Hinderas worked to bring the work of African-American composers to public attention. She arranged for the commissioning of George Walker's Piano Concerto No.1, and made it a featured part of her repertoire. Reviewers applauded both piece and performer for the drama and technical mastery evident in Hinderas's performances. Walker was one of nine composers included on her breakthrough record set, *Natalie Hinderas Plays Music by Black Composers* (1971).

Hinderas continued to perform until her death at age sixty. She was survived by her husband, Lionel Monagas, and their daughter Michele.

> *Once firmly established as a major concert pianist, Hinderas worked to bring the efforts of African-American composers to public attention.*

TO FIND OUT MORE...

- Abdul, Raoul. *Blacks in Classical Music*. New York: Dodd, Mead, 1977.
- Smith, Jessie Carey, ed. *Notable Black American Women*. Detroit, MI: Gale Research Inc., 1992.

Malvina Cornell Hoffman, 1885–1966

The portrait sculptor Malvina Hoffman had an extraordinary ability to capture the intangible in plaster, stone, and bronze. She sculpted pieces that convey the fluid movement of dancers and the dignity of the human spirit. Her techniques were technically demanding; she carved many enormous pieces directly in stone. The difficulty of her methods makes her accomplishments all the more remarkable.

Hoffman's childhood, spent in a supportive and artistic Manhattan home, was a happy one. Her father, who was fifty when Malvina was born, was a pianist, and the house was always filled with music, Malvina's five siblings, and guests. Malvina Hoffman split her time between the Brearley School and private art classes. She sculpted her first important piece, a bust of her father, in 1909—the year he died. His death left the family in dire financial straits, but Malvina's loving portrait of him launched her career when it was accepted for the National Academy of Design's annual exhibition.

Armed with a letter of introduction, the last of the family money, and her mother, Hoffman went to Paris in 1910 to meet her artistic idol, Auguste Rodin. He rebuffed her first three attempts to meet him, but she sat insistently upon his doorstep the fourth time until he allowed her in. He had other company, and pointedly ignored the American until she completed—in French—a poem he was struggling to recite. Finally impressed, Rodin agreed to see her work and became Hoffman's mentor.

To enrich her work with Rodin, Hoffman studied anatomy and attacked the more strenuous areas of sculpture to gain technical experience. She visited bronze foundries to learn about the metal's properties and learned how to rebuild her own tools and manipulate wood and metal. In her personal life, too, she could not help but find inspiration; other Paris residents at

the time included **Romaine Brooks**, Gertrude Stein, Mattisse, and the Russian ballet star Anna Pavlova. Pavlova became Hoffman's close friend and muse, sometimes posing for her late into the night after exhausting performances.

When she returned to New York, her bronze sculptures of Pavlova and other Ballet Russe members made her reputation and won her many prizes and commissions. Among these pieces were *Pavlova Gavotte*, and *Bacchanale Russe*, both sculpted between 1915 and 1920. Many of the commissions were grander in scale; enormous pieces like the war monument *The Sacrifice* (1920) (a mother kneeling over a prostrate soldier) and *To the Friendship of English-Speaking Peoples* (1925) soon took up much of her time. The latter sculpture was deemed to be too shallowly carved after it was cemented high off the ground in the facade of London's nine-story Bush House. Unperturbed, Hoffman spent quite some time eighty feet in the air, perfecting her fifteen-foot figures.

Her most famous work was equally ambitious, although the individual pieces were not as physically imposing as the London work. *The Races of Man* (1933), originally

> She sculpted pieces that convey the fluid movement of dancers and the dignity of the human spirit.

intended for five sculptors, was a masterwork commissioned by the Marshall Field Museum of National History. One hundred and five separate pieces, cast in bronze, depict people of diverse ethnicities and nationalities. Hoffman traveled widely to research the project, and her knowledge of her materials and of anatomy served her well.

In later years Hoffman turned her energies to some commissioned bas-relief projects and to writing. Her memoirs reveal that, despite her astonishing productivity, she sometimes struggled with work-induced exhaustion and the nagging idea that she might not be up to her work. She died at her Manhattan studio in 1966.

TO FIND OUT MORE . . .

- Hoffman, Malvina. *Yesterday is Tomorrow*. New York: Crown Publishers, 1965.
- Rubenstein, Charlotte Streifer. *American Women Artists: From Early Indian Times to the Present*. New York: Avon, 1982.
- Sicherman, Barbara, and Carol Hurd Green, eds. *Notable American Women: The Modern Period. A Biographical Dictionary*. Cambridge, MA: The Belknap Press of Harvard University Press, 1980.

Helen Elna Hokinson, 1893-1949

H elen Elna Hokinson was an illustrator best known for her satirical covers and cartoons drawn for the *New Yorker* in the 1920s and 1930s.

Born the only child of comfortable businesspeople in Mendota, Illinois, Hokinson began sketching in high school. Her early caricatures of classmates and teachers appeared in her high school yearbook. After her graduation in 1913, she talked her reluctant parents into letting her attend the Chicago Academy of Fine Arts, where she studied cartooning and illustrating for five years.

She was able to supplement her funds by making sketches for fashionable department stores. After her graduation, she moved with her Fine Arts roommate Alice Harvey to New York City, where they found lodgings together at the Smith College Club. Hokinson's experience doing fashion sketches served her well in New York, and she did freelance work in the same vein for the pricey Manhattan department stores B. Altman and Lord and Taylor. Influenced by the artistic currents of the city, her interest turned to grittier subjects like the working servicepeople of the city—garbage collectors and snow shovelers.

In 1925 she sent some sketches to *New Yorker* editor Harold Ross for consideration. He was impressed, and published her first cartoon in November of that year. It was typical of much of her later work, showing a baffled woman shopping for perfume with the caption, "It's *N' Aimez que Moi*, madam—don't love nobody but me." After 1931, James Reid Parker regularly wrote the captions for her cartoons. Her favorite target was the sort of bemused older everywoman who found herself several steps behind the times. Sometimes her cartoons veered dangerously towards cruelty, when she skewered her hapless heroines a little too vigorously, but mostly she kept it sympathetic.

Although her work threw her into the most exclusive circles, *New Yorker* illustrator Helen Hokinson remained mostly withdrawn from New York cultural life. She was rather shy and aloof, and kept a small circle of close friends instead of a wide one of mere acquaintances. Reid Parker, her caption writer, became a dear friend, and she often chose him as her escort for social purposes.

Hokinson's work with the *New Yorker* and, occasionally, with the *Ladies' Home Journal* earned her a comfortable living. She had turned her attention to writing a play when she accepted an invitation to speak at a fund raiser in Washington, D.C. Her airplane crashed into another above Washington's National Airport. There were no survivors. She was buried near her childhood home in Mendota, Illinois.

> *Although her work threw her into the most exclusive circles,* New Yorker *illustrator Helen Hokinson remained mostly withdrawn from New York cultural life.*

- *The New Yorker,* p. 160, Nov. 12, 1949.
- Obituary. *The New York Times,* November 12, 1949.

TO FIND OUT MORE . . .

- James, Edward T., ed. *Notable American Women 1607–1950: A Biographical Dictionary.* Cambridge, MA: The Belknap Press of Harvard University Press, 1971.

- Parker, James Reid. Introduction to Hokinson, Helen Elna. *The Ladies, God Bless 'Em!* New York: E.P. Dutton and Co. Inc., 1950.

Billie Holiday, 1915–1959

Jazz singer Billie Holiday has been called one of the most influential female singers ever to command a spotlight. Even as she rose to prominence in the 1940s, however, her personal life suffered repeated shocks. Addiction got her in trouble with both the law and the media, and eventually she died from the effects of combined drug and alcohol abuse. Still, her voice, recorded throughout her career, is as glorious to hear now as it was when the albums were cut.

Billie Holiday was born Eleanora Fagan in Baltimore, Maryland. She was the only child of a young unwed couple, Sadie Fagan and Clarence Holiday. They married when she was still a toddler, and her last name was changed to her father's, but her parents divorced when Clarence left to play the guitar and banjo in a traveling band. When Sadie was widowed by her second husband, she too disappeared, leaving her daughter with relatives while she went to New York to find paying work as a maid. Money was tight in Baltimore, and Holiday began to work before she was ten.

By the time she was sixteen, she was working in nightclubs as a dancer and calling herself "Billie." Her first break came when someone asked her to sing at a nightclub. Even as a teenage amateur, she had the power to still an audience with her voice.

Once Holiday started singing, there was a demand for her performances. She quickly went from singing the midnight-to-dawn shift for a few dollars' salary, plus tips, to recording her first records in 1933 with clarinetist Benny Goodman. In 1935 she had her second big break as the singer for Teddy Wilson and his band in a popular series of records; that same year she was a success at the famous Apollo Theater in Harlem. By 1936 she was cutting records under her own name.

In 1937 and 1938, she went on tour with both Count Basie and his band and Artie Shaw's band. Back in Harlem, she sang with other leading jazz artists. One of these was saxophonist Lester Young, with whom she formed an enduring friendship. His nickname for her, "Lady Day," fit her cool, dignified style onstage. Their recordings together are some of her most remarkable.

From 1939 to 1941, Holiday sang regularly in Greenwich Village's Café Society Downtown, where she was able to sing to a small, mesmerized audience.

Her marriage in 1941 to nightclub manager James N. Monroe marked the beginning of her long battle with addiction. The marriage ended in 1949 after they had long been estranged, but by that time a recreational marijuana habit had turned into opium and heroin use. During the forties, her career peaked while her personal life suffered. While her marriage was falling apart, her mother, to whom she was very close, died in 1945. Meanwhile she toured, singing to enthusiastic audiences and critics who named her for several jazz awards.

> Lester Young's nickname for Holiday, "Lady Day," fit her cool, dignified style onstage.

A Hollywood film role in 1946 further battered her self-esteem—it turned out to be that of a stereotyped African-American maid. In 1947 her drug problems went public when she was convicted and did nine months in jail for narcotics offenses. Her public welcomed her back in a Carnegie hall concert in early 1948, but her personal life continued to plague her. More arrests, unsuccessful attempts to stop using heroin, and another marriage that did not last (to Louis McKay, in 1956) began to take their toll on her career. She continued to perform and remained popular through the fifties, but by 1959 her voice showed the effects of her hard living.

Early that summer, Holiday checked into the hospital for the last time for her drug problems. She died at New York's Metropolitan Hospital from the ravages of her longtime drug and alcohol abuse. She was forty-four years old.

TO FIND OUT MORE . . .

- Chilton, John. *Billie's Blues: Billie Holiday's Story, 1933-1959.* New York: Stein and Day, 1975.
- Dufty, William with Billie Holiday. *Lady Sings the Blues.* Garden City, NY: Doubleday, 1956.
- Sicherman, Barbara, and Carol Hurd Green, eds. *Notable American Women: The Modern Period. A Biographical Dictionary.* Cambridge, MA: The Belknap Press of Harvard University Press, 1980.
- Smith, Jessie Carey, ed. *Notable Black American Women.* Detroit, MI: Gale Research Inc., 1992.

Doris Humphrey, 1895–1958

Choreographer and dancer Doris Humphrey was an early member of the influential Denishawn troupe founded by **Ruth St. Denis** and her husband Ted Shawn. After leaving Denishawn over artistic differences, Humphrey became an influential teacher and choreographer in her own right. In her late fifties she founded the Julliard Dance Theater in New York City.

Humphrey was the only child born to artistic but impoverished parents in Oak Park, Illinois. Her mother was a musician, her father a photographer and hotel manager. From age eighteen to twenty-two she contributed to the family's income by teaching social dancing in and around Chicago. It was frustrating work for an aspiring performing artist, and she longed to break away.

Her chance came in 1917 in the form of an opening at the Denishawn school in Los Angeles. She soon joined the troupe as a performer, traveling with the company on a tour of Asia in 1925 and 1926. She also began to produce experimental choreography. The creative direction of the company, how-

ever, was firmly controlled by Ruth St. Denis and Ted Shawn, and Humphrey was forced to leave Denishawn in 1928, after more than a decade spent with the company.

Despite a serious lack of funding, Humphrey bravely set out to pursue her own artistic visions in New York City. With former Denishawn troupe members Charles Weidman and Pauline Lawrence, she founded a studio. The dance lessons they provided paid for innovative performances of avant-garde choreography. Human emotion and the natural world provided inspiration for her early abstract choreography, which shunned conventions such as costumes, plot, and sound. In the 1930s the group took the show on tour, performing in college towns across America.

Although her strong, functional marriage with seagoing businessman Charles Francis Woodward never interfered with her work, other pressures and restrictions led to the breakup of Humphrey's company in 1940. After four more years fighting her increasingly painful arthritis, Humphrey was forced to stop dancing. She rebounded with

a period of intense creativity choreographing for her ex-student José Limón's troupe from 1946 until her death. She produced a stunning experimental piece on Federico García Lorca's *Lament for Ignacio Sánchez Mejías* in 1946.

Honors came late in life for Humphrey. She won a Guggenheim Fellowship in 1949, a Capezio Award in 1954, and the Dance Magazine Award in 1958. Money, always tight, was supplemented by her teaching, and in 1951 she was hired by the Julliard School to choreograph and direct her own performance pieces. In 1955 she founded Julliard's Dance Theater. Sadly, she only had three years to enjoy this achievement before her death at the age of sixty-three.

> *Human emotion and the natural world provided inspiration for her early abstract choreography, which shunned conventions such as costumes, plot, and sound.*

TO FIND OUT MORE . . .

- Humphrey, Doris. *Doris Humphrey: An Artist First.* Middletown, CT: Wesleyan University Press, 1972.

- Sherman, Jane. *The Drama of Denishawn Dance.* Middletown, CT: Wesleyan University Press, 1979.

- Sicherman, Barbara, and Carol Hurd Green, eds. *Notable American Women: The Modern Period. A Biographical Dictionary.* Cambridge, MA: The Belknap Press of Harvard University Press, 1980.

Alberta Hunter, 1895–1984

Alberta Hunter had three careers. She was a popular blues performer for nearly four decades, singing in Chicago, New York, and Europe until the mid-fifties. At sixty-two she became a nurse. It was only when she was forced to retire at eighty-two (the board thought she was at most seventy) that she returned to performing. She was an even bigger hit her second time around, much honored as a traditional blues artist and invited to sing at the White House.

Hunter had a confusing childhood. Her father left the family when she was still an infant, and her mother, Laura Hunter, told her that he had died. (Alberta never discovered the fiction.) Laura Hunter also kept her job as a maid in a brothel a secret from Alberta and her sister, La Tosca. Both children were cared for by Laura's mother, Nancy Peterson, but Laura was the disciplinarian of the young family.

When Laura Hunter married Theodore Beatty around 1906, a dark period in Alberta Hunter's life began. Her new stepfather was a jealous man who often hit his wife, and Alberta hated him. Other men in the young teenager's life, including a school principal and the white boyfriend of her family's landlady, sexually abused her. She became angry and headstrong, and at sixteen ran away to Chicago with the unwitting aid of one of her teachers.

In Chicago, Hunter cleaned house and peeled potatoes to make ends meet until she finally found a job singing at a brothel. She dodged offers of other employment at the brothel and added new songs to her original repertoire of two. From the brothel, she worked her way up through the Chicago nightclubs until she had become a popular performer on the circuit, playing for $35 per week plus tips, which could run hundreds of dollars a night.

Hunter began to compose her own songs, including "Down Hearted Blues," which **Bessie Smith** turned into a hit in 1923. Hunter was a powerful presence both on and off the stage. After an unconsummated marriage that lasted two months, she went through a string of relationships, some tempestuous. She moved to New York City

in 1923 to avoid the jealous boyfriend of her lover at the time, Mae Alix, and began to star in productions at Harlem's Apollo Theater.

In 1927 she toured Europe, singing in fashionable clubs in Paris and performing in *Show Boat* in London. She enjoyed the lack of overt racism in Europe, and returned several times to perform there. In America she found a career on radio until World War II, when she joined the war effort by performing in USO shows in the Pacific. Back in New York after the war, Hunter decided to quit performing two years after her mother, who had been living with her, died in 1954.

Hunter was a longtime volunteer at the Joint Diseases Hospital in Harlem. At sixty she enrolled at the YWCA's nursing program, listing her age as forty-eight. She was an excellent nurse for twenty years, and was not ready to quit when, in 1977, she was told she would have to retire at eighty-two. Unwilling to quit working altogether, she returned to singing.

As the lead performer at a nightclub opening later that year, Hunter was a runaway hit. She became a celebrity almost immediately, and was interviewed on the *Today* show and in numerous magazine ar-

ticles. She sang at the White House in 1979 and was invited to sing at the Kennedy Center's lifetime awards ceremony honoring **Marian Anderson**. In her late eighties she continued to tour, singing at jazz festivals across the United States and abroad.

Neither her voice nor her powerful personality faded with the years. She dressed in purposely shabby clothes, which, she explained, deterred muggers. She also carried an ice pick in case her camouflage was not effective. She brushed off friends' concerns about her health and did not tell them when she had a pacemaker installed. Her health finally got the better of her in 1984, forcing her at last to quit singing at the age of eighty-nine. She died at home the same year.

> *In her later years, Hunter dressed shabbily to deter muggers—and carried an ice pick in case her camouflage was not effective.*

TO FIND OUT MORE . . .

- Gilbert, Lynn, and Gaylen Moore. *Particular Passions: Talks with Women Who Have Shaped Our Times.* New York: Clarkson N. Potter, 1981.

- Smith, Jessie Carey, ed. *Notable Black American Women.* Detroit, MI: Gale Research Inc., 1992.

- Spradling, Mary Mace. *In Black and White.* 3rd ed., Vol. I. Detroit: Gale Research, 1980.

- Taylor, Frank C., with Gerald Cook. *Alberta: A Celebration in Blues.* New York: McGraw-Hill, 1987.

Clementine Hunter, 1886–1988

· ·

Folk artist Clementine Hunter was hailed as "the black Grandma Moses" because, like Grandma Moses, she was a self-taught painter who began painting late in life. For all the fuss that the art world made over her, Hunter did not benefit much from the sale of her thousands of oil paintings, which brought hundreds of dollars in urban galleries. She stayed in her home town of Natchitoches, Louisiana, moving from her old cabin to a house trailer in her late eighties, and continued to sell her paintings to neighbors for as little as six dollars apiece.

Clementine Reuben was born on a cotton plantation near Cloutierville, Louisiana. She attended elementary school at a local Catholic school, but quit school permanently when she was still young. As an adult she could not read or write. The family settled near Natchitoches on Melrose Plantation, and Hunter stayed there the rest of her life, working in the fields and raising seven children.

Hunter's first husband, Charlie Dupree, died in 1914. She was married ten years later to Emanuel Hunter and moved into the plantation house to take over domestic work. The plantation mistress made art her hobby, and invited many prominent artists (briefly including Richard Avedon) to the plantation over the years. It was an artist-in-residence, François Mignon, to whom Hunter turned in her late fifties when she wanted to paint.

Hunter had found some discarded paint; she wanted canvas from Mignon. He scrounged up an old window shade, and in a few hours, she showed him her completed painting. Hunter never slowed down, and the shortage of materials never bothered her. She painted on whatever was available, including scrap wood, cardboard boxes, even paper bags. She became an expert at stretching out her supply of oil paint by thinning it until the finished paintings resembled watercolors.

Mignon became her biggest promoter, and in the 1950s her work began to attract attention. Solo exhibitions pegged Hunter as a "primitive" painter, perhaps detracting from the impact she might have had as the first African-American artist to have solo exhibitions in some Louisiana museums. At a 1955 show at Northwestern State College, she was not allowed to view the show with white patrons, but had to sneak in after hours.

Hunter painted what she knew—boldly colored images from plantation life, both the commonplace and the festive. Her subjects included doing laundry, going to church, dancing, weddings, and school. She also painted a number of Bible stories, including the Nativity and the Crucifixion. Hunter's preference for painting from memory is apparent in the flat, representational quality of her work, in which realistic detail is subordinate to meaning.

Another Melrose artist-in-residence, James Register, became a supporter. In the 1940s he supplied her with materials and a Julius Rosenwald Foundation grant. In the early sixties he encouraged Hunter to try abstract art. She obliged him, letting him assign the works rather fanciful titles like

For all the fuss that the art world made over her, Hunter did not benefit much from the sale of her thousands of oil paintings.

Chanticleer and the Moon Bird, but was glad to return to her representational work.

Besides the upgrade from cabin to house trailer, one of the few indulgences Hunter spent her earnings on was a nice coffin and mausoleum space. She continued to paint until her death at the age of 101.

TO FIND OUT MORE . . .

- *Black Women Oral History Project*. Interview with Clementine Hunter. Cambridge: Schlesinger Library, Radcliffe College, 1979.

- Smith, Jessie Carey. *Notable Black American Women*. Detroit, MI: Gale Research Inc., 1992.

- Wilson, James L. *Clementine Hunter: American Folk Artist*. Gretna, Louisiana: Pelican Pub. Co., 1988.

Anna Vaughn Hyatt Huntington, 1876–1973

A nna Vaughn Hyatt Huntington found her artistic niche in sculpting animals. She was comfortable with animals in her personal life as in her art, raising deerhounds and watching birds on her Connecticut estate. "Animals have many moods," she once said, "and to represent them is my joy." She moved easily about within the animal kingdom for inspiration, creating powerful tigers and panthers, a skittish fawn, and noble equestrian pieces with equal expertise.

Anna Hyatt was born in Cambridge, Massachusetts, to Audella and Alpheus Hyatt. Her father's work as a paleontologist at the Massachusetts Institute of Technology made her familiar with animal anatomy early on, and Audella's work illustrating Alpheus's writings piqued Anna's interest in art. She was especially interested in horses, becoming quite expert in distinguishing among breeds as a child.

With an older sister, Hyatt studied sculpture in Boston with Henry Hudson Kitson. Her first exhibit, at age twenty-four, included forty pieces—a phenomenal number for a young artist. She moved to New York, where she continued to study both with teachers and on her own, visiting zoos and circuses to observe a range of animals. She lived for a time with another young sculptor, **Abastenia St. Leger Eberle**, who collaborated with her on their prizewinning *Men and Bull* (1904). Eberle sculpted the men, Hyatt the bull.

Huntington became immersed in an ambitious project, *Joan of Arc*, in 1909. She spent quite some time researching her subject in Rouen and Órleans, France, meticulously studying details such as the period armor that her Joan wears. Her Joan, on horseback, rises in her stirrups, sword outstretched. The huge sculpture was cast in bronze for Riverside Drive in New York, and has been reproduced for other American and French cities. France made her a

Chevalier of the Legion of Honor for her achievement.

Her success with *Joan* cemented her reputation as one of America's finest animal sculptors. At forty-seven she married the Hispanic poet and scholar Archer Milton Huntington, the adopted son of railroad magnate Collis Potter Huntington. They shared interests in philanthropy and wildlife preservation, and together they opened Brookgreen Gardens in South Carolina, an outdoor sculpture museum. In 1940 they settled in Connecticut, where Anna was able to study her deerhounds and birds in peace.

Huntington was comfortable with animals in her personal life as well as in her art, raising deerhounds and watching birds on her Connecticut estate.

The Huntingtons' estate, Stanerigg Farm, was the locale of Sunday tea gatherings of friends and intellectuals. There Huntington could discuss art or roam the grounds for inspiration (and to scare off bird-threatening squirrels with her .22 calibre rifle). She continued to sculpt prolifically until her death at Stanerigg at age ninety-seven.

TO FIND OUT MORE . . .

- Evans, Cerinda W. *Anna Hyatt Huntington.* Newport News, VA: Mariners Museum, 1965.

- Rubenstein, Charlotte Streifer. *American Women Artists: From Early Indian Times to the Present.* New York: Avon, 1982.

- Sicherman, Barbara, and Carol Hurd Green, eds. *Notable American Women: The Modern Period. A Biographical Dictionary.* Cambridge, MA: The Belknap Press of Harvard University Press, 1980.

- Huntington's papers are in the Schlesinger Library at Radcliffe College.

Mahalia Jackson, 1911–1972

Renowned as the greatest gospel singer of all time, Mahalia Jackson's career in music grew out of her Sunday performances in her church choir. Although she had many opportunities to pursue a career in the far more lucrative fields of blues and jazz, Jackson preferred to apply her highly emotional style to gospel. "I don't work for money," she once explained. "I sing because I love to sing." In the early 1960s, she raised her voice in support of the civil rights movement, singing at the 1963 March on Washington.

Jackson was raised by a series of relatives in New Orleans, Louisiana. Her father, a Baptist preacher and barber, was not around for Mahalia's childhood, and her mother, who took in laundry and worked as a maid, died when she was just five years old. Some of the assorted aunts and older half-siblings who raised her were entertainers, and they brought music into Jackson's early years.

Mahalia Jackson gravitated toward church music early on. When she wasn't working to help support her extended family or attending school, she was absorbing the traditions of the nearby Mount Moriah Baptist Church. At sixteen she moved to Chicago, where she began singing in a gospel group and the choir of the Greater Salem Baptist Church. She hoped to become a nurse, but in the meantime she worked laundering clothes and took classes at a local beauty school. She opened her own beauty shop in her early twenties.

In 1936 Jackson married fellow entrepreneur Isaac Hockenhull. He considered it tragic that Mahalia's voice was only heard by churchgoers, and he urged her to try out for a Gilbert and Sullivan musical. Reluctantly, she did, winning her first offer to sing the blues for Decca Records. She turned this and all other such offers down. In 1937, Louis Armstrong tried to convince her to sing with his band. "Make you some real green," he told her. ". . . I *know* what you can do with the blues." "I know what I can do with it too, baby," she shot back, "and that's not sing it."

Despite the limited visibility of gospel singing, Jackson's powerful contralto took

hold of her listeners and brought them back for more. Her recordings grew in popularity, and in the 1950s she balanced concerts with her own radio and television show, while running a flower shop in Chicago. Tours in Europe had been successful; the French press called her "the Angel of Peace" and her radio show was a hit in Great Britain. The joy her singing brought her was inevitably transmitted to her enthusiastic audiences.

In 1965, she married fellow musician Sigmond Galloway. Like her first marriage, this one ended in divorce.

> *"I don't work for money,"* she once explained. *"I sing because I love to sing."*

Jackson's position as the undisputed queen of gospel resulted in engagements to sing for royalty abroad and presidents at home. She sang at President Kennedy's inauguration in 1961. Her moving 1963 performance of "How I Got Over" at the Lincoln Memorial in Washington, D.C. recalled **Marian Anderson's** historic performance twenty-four years earlier.

Jackson was generous with her support of aspiring artists, including Della Reese and Aretha Franklin. She established a scholarship in her own name for college students. She died in Chicago in 1972.

TO FIND OUT MORE ...

- Dahl, Linda. *Stormy Weather*. New York: Pantheon, 1984.

- Sicherman, Barbara, and Carol Hurd Green, eds. *Notable American Women: The Modern Period. A Biographical Dictionary*. Cambridge, MA: The Belknap Press of Harvard University Press, 1980.

- Smith, Jessie Carey. *Notable Black American Women*. Detroit, MI: Gale Research Inc., 1992.

Eva Jessye, 1895–1992

This matriarch of African-American music was around for almost a century's worth of great changes in music—some of which she had a hand in. Her work with George Gershwin on his 1935 *Porgy and Bess* helped shaped the opera and gave it a more truthful feel. "George Gershwin knew a great deal, he studied a great deal, but I've been black longer than he has. . . . No imitator can be as close to a thing as one who is the source," said Jessye in a 1989 interview in Brian Lanker's *I Dream a World*.

Jessye was born on January 20, 1895, in Coffeyville, Kansas. Julia Buckner Jessye and Al Jessye were separated when Eva was three years old, and she went to live with her mother's mother and sisters while her mother went to work in Seattle. Her Coffeyville relatives were a strong rooting factor; Jessye went to public schools in Kansas, Missouri, and Washington. At twelve she organized a singing group; at thirteen, she was accepted early at Western University in Quindaro, Kansas.

She graduated from Western in 1914 and earned a teaching certificate from Oklahoma's Langston University in 1916. After teaching and writing for ten years, she moved to New York in 1926. She thrived there, joining and then taking over a singing group, which would eventually become her famous Eva Jessye Choir. Jessye directed them in King Vidor's *Hallelujah*, the first black musical. "I knew how to put little moans and groans and things that would make it real, you know," she said of the film's choral direction.*

In 1935, Jessye and her choir were able to put their Hollywood experience to work in George Gershwin's *Porgy and Bess*. The choir performed in the opera on its opening night, and Jessye was its first—and definitive—choral director. Jessye worked with Gershwin to authenticate the score, which she characterized as "quite white." (During her work with him in his penthouse, she says she came up with an eleventh commandment: Thou shalt not envy thy neighbor's Steinway pianos.)* Jessye's original direction has become the standard by which all succeeding productions of the opera are judged.

THE REMARKABLE LIVES OF

Jessye was at important junctures in American history as well as in musical history. She raised money for the war effort with her Victory Concert tour during World War II. She composed and directed her choir in singing the theme for the Soviet Friendship Day ceremonies in New York and Washington, D.C., in 1944. And in 1963 her choir sang in the Capitol for Martin Luther King's March on Washington.

Jessye established music collections in her name at both the University of Michigan (Ann Arbor) and at Pittsburg State University in Kansas. Her compositions *Chronicle of Job* and *Paradise Lost* are especially powerful works. She was honored by universities and musical organizations; in 1985 the Apollo Theatre in New York paid tribute to her work. She died in 1992 at the age of ninety-seven.

> *Jessye worked with George Gershwin to authenticate the score of Porgy and Bess, which she characterized as "quite white."*

TO FIND OUT MORE . . .

- Black, Donald Fisher. *The Life and Work of Eva Jessye and Her Contributions to American Music.* Ann Arbor, Mich.: University Microfilms, 1986.

- Lanker, Brian. *I Dream a World: Portraits of Black Women Who Changed America.* New York: Stewart, Tabori & Chang, 1989.

- Smith, Jessie Carey, ed. *Notable Black American Women.* Detroit: Gale Research, Inc, 1992.

- Southern, Eileen. *A Biographical Dictionary of Afro-American & African Musicians.* Westport, CT: Greenwood Press, 1982.

Adelaide Johnson, 1859–1955

Feminist sculptor Adelaide Johnson had a flair for the dramatic. She switched her age around to suit her at different periods in her life, making herself much younger at her wedding and much older during her old age, although she lived to be ninety-six. She recorded in stone many of the high points of the feminist movement, sculpting portrait busts of feminist leaders like Susan B. Anthony. Her crowning achievement was a monument to the women's movement, erected in Washington, D.C., in 1921.

Born Sarah Adeline to farmers in Plymouth, Illinois, Johnson was the eldest of three children. Margaret Huff Hendrickson Johnson and Christopher William Johnson had each been married twice before and had other children. Johnson attended rural schools until her teens, when she lived with an older half brother and took classes at the St. Louis School of Design. Competing with professionals, she took both first and second prize at a state exposition at age eighteen.

In 1878 Sarah Adeline changed her name to the more theatrical Adelaide. She moved to Chicago to study, supporting herself with her woodcarvings. She turned a painful accident to her advantage when she fell down an open elevator shaft in the Central Music Hall and broke her hip. Her casualty suit provided the money—$15,000—that she needed to study in Europe. She spent 1883 studying painting in Dresden, then moved to Rome. From 1884 until 1895 she studied with Giulio Monteverde in Rome, and she kept a studio there until 1920.

Johnson indulged her taste for the dramatic in her 1896 marriage to British businessman Frederick Jenkins. She used every step of the marriage to make a statement. He took her name instead of the other way around, and they were wed by a (then rare) woman minister. The bridesmaids were her busts of feminists Elizabeth Cady Stanton and Susan B. Anthony. She also indulged her vanity by dropping twelve years from her age on the marriage certificate, claiming she was twenty-four to seem younger than Frederick Johnson's twenty-five years. Despite all this effort, the marriage ended in

an acrimonious divorce twelve years later.

An early advocate of the women's movement, Johnson showed busts of suffragists Stanton, Lucretia Mott, and Anthony at the 1893 World's Columbian Exposition in Chicago. All her professional life, Johnson fought public skepticism and lack of funds to achieve her dream of a museum honoring the women's movement. Although she never did manage to bring it about, she did create an impressive sculpture to commemorate the movement, featuring new versions of her busts of Mott, Anthony, and Stanton. New York suffragist Alva Belmont helped her secure funding for the project from the National Women's Party, and the seven-ton white marble sculpture was unveiled on Anthony's birthday in 1921.

Toward the end of her career, Johnson was unable to sell her work for prices she considered acceptable. Threatened with the loss of her home when she could not pay her taxes in 1939, she pulled a publicity stunt that saved her. She disfigured several of the pieces in her studio, then alerted the press to her symbolic protest. Public sympathy prompted New York Congressman Sol Bloom to intercede on her behalf, which allowed her to hold on to her house until 1947. At that point, she sold her home and lived with friends. She began to inflate her age, going from eighty-eight to 100 for more press and more sympathy. Newspapers reported her age at her death at 108, although by that time her real age, ninety-six, was remarkable enough in itself.

> *Johnson's crowning achievement was her monument to the women's movement, erected in Washington, D.C., in 1921.*

TO FIND OUT MORE . . .

- Fairman, Charles E. *Art and Artists of the Capitol of the United States.* 1927.

- Sicherman, Barbara, and Carol Hurd Green, eds. *Notable American Women: The Modern Period. A Biographical Dictionary.* Cambridge, MA: The Belknap Press of Harvard University Press, 1980.

- Obituary. *The New York Times.* November 12, 1955.

- Obituary. *The Washington Post,* Nov. 11, 1955.

- Johnson's papers are in the Adelaide Johnson Collection in the Manuscript Division of the Library of Congress.

Frances Benjamin Johnston, 1864–1952

Frances Johnston was one of America's greatest early documentary photographers. Her photographs were not the candid, spontaneous snapshots that the term "documentary" might suggest: Johnston carefully composed each photo both for artistic effect and for social comment. She felt she could best contribute to the struggle for civil and women's rights by literally *showing* people her point of view.

Frances Johnston, like **Gertrude Käsebier**, got her first artistic training in painting and drawing classes. Her family moved several times when she was young. She was born in Grafton, West Virginia, but grew up in Rochester, New York, and Washington, D.C., where she studied at the Art Students' League. Further training was obtained at the Académie Julian in Paris. Despite all of this training, Johnston got into photography indirectly. She took a job as a reporter for a New York magazine, and turned to photography originally as a means of illustrating her articles.

Her success with reportorial photographs of historic homes and of political figures for *Demorest's Family Magazine* prompted Johnston to set up shop in Washington as a professional portrait photographer. She gained a reputation as a rather unconventional but quite professional photographer, and in 1899 had a breakthrough with a series of photographs of the Hampton Institute in Virginia and of the Washington, D.C., school system. In 1900 she won a gold medal at the Paris Exposition for the series, gaining stature as a prominent documentary photographer in her own time.

The series is of historical interest on several levels: as a straightforward document of conditions in both school systems at the turn of the century, as an indicator of taste in documentary photography at the time, and as a statement of Johnston's opinions. In one photograph from the Hampton series, *Testing at Hampton Insti-*

tute, she seems to have been conscious of all these levels. She has carefully composed her picture by arranging her subjects, young African-American students in a laboratory, to produce a balanced scene. While the effect is obviously staged, the picture still manages to make a social point simply by virtue of its subject matter. (African-American scientists were few in number at the turn of the century.) By depicting the students in the lab, Johnson seems to challenge her viewers' social expectations.

Johnston continued to work into her seventies. As one of America's premier photographers of the time, she lectured at the International Photographic Congress in Paris on women photographers in America. Later, the lecture was modified for a series of *Ladies' Home Journal* articles. She continued to photograph with a critical eye, documenting the stately early architecture of the South in one memorable series taken between 1933 and 1940. These pictures are as carefully framed as any she arranged at the Hampton Institute. In their attention to design, they go beyond any simple documentation of the scene.

Johnston died at the age of eighty-eight in 1952. Fourteen years later, she was sa-

> *Johnston felt she could best contribute to the women's movement by literally showing people her point of view.*

luted by the Museum of Modern Art, which exhibited a group of photographs from the Hampton Institute series. The exhibit toured widely, a tribute to the lasting power of Johnston's work.

TO FIND OUT MORE . . .

- Munsterberg, Hugo. *A History of Women Artists.* New York: Clarkson N. Potter, 1975.

- Daniel, Pete, and Raymond Smock. *A Talent for Detail: The Photographs of Miss Frances Benjamin Johnston, 1889–1910.* New York: Harmony Books, 1974.

Matilda Sissieretta Joyner Jones (Sissieretta Jones), 1869–1933

· ·

Soprano Sissieretta Jones was trained as an opera singer, but audiences were unused to hearing an African-American woman sing a classical repertoire around the turn of the century. She turned her trained voice to use on the vaudeville circuit, where she performed scenes from classical opera in her own company, Black Patti's Troubadors.

Sissieretta Joyner was born in Portsmouth, Virginia, where her father was a preacher. Around 1876 the family moved to Providence, Rhode Island, where he had a new congregation, and Joyner began singing in church. She made a bad early marriage at fourteen to David Richard Jones, a gambler and sometime hotel bellman. She divorced him by the time she was nineteen.

Voice lessons at the Providence Academy of Music reportedly led to further train-ing at the New England Conservatory of Music in Boston, and at age nineteen she made her New York City debut. Opera was inaccessible to her, so she sang ballads and emotional songs with a string of concert companies over the next decade or so. During this period, Jones also toured Europe and sang at the White House in Washington and for the Prince of Wales in London.

She achieved great popular success, but her audiences constantly pushed her toward a more stereotypically ethnic repertoire. She compromised, including the operatic arias she favored along with popular songs like "Old Folks at Home." After 1896, however, Jones performed in a very different setting, as the head of a vaudeville company.

Jones had often been compared to operatic singer Adelina Patti, and along the way she picked up the appellation "the

black Patti." She changed it slightly, calling her troupe of jugglers, comedians, dancers and singers the Black Patti Troubadors. In this eclectic format, she was finally able to direct herself in scenes from famous operas, including *Lucia di Lammermoor* and *Il Trovatore*. Ironically enough, her audiences for these performances were mostly white.

The troupe's success was short-lived. After a decade of enthusiastic reviews hailing Jones as the greatest African-American singer of her time, vaudeville went out of vogue around 1916. Jones died in obscurity seventeen years later at the age of seventy-four.

> *Jones achieved great popular success, but her audiences constantly pushed her toward a more stereotypically ethnic repertoire.*

TO FIND OUT MORE . . .

- James, Edward T., ed. *Notable American Women 1607-1950: A Biographical Dictionary.* Cambridge, MA: The Belknap Press of Harvard University Press, 1971.

- Smith, Jessie Carey, ed. *Notable Black American Women.* Detroit, MI: Gale Research Inc., 1992.

Frida Kahlo, 1907–1954

Mexican painter Frida Kahlo had a very short, very difficult life. A bus accident crushed her spine and pelvis when she was a teenager, leaving her with agonizing pain that thirty-five operations did little to ease. She expressed her pain in her painting, creating fantastic, often disturbing images that led the French critic André Breton to group her with the Surrealists. Kahlo protested, saying, "[Breton] thought I was a Surrealist, but I wasn't. I never painted dreams. I painted my own reality."

Kahlo grew up in Coyoacán, a suburb of Mexico City. At thirteen she developed a crush on a thirty-four-year-old muralist, Diego Rivera, whom she would later marry. Despite her infatuation with the artist, Kahlo's professional ambition was to be a physician. Her life was permanently changed by a street car, which crushed a bus she was riding in against a telephone pole.

Kahlo's pelvis was shattered and her spine fractured in the accident. She surprised her doctors by surviving, but her recovery was agonizing and never fully complete. While still an invalid she began to put her pain down in paint, teaching herself as she went. Over the years, death and suffering became her major themes, joined by her grief over her inability to have children and her later marital woes. Despite these disturbing subjects, Kahlo retained a dignity in her paintings and in life. She wore colorful, formal Mexican clothing and plaited her hair into sculpted styles, adding to her aura of composure.

When she was well enough to move about, Kahlo took some of the paintings she had done in bed to Diego Rivera, who was much impressed by them. Their famously stormy relationship would last for the rest of Frida's life, and Diego would often appear in Frida's paintings. These paintings have provoked much speculation about the nature of their relationship. Rivera's philandering and Kahlo's obsessive attempts to have children contributed to their divorce in the late 1930s, but they remarried only a few years later.

Kahlo's highly distinctive paintings usually feature her unmistakable face. In photographs she is a strikingly beautiful woman

with smoothly parted and plaited black hair and strong eyebrows, but in her work she emphasizes the more masculine aspects of her face, giving herself a single, thick eyebrow and a distinct mustache. The severity of her painted self stares out in a kind of martyrdom. Often she painted herself calmly suffering, with parts of her body opened up to display pain; she sometimes included lifeless fetuses, or her cumbersome metal braces. In a 1940 self-portrait, she looks calmly out of the painting while a necklace of thorny branches stabs her neck and blood drips down her chest.

> "[Breton] thought I was a Surrealist, but I wasn't. I never painted dreams. I painted my own reality."

In 1953 Kahlo had her first major exhibit at Mexico City's Gallery of Contemporary Art. Despite her increasing debility, she attended the opening on a four-poster bed. Four months later, her leg was amputated, and a year later she died. Rivera donated her home to the Mexican government, which turned it into the Frida Kahlo Museum.

TO FIND OUT MORE . . .

- Harris, Ann Sutherland, and Linda Nochlin. *Women Artists: 1550-1950*. New York: Alfred A. Knopf, 1976.

- Heller, Nancy G. *Women Artists: An Illustrated History*. New York: Abbeville Press, 1987.

- Herrera, Hayden. *Frida: A Biography of Frida Kahlo*. New York: Harper and Row, 1983.

- Tibol, Raquel. *Frida Kahlo: An Open Life*. Translated by Elinor Randall. Albuquerque: University of New Mexico Press, 1993.

Gertrude Stanton Käsebier, 1952-1934

G ertrude Käsebier didn't take up photography until her three children were grown. Once she did, she focused her camera on the relationship between mother and child, producing thousands of prints of family scenes in her four decades of work. Her misty, staged photos of idealized women and children made her widely popular until her photographs went out of style after World War II.

Gertrude Stanton was born in Des Moines, Iowa, when the West was still in the process of being "settled." Her parents were frontierspeople until her father died when she was still quite young; after that, Gertrude was sent East to live with her grandmother. Her mother followed Gertrude to the East Coast to set up a boardinghouse in New York City, and Gertrude moved in with her mother.

At the age of twenty-two, Gertrude Stanton married Eduard Käsebier. They had three children together, and Gertrude lived

a quiet life as a wife and mother. By the time all her children were in their teens, however, she had decided to do something just for herself. In her late thirties, Käsebier enrolled in painting classes at the Pratt Institute in Brooklyn.

She studied portraiture diligently, but was only moderately successful as a painter. In 1893, however, while she was living in rural France, she began to experiment with a camera. She became so enthralled by the new medium that she often worked through the night to develop her pictures, since she had no darkroom and could not work during daylight.

To refine her technical knowledge of her art, she worked for a period as an apprentice to a chemist in Germany. Back in Brooklyn she also worked under a professional photographic portraitist for a time before setting up her own portrait studio in 1897. Eduard Käsebier disliked his wife's newfound profession, but his disap-

proval did not impede her swift and lasting success.

From about the turn of the century until the end of World War I, Gertrude Käsebier was one of America's best-known photographers. Alfred Steiglitz's pioneering photography magazines, *Camera Notes* and *Camera Work*, often featured her photos, and she gave exhibits at Steiglitz's "291" Gallery and at the New York Camera Club. Around 1902 she was one of the artists credited with starting the Photo-Secessionist movement. And in 1916, she cofounded the Pictorial Photographers of America.

> *Her misty, staged photos of idealized women and children made her widely popular until her photographs went out of style after World War II.*

Käsebier found a wide audience with carefully composed, gently nostalgic photographs like *Mother and Child* (c. 1900) and *Blessed Art Thou Among Women* (20th century). But she is also remembered for the striking series she did of Western subjects like Buffalo Bill's Wild West Show and the increasingly displaced Native American population. All in all, she produced over a hundred thousand prints that are valuable not only as works of art but as historical documents of her time.

Although she continued to photograph for much of the rest of her life, Käsebier's style had gone out of vogue by the twenties, replaced by a harder-edged, less sentimental approach. She died at age eighty-two.

TO FIND OUT MORE . . .

- Michaels, Barbara L. *Gertrude Käsebier: The Photographer and Her Photographs.* New York: H.N. Abrams, 1992.
- Munsterberg, Hugo. *A History of Women Artists.* New York: Clarkson N. Potter, 1975.
- Tucker, A. *The Woman's Eye.* New York: Alfred A. Knopf, Inc., 1974.

Lee Krasner, 1908–1984

Lee Krasner's bold canvases mark her as one of the most important figures of the New York School of painters. Nevertheless, she struggled for a period in her career when her husband, Jackson Pollock, gained prominence and she was disparaged as the artist's wife. Ironically, she spent much of her energy promoting his work during their fourteen-year marriage. In a 1975 interview, she explained her position: "I couldn't run out and do a one-woman job on the sexist aspects of the art world, continue my painting, and stay in the role I was in as Mrs. Pollock. . . . What I considered important was that I was able to work."

Lenore Krasner was born nine months after her family moved from a shtetl near Odessa, Russia, to Brooklyn. Her parents ran a produce market to support their large family. Krasner, the fifth child, grew up hearing Russian, Hebrew, and Yiddish at home. Independent at an early age, Krasner worked at age thirteen to earn her own carfare and lunch money. Although she committed herself to art as a student, she was

not always encouraged by her teachers; in her senior year at Washington Irving High School, her art teacher told her he would give her a passing grade only because she had done so well in her other courses.

At twenty-two Krasner painted herself for a life class at the National Academy of Art with a stubbornly jutting chin, looking out at the viewer with a coolly assessing eye. Picasso and Matisse provided early inspiration; when Krasner first saw their work at the Modern Museum of Art, she was rocked by it. "I flipped my lid," she said in a later interview with *Newsday*. After her graduation in 1929, she cast about for a few years, painting and earning her high school teaching credentials while supporting herself on a waitress's salary. She found new direction in the form of the Federal Art Project, which employed her from 1934 to 1943.

In the late 1930s and early 1940s, Krasner's work began to attract attention. "You have a strong inner rhythm," the artist Piet Mondrian told her. "You must never lose it." Her teacher for the years 1937–1940, Hans Hoffmann, paid her work a more

THE REMARKABLE LIVES OF

qualified compliment: "This is so good you would not know it had been done by a woman." In 1945 she married another budding artist, Jackson Pollock. The couple moved to Springs, Long Island.

Krasner always emphasized the reciprocity of their professional and domestic relationship. Each was the other's greatest fan and constant critic, and they happily divided up the chores in their rickety farmhouse. The public however, made no such assumptions. While both artists developed tremendously during the 1940s and 50s, Pollock's work received far more attention than Krasner's. This may be partly due to the energy she poured into promoting his paintings. Whatever the reason, the small slights reached an unbearable level in 1951, when her solo show at the Betty Parsons Gallery was dropped after Pollock left the gallery.

Despite depression at her lack of public recognition, Krasner produced an authoritative body of work during and after her marriage to Pollack. The "little image" series employed hundreds of tightly packed, thickly painted calligraphic images arranged neatly on a canvas. After the Betty Parsons Gallery incident, Krasner cut up several of her paintings, reworking them into collages with black paper and scraps of Pollock's work.

"You have a strong inner rhythm," the artist Piet Mondrian told her. "You must never lose it."

After Pollock's death in 1956, she continued her shift toward larger forms and rich colors, which swirl across wall-filling canvases. She began to be heralded as a pioneer of Abstract Expressionism, one of the great original art movements in American history, in the 1970s. In 1978 she was included in an exhibit called "Abstract Expressionism: The Formative Years." She continued to work until her death in 1984.

TO FIND OUT MORE . . .

- Fine, Elsa Honig. *Women & Art: A History of Women Painters and Sculptors from the Renaissance to the 20th Century.* Montclair, NJ: Allanheld, Osmun & Co and Abner Schram Ltd., 1978

- Harris, Ann Sutherland, and Linda Nochlin. *Women Artists: 1550-1950.* New York: Alfred A. Knopf, 1976.

- Heller, Nancy G. *Women Artists: An Illustrated History.* New York: Abbeville Press, 1987.

- Rubenstein, Charlotte Streifer. *American Women Artists: From Early Indian Times to the Present.* New York: Avon, 1982.

Dorothea Lange, 1895–1965

Disabled by polio as a child in New Jersey, the photographer Dorothea Lange brought her sympathy for the disadvantaged to her work. Her talent truly shone when she was documenting the plight of those in distress, and her images made her viewers take notice of her subjects' distress. Her photo "Migrant Mother" is one of the most widely recognized images of the Depression.

Lange was born in Hoboken, New Jersey, which in 1895 was an immigrant town. Her parents were second-generation German immigrants, a lawyer and an amateur singer. Her early childhood was a nurturing one, but she was stricken by two hardships: she became infected with polio at age seven, leaving her with a permanent limp, when she was twelve, her father deserted the family. Although her classmates called her "Limpy," she studiously ignored the taunts. She also refused to acknowledge her father's absence: Her husband and children only learned that her birth name had been Nutzhorn after her death. Her mother went to work in Manhattan, and there Lange

often played truant, absorbing the city scenes, the people and the bustle. Her rovings were the best possible education for her later work as a photographer.

Although she had never owned a camera, Lange decided on a career as a photographer before the age of twenty, and managed to get herself a string of apprenticeships through sheer tenacity. At twenty-three, she felt ready to make a living as a photographer. Ignoring the objections of her mother and grandmother, she set out with the intention of traveling around the world, paying her way with her camera. Instead, she settled quickly in San Francisco, where she soon secured her own portrait studio with a regular clientele. She married a painter, Maynard Dixon, and spent several happy years with him in the midst of San Francisco's bohemian life before deciding again, in the late twenties, to stretch her boundaries.

Lange and Dixon took a trip through Arizona, where Lange was first struck by the bleak poverty of people in the ranch towns. The photographs from this trip are

her first significant images of the subject matter for which she would later become famous. Her family life had been deteriorating: the birth of two sons made her feel tied down, and Dixon's infidelities were a source of friction. Lange retaliated in kind. In 1930 and 1931, they took a series of trips through New Mexico, as a last-ditch effort to save the marriage. They ultimately failed, but Lange was launched on her life's work, as she saw some of the first of the migrant families on their miserable flight from the drought and poverty of their former homes.

After a period of photography in San Francisco, where she captured images of bread lines and labor unrest, Lange's work caught the eye of Paul Schuster Taylor, whom she later married. They were hired by the Farm Security Administration to document the housing problems of the migrant workers. Lange was tirelessly devoted to the cause of her subjects, photographing them with sensitivity and righteous passion. When funds ran out, she paid her own expenses. The resulting book, which Paul Taylor co-authored, was *American Exodus: A Record of Human Erosion.*

Lange's rigid desire for artistic control led to her eventual break with the FSA and the end of her most remarkable period of creativity. The activism driving her FSA work gave her photographs a special urgency that was never in her portrait work in San Francisco or in most of her later photos. But with a camera and a cause, Lange created powerful photographs, a statement of injustice that still reverberates for viewers of her work.

> *Lange's photo "Migrant Mother" is one of the most widely recognized images of the Depression.*

TO FIND OUT MORE . . .

- Hugo Munsterberg. *A History of Women Artists.* New York: Clarkson N. Potter, 1975.

- Naylor, Colin. *Contemporary Photographers.* Chicago: St. James Press, 1988.

- *Dorothea Lange: Photographs of a Lifetime.* New York: Aperture, Inc., 1982.

- *Great Photographers.* New York: Time-Life Books, 1971.

Ethel (Liggins) Leginska, 1886–1970

Originally a concert pianist who rejected the conventional formal evening gowns on stage for a comfortable skirt and jacket, Ethel Leginska made a mid-career shift that was then considered radical: She became a conductor. Her reputation as a brilliant pianist undoubtedly helped her overcome the skepticism voiced by some critics.

Ethel Liggins was born in Hull, England. Her early aptitude as a pianist attracted the patronage of the socially prominent Mary Emma Wilson and her husband, Arthur, a shipowning magnate. They financed her study in Frankfurt, Vienna, and Berlin, until she met and married Roy Emerson Whittern, another pianist. Both changed their names—she to the European-sounding Leginska, he to the more Britishy Emerson Whithorne.

Leginska came to the United States in 1913 for her New York solo debut. An energetic performer who played a long, de-manding Chopin program without an intermission, she was extremely well received and became quite popular on the American stage. As time went on, Leginska became more and more concerned with the barriers to working women. At first she addressed the issue in small ways: It was about this time that she adopted her comfortable uniform of a black velvet jacket and a skirt. Her hair was cut in a short, practical style. Later she addressed more serious issues, among them child care.

It is safe to assume that these innovations did not help her in her divorce in late 1917 and 1918. She lost custody of her nine-year-old child, Cedric, in the proceedings, despite her offer to give up performing to teach private piano lessons. The messy breakup of her marriage marked a turning point in her professional as well as her personal life. In 1918 she began to study composition, and in 1923 she began to prepare to conduct.

She made her conducting debut in January of 1925 with the New York Symphony, and gradually made a name for herself (although she was regarded as something of a novelty) conducting in Boston and Los Angeles. In 1926 she founded the Boston Philharmonic Orchestra, which she conducted until 1927. She also spent four years with the Boston Woman's Symphony Orchestra before touring Europe in 1930, and organized the New York-based National Symphony Orchestra in 1932. She was the first woman to conduct a major U.S. orchestra, and the first woman to write an opera (*The Rose and the Ring*, 1932).

In 1935 she conducted her opera *Gale* in Chicago. It was one of her last major conducting performances. Offers began to dry up. It has been suggested that her age—nearly fifty years old—was a factor. Whatever the reason, Leginska moved quietly into a career teaching piano. She had a short revival in 1957, when she conducted *The Rose and the Ring* in Los Angeles. She died in Los Angeles of a stroke at eighty-three.

> *In 1926 Leginska founded the Boston Philharmonic Orchestra, which she conducted until 1927.*

TO FIND OUT MORE . . .

- Read, Phyllis J., and Bernard L. Witleib. *The Book of Women's Firsts.* New York: Random House, 1992.
- Sicherman, Barbara, and Carol Hurd Green, eds. *Notable American Women: The Modern Period. A Biographical Dictionary.* Cambridge, MA: The Belknap Press of Harvard University Press, 1980.

Lillian Leitzel, 1892–1931

Aerial gymnast Lillian Leitzel entertained and amazed audiences in her performances with the Ringling Brothers-Barnum & Bailey Circus. The tiny acrobat performed on high ropes and rings, setting her fluid whirls and twists to selections of classical music. Her career came abruptly to a halt when an equipment failure pitched her twenty-nine feet to the ground. She died of her injuries.

Leitzel was born into a family of Bohemian circus performers in Breslau, Germany. Her given name was Leopoldina Alitza Pelikan, but her nickname, Litzl, eventually became her stage name. Her mother aspired to great things for her, and supplemented her traditional acrobatic training with formal training in piano, dancing, and four languages. Leitzel was drawn to her heritage, and at sixteen she followed her mother's troupe, the Leamy Ladies, to the United States.

At 4'9" and weighing just ninety-five pounds, Leitzel was perfectly built for her airy acrobatics. Her petite grace belied the enormous upper-body strength required by

her routine, and she captivated her audiences. By 1915 she was a featured soloist with Ringling Brothers' circus in Chicago. She also performed for Barnum and Bailey, and when the two merged, she was a featured attraction of the so-called Greatest Show on Earth.

Leitzel always performed in the coveted center ring of the circus, with much pomp and circumstance. The band greeted her appearance with drums and cymbals, and started into its classical routine when she nimbly ascended a rope to the top of the tent. A routine on rings was performed to the "William Tell Overture." "Flight of the Bumblebee," appropriately, accompanied her grand finale, in which, holding a single dangling rope with one hand, she whirled her entire body in a circle 100 times as the audience counted her revolutions aloud.

Most of Leitzel's life was spent happily immersed in the circus. Both husbands were circus workers: She married Ringling executive Clyde Ingalls in 1920, and after their divorce, married trapeze artist Alfredo Codona in 1928. Less than three years later,

she was performing on the rings in a show in Copenhagen, Denmark when a swivel on one of her rings broke. She plummeted to the ground, sustaining fatal injuries. She died two days later. Her ashes were buried in Inglewood, California.

TO FIND OUT MORE . . .

- Bradna, Fred. *The Big Top: My Forty Years in the Greatest Show on Earth, as Told to Hartzell Spence.* New York: Simon and Schuster, 1952.

- James, Edward T., ed. *Notable American Women 1607-1950: A Biographical Dictionary.* Cambridge, MA: The Belknap Press of Harvard University Press, 1971.

- Taylor, Robert Lewis. *Center Ring.* Garden City, NY: Doubleday, 1956.

Leitzel's petite grace belied the enormous upper-body strength her routine required.

Evelyn Beatrice Longman, 1874–1954

E velyn Longman was one of the rare breed of sculptors who are actually able to successfully support themselves with their work. Her many commissions for monuments, memorials, public buildings, and exposition and fair pieces made her an incredibly prolific artist. Her style was perfect for the public-spirited works then in demand, and her allegorical figures (like "Patriotism" and "Victory") were typical of the period.

Longman was born in a log cabin on a farm near Winchester, Ohio. She was one of six children of a father who was a better musician than a farmer. When Evelyn decided as a young girl that she wanted to study art, she knew she would have to do it with little help from her family. In Chicago she supported herself by working for a wholesaler from age fourteen to twenty while taking art classes at night at the Chicago Art Institute.

When Longman had saved up enough money to devote all her time to sculpture, she studied at the Art Institute, graduating with top honors. Her talent won her positions teaching and working under noted sculptors such as Isodore Konti, Herman MacNeil, and Lorado Taft (who was a mentor of "white rabbits" **Janet Scudder** and **Bessie Vonnoh**).

Some of Longman's work with Konti and MacNeil for the 1901 Pan-American Exposition caught the eye of Daniel Chester French, the sculptor of the central seated Lincoln at the Lincoln Memorial in Washington, D.C. As French's only woman assistant, Longman was at last able to work on her own sculpture. One of these, her 1903 *Victory*, was her first big success. It was installed on top of the Festival hall in St Louis for the 1904 Louisiana Purchase Exposition. It won the exposition's silver medal, and a replica now resides in the Metropolitan Museum of Art.

Victory was one of Longman's conven-

tional allegorical figures, with an important twist: Victory, usually a female figure, was in her incarnation male. A dozen years later, she created another male deity in *Genius of Electricity* (1916), an enormous (twenty-four-foot) gilded bronze figure that took her two years to complete. The figure looks something like a winged *David*, with muscles flexed. He holds stylized lightning bolts triumphantly over his head, and his body is draped with electric cable, the bare, frayed end of which is gripped in his other hand. *Genius of Electricity* was a New York landmark for several decades on top of the old American Telephone and Telegraph Building on Broadway.

> *A replica of Longman's 1903 sculpture* Victory *now resides in the Metropolitan Museum of Art.*

Longman went on to compete for and win several important commissions, including two for pairs of imposing bronze doors at Wellesley College and at the United States Naval Academy at Annapolis. For the latter, she beat out several better-known male artists in an anonymous contest. She was the only sculptor to have Thomas Edison sit for her, and she was the first woman sculptor to be elected a full member of the National Academy of Design.

In 1920 Longman married Nathaniel Horton Batchelder and moved with him to Windsor, Connecticut, where he was the headmaster of the Loomis School. She continued to sculpt after her marriage, and many of her later patriotic memorials and reliefs reside in Connecticut. Longman died on Cape Cod at the age of eighty.

TO FIND OUT MORE . . .

- Obituary. *The New York Times.* March 11, 1954.

- Proske, Beatrice Gilman. *Brookgreen Gardens Sculpture.* Rev. ed. Brookgreen Gardens, S.C.: 1968.

- Rubenstein, Charlotte Streifer. *American Women Artists: From Early Indian Times to the Present.* New York: Avon, 1982.

Marian Griswold Nevins MacDowell, 1857–1956

Pianist Marian Nevins MacDowell abandoned her own career as a performer at age twenty-six when she married composer Alexander MacDowell. After his death, the childless, fiftysomething MacDowell founded the MacDowell Colony in Petersborough, New Hampshire, in her husband's name, and proceeded to run and promote it for nearly fifty years. The MacDowell Colony continues to serve as a haven for artists and writers, and memorializes both the man for whom it was named and the woman who made it a reality.

Marian Nevins was the descendant of old Connecticut families, dating (on her mother's side) back to 1636. Marian was born in New York City and raised in Waterford, Connecticut on her family's farm. Her mother, Cornelia Perkins Nevins, died when Marian was in her eighth year, and Marian took over the self-effacing role of caring for her younger sisters. She began to study the piano at ten, and at twenty-two traveled to

Germany, originally to complete her training as a concert pianist with Clara Schumann. Instead, she studied with and married Alexander MacDowell.

She immediately assumed a supporting role in his career, including providing financial support by means of her inheritance from 1884 until 1888. She kept house and acted as his secretary and educated critic. Her unflagging support came at personal cost; after an 1886 miscarriage, she found that she was unable to have children, and began to suffer from a series of chronic illnesses, perhaps aggravated by her grief and frustration.

Whatever her personal hardships, she was her husband's most faithful supporter. She backed him through eight shaky years in Boston, where he taught piano and gave recitals, and another eight years at Columbia, where he was the university's first professor of music. In 1904, suffering the early effects of the syphilis that would kill him

within four years, Edward Macdowell resigned in a flurry of publicity over his power struggle with the Columbia authorities. A fund drive to support the weakened composer was not complete when he died in 1908.

Marian Macdowell used the $30,000 the drive had raised to establish the Edward MacDowell Memorial Association, with the intention of creating a colony at the New Hampshire estate where he had worked in the summers. Macdowell threw herself into the work, and had begun funding MacDowell Fellows in New Hampshire the year before her husband's death. Sculptor Helen Farnsworth Mears, who did a portrait bust of Edward MacDowell shortly before his death, was one of the first recipients of the Foundation's aid.

The MacDowell Colony continues to serve as a haven for artists and writers, and memorializes both the man for whom it was named and the woman who made it a reality.

Through hard work and constant promotion, MacDowell built the colony into a cornerstone of American creativity. Artists, writers, and composers were housed for a nominal fee, unless they were flat broke. In those cases, the Foundation paid their room and board. Meanwhile, MacDowell raised money to buy more land and build working, eating, recreational, and living quarters, and a library. The Colony currently occupies over seven hundred acres.

Although she continued to promote the Colony vigorously well into her eighties, she needed help in her later years. She came to rely increasingly on Nina Maud Richardson, her assistant and, later, biographer, for advice and companionship. She spent most of her nineties at Richardson's home in Los Angeles, where she died at the age of ninety-eight. She was buried next to her husband near the MacDowell Colony.

TO FIND OUT MORE . . .

- Brown, Rollo Walter. "Mrs MacDowell and Her Colony," *Atlantic Monthly*, Vol. #184 (1949): pp. 42–46.

- Rubenstein, Charlotte Streifer. *American Women Artists: From Early Indian Times to the Present.* New York: Avon, 1982.

- Sicherman, Barbara, and Carol Hurd Green, eds. *Notable American Women: The Modern Period. A Biographical Dictionary.* Cambridge, MA: The Belknap Press of Harvard University Press, 1980.

- MacDowell's papers are in the Schlesinger Library at Radcliffe College.

Jenne Magafan, 1916–1952

Jenne Magafan and her twin sister Ethel pursued parallel careers in painting in the Midwest in the thirties and forties. They shared their successes and helped each other through hard times. They gave many exhibitions as a pair. Interestingly enough, there seem to have been no conflicts over who was the *better* painter; their work was received with equal enthusiasm and honors, and they worked together on at least one large-scale project.

The twins' father, Petros Magafan, emigrated to the United States in 1912. He felt at home in the Colorado mountains, which he said reminded him of "the Old Country," and chose to settle with his young family in Colorado Springs. Jenne and Ethel Magafan were born in Chicago, Illinois. Growing up among the mountains, they gained an abiding love of the Western landscape, which appears again and again in their work.

Grammar school teachers encouraged the twins' artistic aspirations, and their hopes for opportunity were fulfilled when Jenne won a competition for the Carter Memorial Art Scholarship. Jenne shared the prize money—a generous ninety dollars—with Ethel, and both used it for classes at the Colorado Springs Fine Arts Center. It only covered two months for the two of them, and it seemed as if they would have to give up their study until an instructor at the Fine Arts Center, Frank Mechau, hired both as assistants on his large-scale mural projects.

In fact, all of their instructors were impressed with the Magafans' painting. Peppino Mangravite later called Ethel out to Atlantic City, New Jersey to help him on another mural project. The training given the twins by Mangravite, Mechau, and Boardman Robinson gave them a strong technical background. Soon they were entering competitions for projects commissioned by the Treasury Department Section of Fine Arts. Ethel won commissions for *Wheat Threshing* (1937) in Auburn, Nebraska, and *The Lawrence Massacre* (1937) in Fort Scott, Kansas. Her sketches for *The Lawrence Massacre*, however, were firmly returned by a bureaucrat in the Treasury Department, who informed her that, while the composi-

tion of the planned painting was exceptional, the memory of racial conflict in Kansas was still too raw to allow for such a distressing scene to be painted on the Fort Scott post office.

Not long after that, Jenne won a commission for a post office mural in Helper, Utah. The inhabitants of her stylized *Western Town* (1939–1944) are mostly tough-looking men and horses. Underneath the sign for the BLACKSMITH stands a man with a burly chest, one hand resting on a finished wagon wheel. A woman enters the building prominently marked both GROCERIES and POST OFFICE. In the distance, the SALOON can be seen. Magafan seems to be poking gentle fun at these conventions; her scene also includes two gaunt-faced men in wide-brimmed hats riding into town in a cloud of dust. She signed her painting on a scrap of paper that lies, discarded, in her town's street.

On a joint trip to Los Angeles, the Magafans met Doris Lee and Arnold Blanch. Their descriptions of Woodstock, the New York artists' haven, prompted Jenne and Ethel to load up their station wagon and drive east in 1945. At Woodstock they both met and married artists: Ethel married

> *Jenne was considered more "sensitive," while Ethel, with her love of horses, was called "rugged."*

Bruce Currie and Jenne married Edward Chavez. Their work began to develop separately at Woodstock, and critics commented on stylistic distinctions between the two. Jenne was considered more "sensitive," while Ethel, with her love of horses, was called "rugged."

Still, they were equally recognized. Both won Fullbright fellowships and Tiffany Foundation awards when they were about thirty-five years old. Jenne used her Fullbright to go to Italy, while Ethel roamed Greece. Both returned in 1952. Only a few days after the twins had been reunited in the United States, Jenne suffered a cerebral hemorrhage and died at the age of thirty-six.

Despite Ethel's grief at her loss—"a tragedy from which I have never fully recovered," she once called it—her career continued with regular success. Her murals, which she went on painting into her late sixties, won her many prizes.

TO FIND OUT MORE . . .

- Rubenstein, Charlotte Streifer. *American Women Artists: From Early Indian Times to the Present.* New York: Avon, 1982.

- Watson, Ernest W. "*Magafan and Mountains.*" *American Artist.* (December 1957): 57–64.

Maria Montoya Martinez, 1891–1980

I n an attempt to reconstruct the ancient wares of her Pajarito ancestors, Maria Martinez developed an entirely new and sleekly beautiful technique in pottery. Her creations, which have designs in shiny black on a smooth matte black surface, made her the best-known representative—of either sex—of North American Indian art in the twentieth century.

Maria Martinez's home was the San Ildefonso Pueblo in New Mexico's Rio Grande Valley. She learned to throw pots there by watching her aunt, Tia Nicolasa. When she was sixteen, an anthropologist excavating the nearby Pajarito plateau, Edgar Hewitt, showed her some pottery shards. The original pot was hopelessly shattered, but Hewitt asked her to try to reconstruct it as it might have been.

The shards' dark charcoal color intrigued the young artist, and with the help of her husband, Julian Martinez, she set about duplicating their design. The "green,"

or unfired, pots were rubbed to a glossy sheen with a smooth stone. The pots were fired, or baked, at very high temperatures, with lots of manure to produce dense smoke. The carbon from the manure colored the pots deep black.

The Martinezes moved to Santa Fe, where Julian took a job as a janitor at the Museum of New Mexico in order to be able to study the ceramic collection there. With the support of Hewitt and another archaeologist, Kenneth Chapman, they further refined the technique. Maria threw the pots in classic, rounded forms, polishing them to their trademark gloss, and Julian painted designs in a rich matte black on the pots. After firing, the painted designs showed up as flat black on the shiny black pots, creating an elegant effect that still remained faithful to the technique's native roots.

Martinez toured occasionally to demonstrate the much-admired technique, representing her art at World's Fairs from 1904

THE REMARKABLE LIVES OF

onwards. She was invited to lay the corner-stone of New York City's Rockefeller Center in 1904. But her heart was in her pueblo at San Ildefonso, and she spent most of her long life there, passing on her knowledge of pottery and giving demonstrations for curious outsiders. Her great-granddaughter, Barbara Gonzales, and her daughter-in-law, Santana, carry on her work today in San Ildefonso. Martinez died at her home in 1980. Examples of her work can be found at the National Museum of the American Indian in New York City.

> *Martinez' creations made her the best-known representative—of either sex—of North American Indian art in the twentieth century.*

TO FIND OUT MORE . . .

- Marriott, Alice Lee. *Maria, the Potter of San Ildefonso.* Norman, OK: University of Oklahoma Press, 1948.

- Munsterberg, Hugo. *A History of Women Artists.* New York: Clarkson N. Potter, 1975.

- Rubenstein, Charlotte Streifer. *American Women Artists: From Early Indian Times to the Present.* New York: Avon, 1982.

- Spivey, Richard L. *Maria.* Flagstaff, AZ: Northland Pub., 1979.

Alice Trumbull Mason, 1904-1971

The abstract painter Alice Mason was a meticulous craftswoman who ground and mixed her own oil paints and carefully diagrammed her constructions of pure blocks of color. Her personal life, however, was more difficult for her to master. Her husband, a ship's captain, was away from home for long periods of time. Mason raised their two children alone and struggled for artistic recognition. It would not come in her lifetime. When her son died in an accident at sea, she withdrew into increasing isolation until her death.

Alice Trumbull's family on both sides was well established and wealthy. A paternal ancestor was the great painter of the American Revolution, John Trumbull. The family was financially comfortable, and Alice's father did not need to work; instead, the family took extensive trips to Europe.

When she was seventeen, Alice studied art at the British Academy in Rome. At twenty she settled in New York to study at the National Academy and, for a short while, at the Grand Central Art Galleries. It was at the Art Galleries that she first started experimenting with abstract painting, under the influence of her teacher, Arshile Gorky. She painted the first of her "architectural abstractions," as she called them, on her return from a 1928 trip to Italy and Greece.

In 1928 Trumbull married Warwood Mason. She suspended her painting for the next five years, occupied with her two small children. To express herself, she turned to poetry until she was able to go back to her art in 1935. The next year she was one of the founding members of the American Abstract Artists, and later served terms as its president, treasurer, and secretary. Her dedicated work for the AAA was part of a groundbreaking effort, for abstraction was generally viewed with skepticism or hostility in the mid-1930s.

A shift in attitudes toward abstraction in the early 1940s helped Mason to her first

solo show in 1942 at NYU's Museum of Living Art. Other shows followed, but wide recognition proved elusive for Mason. She pressed on, producing beautifully balanced compositions like *L'Hasard* ("Chance," 1948), using small, overlapping squared-off blocks of color.

Mason's work gradually became starker and sparer in the fifties and sixties. She pared down the number of forms, muted her color palette and used larger blocks of color, achieving the same sense of balance and harmony as she had with many small forms. Her paintings are carefully laid out to keep their harmony no matter which side of the frame points up.

> *Her beautifully balanced composition* L'Hasard *("Chance") used small, overlapping squared-off blocks of color.*

When her son drowned in 1958, Mason sank into grief but did not stop painting. It is interesting to note that her *Memorial* (1958–1959), which was painted for her son, is as tightly composed as any of her paintings. Dominated by three large rectangular shapes and paints the colors of a bruise, it is somber but controlled.

Mason's last years were lived in increasing solitude as she withdrew emotionally from the world around her. After her death in 1971, the Whitney Museum gave a major retrospective of her work, and new interest in Mason has followed. Exhibits of American Abstract Artists routinely include her work. Mason's surviving child, Emily Mason Kahn, became an artist.

TO FIND OUT MORE . . .

- Harris, Ann Sutherland, and Linda Nochlin. *Women Artists: 1550–1950.* New York: Alfred A. Knopf, 1976.
- Mason, Alice Trumbull. *Alice Trumbull Mason: Etchings and Woodcuts.* Introduction by Una E. Johnson. New York: Taplinger Pub. Co., 1985.
- Rubenstein, Charlotte Streifer. *American Women Artists: From Early Indian Times to the Present.* New York: Avon, 1982.

Neysa McMein, 1888–1949

Illustrator and New York socialite Neysa McMein became a tastemaker in popular American art with her illustrations for the covers of magazines like *McCall's, The Saturday Evening Post, Collier's,* and *The Woman's Home Companion* in the 1920s and 1930s. Although many famous subjects (including Charlie Chaplin, Edna St. Vincent Millay, and two presidents) sat for her portraits, she never gained the reputation as a serious artist that she coveted in later years.

Neysa McMein was christened Margary Edna by her middle-class, educated parents in Quince, Illinois. She later changed it when a numerologist (whose name, Asa Neith, sounds suspiciously similar) suggested that "Neysa" might bring her more luck. She was an artistically talented young woman who could draw and play the piano with equal skill, and after high school she entered the Chicago Institute of Art.

At twenty-five she moved to New York with an actress friend, determined somehow to find fame. She quickly discovered that her breakthrough wouldn't come on the stage. Taking the name suggested by the numerologist, she enrolled in classes at the Art Students League and soon began selling sketches to magazines.

By around 1917, her services as a cover artist were in demand. For fourteen years, starting in 1923, McMein designed all the covers for *McCall's Magazine.* That contract provided her with the then-princely sum of $25,000 a year, and over her time with *McCall's* it increased to $30,000 annually. Her marriage in 1923 to mining engineer John Baragwanath never interfered with her seemingly effortless popular success, even when they had a daughter in 1924.

Meanwhile, she moved easily in the most exclusive social circles. In the 1920s she became a member of a group of friends and intellectuals known as "The Vicious Circle," who congregated at the Algonquin Hotel and at Neysa's apartment to drink her bathtub gin. Her own glamorous sense of style set a trend in her illustrations, her lithe, stylish female figures replacing the cutsey "baby doll" figures of women that had previously been popular.

After color photographs began to

phase out the pastel illustrations that were her specialty on magazine covers, McMein devoted her efforts to oil portraiture. The success that had come so easily to her as an illustrator eluded her as a serious artist. Nevertheless, she attracted a long series of famous and fascinating subjects, including Anne Lindbergh, Presidents Hoover and Harding, Dorothy Parker, and Charlie Chaplin.

Neysa McMein died in New York at the age of sixty-one.

> *She attracted a long series of famous and fascinating subjects, including Anne Lindbergh, Presidents Hoover and Harding, Dorothy Parker, and Charlie Chaplin.*

TO FIND OUT MORE . . .:

- Gallagher, Brian. *Anything Goes: The Jazz Age Adventures of Neysa McMein and Her Extravagant Circle of Friends.* New York: Times Books, 1987.

- James, Edward T., ed. *Notable American Women 1607–1950: A Biographical Dictionary.* Cambridge, MA: The Belknap Press of Harvard University Press, 1971.

- Obituary. *The New York Times,* May 13, 1949.

Lisette Model, 1901–1983

Photographer Lisette Model is now considered a member of "the New York school," a group of photographers who worked in New York City between the 1930s and 1960s. Included in this group are Richard Avedon, Ted Croner, and Model's student, **Diane Arbus**. Model's work can rely on the impact of its image alone, but she was also interested in manipulating her photographic images, and predicted that future photographers would be able to use new tools to do so.

She could manipulate her own image, too. The birth date she gave for herself was 1907, making her six years younger than Viennese records show her to be. According to these records, she was born in 1901, the second of three children in a comfortable Viennese family. As a young woman she aspired to be a musician. Serious piano training began at age seventeen, and at twenty-five she moved to Paris to take voice lessons.

In Paris she was married in 1932 to abstract painter Evsa Model. She continued to train and to move in artistic circles, but after seven years in Paris she abruptly decided to drop music for art. Painting led her eventually to photography, where her sharp eye helped her chronicle the excesses of Paris: Both the comfort of the leisure class and the hopelessness of the street people were her early subjects.

In 1938 the couple fled the threat of World War II and moved permanently to New York City. Model's family was not quite so lucky; her mother died in 1944, and her older brother was sent to a concentration camp, where Model learned in 1948 that he had died. Meanwhile, Model was achieving considerable artistic if not financial success with her work. She produced some of her most unforgettable images during her first twelve years in the city.

In 1941 the Museum of Modern Art bought some of her photographs, and she began her longstanding relationship with *Harper's Bazaar.* Although she worked for the magazine until 1955, the relationship worked best from 1941 to 1946, when the magazine took aggressive risks that suited Model's experimental style. She photographed middlebrow entertainments like the

circus, Coney Island, and nightclubs, and sometimes reexplored her Paris subject, the poor and disadvantaged.

Model had a huge range of expression. An early series of the 1940s, "Running Legs," pictures hurrying pedestrians below the waist, capturing New York's anonymous, anxious bustle. From the same period, a man in a nightclub is shown in closeup, head resting on a tilting table next to his unfinished drink. A 1959 photograph of **Billie Holiday** in her coffin makes the singer's face appear to float peacefully among flowers and white material.

Model was increasingly recognized in exhibits. Early exhibits with gritty photojournalist Weegee (who used a police radio to get to gory crime scenes, sometimes before the police did) gave way to solo exhibits in San Francisco and Chicago and inclusion in the Modern Museum of Art's traveling exhibit, *Leading Photographers*.

After 1950, Model's photographic output diminished as her teaching load grew. She continued to exhibit in New York and to work as a photographer until her death at eighty-two. Model was honored near the end of her life with a monograph of her work in 1979, and after her death by a one-woman exhibition at the National Gallery of Canada in 1990.

> *A 1959 photograph of Billie Holiday in her coffin makes the singer's face appear to float peacefully among flowers and white material.*

TO FIND OUT MORE . . .

- Abbott, Berenice. Introduction: *Lisette Model.* Millerton, NY: Aperture, 1979.

- Livingston, Jane. *The New York School: Photographs 1936–1963.* New York: Stewart, Tabori & Chang, 1992.

- Model, Lisette. *Model Photographs.* Washington, D.C.: Sander Gallery, 1976.

- Thomas, Ann. *Lisette Model.* Ottawa: National Gallery of Canada, 1990.

- Walsh, George et. al., eds. *Contemporary Photographers.* New York: St. Martin's Press, 1982.

Julia Morgan, 1872–1957

Julia Morgan's remarkable career blew open the doors that had been shut against women in architecture. She won a commission from William Randolph Hearst to build a fantastic castle at San Simeon, on the California coast. The enormous project, for which she became justly famous, incorporated imported pieces from ancient architecture that Hearst bought abroad. It occupied her for nearly a third of her career. Her other work, including surprisingly graceful institutional buildings in reinforced concrete, confirm her position as one of America's innovators of style in architecture.

Julia Morgan was born and mostly raised in San Francisco. Her father was a mining engineer, her mother a child of an old and well-off Virginia family. The family lived comfortably, despite Charles Morgan's occasional schemes to multiply the family finances. Julia, nicknamed "Dudu" by a sibling, was often sick; as an adult she was no more than five feet tall. She was apparently resolved, however, to overcome any obstacles; she weathered a series of childhood ill-nesses and ignored protective rules barring her from athletic activity with the same determination. She brought that same single-mindedness to her studies, at which she excelled. She decided on architecture, and went to the University of California at Berkeley to study it.

She became the first woman student to enroll at Berkeley's College of Engineering. On her graduation in 1894, she worked drafting assignments for her Berkeley mentor, Bernard Maybeck. She also studied for the entrance exam at the École Des Beaux-Arts in Paris. She became, in 1898, the École's Architectural Section's first woman student; in 1902, she was its first woman graduate. She returned to California, where she became the state's first female holder of an architectural license.

In 1904, after working with John Galen Howard on some University of California buildings, Morgan opened her own office. Phoebe Apperson Hearst, who footed the bill for the University buildings, favored Morgan's work and gladly steered commissions in the talented young architect's direc-

tion. Morgan designed redwood shingle houses that set a style for Bay Area architecture. She made a name for herself with her redesign of the landmark Fairmont Hotel, burned and ruined by the great earthquake-fire of 1906. After that, she was in great demand; her work, often in Spanish Revival style, proliferated in the Bay Area. The Berkley campus is graced by many of her creations, including St. John's Presbyterian Church, made easy with shingles and its rambling design.

> *Morgan designed William Randolph Hearst's legendary castle at San Simeon.*

She began work on William Randolph Hearst's San Simeon castle in 1919. She hired a plane to shuttle her back and forth between her home base in San Francisco and San Simeon, positioned midway between San Francisco and Los Angeles on the California coast. The castle is now open to the public. There are many swimming pools on the grounds, including one stunningly ostentatious pool tiled in lapis lazuli. Morgan worked on the project for over twenty years, meanwhile maintaining her San Francisco practice with the help of a growing staff.

Julia Morgan was a favorite of Hearst's. She would design offices for his publishing empire and houses all over the country; at his request she even executed a zoo, theaters, billiard rooms, and a bowling alley. But Morgan was also an innovator in functional structures, handling inexpensive materials for institutional buildings with grace and originality. When World War II made even inexpensive materials inaccessible, Morgan first scaled back her practice and then—at seventy-four—retired. She spent eleven years traveling before her death in 1957.

TO FIND OUT MORE . . .

- Boutelle, Sara Holmes. *Julia Morgan, Architect.* New York: Abbeville Press Publishers, 1988.

- James, E.T. and J.W., eds. *Notable American Women, 1607–1950: A Biographical Dictionary.* Vol. 1. Cambridge, MA: Belknap Press, 1971.

- Richey, Elinor. *Eminent Women of the West.* Berkeley, CA: Howell-North Books, 1975.

Nampeyo (The Old Lady), 1856–1942

Nampeyo (also known simply as "The Old Lady") was already considered her village's best potter when her work came to the attention of archaeologists working a few miles from her home in Arizona. Influenced by ancient fragments of pots, Nampeyo created graceful, wide forms with delicately painted designs of perfectly straight lines and sweeping, fluid curves. She left a great tradition of art that continues today with her great-great-grandson, the painter Dan Namingha.

Nampeyo was thirty-nine when her husband, Lesou, began to work for Dr. Fewkes, an archaeologist. Fewkes was leading an excavation of an ancient village, Sikyatki, three miles from Lesou and Nampeyo's home. Lesou brought home some of the pieces of pots uncovered at Sikyatki for his wife to examine. She was so intrigued that she

> *Nampeyo created graceful, wide forms with delicately painted designs of perfectly straight lines and sweeping, fluid curves.*

brought her pencil and pad to the site to sketch the intricate old designs.

She worked them into her own pottery, throwing low, curved forms that narrowed smoothly from a wide middle to a curved lip. On these simple terracotta pots, Nampeyo painted brick-red and black designs, sometimes abstract, sometimes austerely representational, working flowers or birds into the pattern. Many mix perfectly regular straight lines and grids with rounded curves that echo the lines of the form itself.

Nampeyo's artistic legacy lives on as much in her children as in her works. Three daughters, four granddaughters, and two great-granddaughters all became well-regarded potters in style Nampeyo originated. The passing down of technique was seamless in Nampeyo's later years, when she lost her eyesight. Working by feel, she threw

pots that her daughter Fannie later painted.

When Nampeyo died at age eighty-six, she left an art that continues to be passed on in the Southwest.

TO FIND OUT MORE . . .

- Collins, John E. *Nampeyo, Hopi Potter: Her Artistry and Her Legacy.* Fullerton, CA: Muckenthaler Cultural Center, 1974.

- Rubenstein, Charlotte Streifer. *American Women Artists: From Early Indian Times to the Present.* New York: Avon, 1982.

Alice Neel, 1900–1984

Alice Neel painted portraits of startling honesty. Critics and subjects alike were made uneasy by her paintings, which often depicted her subjects in the nude. She shocked people with full frontal images of nude men, invalids, and pregnant women that gaze penetratingly at the viewer.

Neel's childhood in genteel Colwyn, Pennsylvania, was stifling to her. Her mother was from a very old family, and felt trapped in her marriage to an Irish railroad clerk. Neel herself was an easily disturbed child who wept frantically in church when she learned about the Crucifixion. To escape, Neel pretended that she wanted to study commercial illustration. Considering that a reasonable ambition, her parents allowed her to enroll at the Philadelphia School of Design for Women (now the Moore College of Art). In her four years there, she learned the tools of her art.

After her graduation in 1925, Neel married a fellow art student and returned with him to his native Havana, Cuba, where she had a baby girl and her first solo exhibit.

They returned in 1927 to New York, where a series of personal tragedies rocked Neel. The couple had a hard time earning a living in New York, and their daughter died of diphtheria. Neel's husband took their second child back to Cuba and disappeared from her life. Neel attempted suicide and was repeatedly hospitalized in Philadelphia, where she came to understand that her painting was, for her, a means of survival.

By 1932 she was reestablished in Greenwich Village with her first New York exhibitions. She began painting her forthright portraits. Of these, her 1933 painting of the New York poet Joe Gould is notable for its raw quality. She painted him pitifully bald, leering at the observer with his spread legs showing off three sets of genitals. After a disastrous affair in the Village with a drug-addicted sailor who attacked her paintings with a knife, she moved to Spanish Harlem in 1938, where she lived until 1963. *T.B., Harlem* (1940), a martyrlike image of a tuberculosis victim, is one of the works inspired by her travels in Harlem.

It wasn't until she left Spanish Harlem

that her paintings began to attract attention. Her images of anonymous neighbors, family members, and mother-child pairs sparked the interest of critics. Her feminist wit interested the public when the women's movement gained momentum in the 1970s. In *Margaret Evans Pregnant*, the sitter, outlined sharply in blue, presents her glowing belly to the viewer with a mysterious Mona Lisa smile. Neel also painted a series of portraits of famous artists, including one of Andy Wharhol recovering from an assassination attempt. Before her death in 1984, ahe was elected to the National Institute of Arts and Letters.

> **T.B., Harlem (1940), a martyrlike image of a tuberculosis victim, was inspired by Neel's travels in Harlem.**

TO FIND OUT MORE . . .

- Harris, Ann Sutherland, and Nochlin, Linda. *Women Artists: 1550–1950.* New York: Alfred A. Knopf, 1976.

- Heller, Nancy G. *Women Artists: An Illustrated History.* New York: Abbeville Press, 1987.

- Hills, Patricia. *Alice Neel.* New York: H.N. Abrams, 1983.

- Rubenstein, Charlotte Streifer. *American Women Artists: From Early Indian Times to the Present.* New York: Avon, 1982.

Louise Nevelson, 1899–1988

The sculptor Louise Nevelson cut a dramatic figure in the New York art world over the last three decades of her life. Like any star, she was instantly recognizable. She draped her long, thin frame with odd, haphazardly selected clothes, habitually wore incredibly long false eyelashes and thick black eyeliner, and often indulged her habit of smoking small cigars. According to one legend, when a museum director apologized for arriving ten minutes late for a meeting with her, she grandly told him, "You are ten years late." Her work is just as recognizable: wood "assemblages" of found objects, crates, and parts of furniture grouped in boxes and doused with gallons of flat black, white or sometimes gold paint.

Louise Berliawsky had a difficult but loving childhood. Born in Kiev, Russia, the five-year-old Louise and her mother and siblings followed her father to Rockland, Maine, three years after he had established a successful lumberyard there. Turn-of-the-century Maine was not exactly welcoming: "Rockland was a WASP Yankee town," she later wrote in her memoirs; "think of 1905

when you have a name like BER-LI-AWSKY and you come to Maine."

Louise Berliawsky escaped to New York when she married Charles Nevelson in 1920, but she soon found that she was caught in another WASP hell—her husband's stuffy family. "Within their circle, you could know Beethoven, but God forbid if you *were* Beethoven," Nevelson later quipped. The couple had a son, Mike, in 1922. When he was nine, Nevelson made the break to study in Munich, leaving Mike with her parents and separating permanently from Charles.

In Germany, Nevelson studied with Hans Hoffman until the Nazi regime shut him down in 1931. She studied in Paris before returning, racked with guilt, to raise Mike and begin sculpting. The thirties were lonely years for her; her art would not be widely recognized until the 1960s. "For forty years, I wanted to jump out of windows," Nevelson has said of this time. In 1941, she had her first one-woman show at the Nierendorf Gallery in New York.

In 1957 Nevelson had an artistic breakthrough when she began to place her as-

semblages in boxes. Inspired, she made more and more boxed pieces, stacking them against a wall when she ran out of floor space. When she stopped to look at the wall, she realized that the accumulation of monochrome objects gave each ordinary component a new, mysterious role. In her all-black *Sky Cathedral* (1958), a narrow, curved object in one of the central boxes is revealed on closer inspection to be a juggler's pin—maybe. Or maybe a thick chair leg, or a skinny bowling pin.

> *". . . you could know Beethoven, but God forbid if you were Beethoven."*

Most of her large assemblages are painted black, which to Nevelson symbolizes harmony. Her 1959 show *Dawn's Wedding Feast*, however, was all white, and a 1966 group, *Royal Tides*, was all gold. Nevelson finally got the critical acclaim her work deserved in 1959, when she was one of the "Sixteen Americans" in an important Museum of Modern Art exhibition. In the mid-sixties, she brought her intuitive method of assembling found objects to welded-steel sculpture. Using cast-off factory scraps, she directed a team of workers to assemble her black-painted sculptures. Some of these, like *Atmosphere and Environment X* (1969, at Princeton University), directly echo her walls of boxes by placing curved forms in and across boxy vertical and horizontal ones.

Nevelson lived out her eighty-nine remarkably productive years with great drama and determination. Her later years were sweetened by professional success and the pleasure of watching her family grow. Her son Mike, who became a sculptor, today has grandchildren. In her 1976 autobiography, *Dawns and Dusks*, Nevelson wrote, "I knew I was going to be what I was today. . . . I take the whole credit for moving myself."

TO FIND OUT MORE . . .

- Fine, Elsa Honig. *Women & Art: A History of Women Painters & Sculptors from the Renaissance to the 20th Century.* Montclair, NJ: Allanheld, Osmun & Co. Publishers, Inc. and Abner Schram Ltd., 1978.

- Heller, Nancy G. *Women Artists: An Illustrated History.* New York: Abbeville Press, 1987.

- Munro, Eleanor. *Originals: American Women Artists.* New York: Simon & Schuster, 1979.

- Munsterberg, Hugo. *A History of Women Artists.* New York: Clarkson N. Potter, 1975.

- Nevelson, Louise. *Dawns and Dusks.* New York: Charles Scribner's Sons, 1976.

- Rubenstein, Charlotte Streifer. *American Women Artists: From Early Indian Times to the Present.* New York: Avon, 1982.

Camille Nickerson, 1888–1982

. .

Camille Nickerson dedicated the whole of her ninety-six years to Creole music. She served in almost every possible capacity: as a composer, as a conductor, and as a performer. Most notably, she worked to preserve the music of her Louisiana home through teaching and transcribing during her thirty-six years on the faculty at Howard University.

Nickerson grew up in a home in the French Quarter of New Orleans that was dominated by music. Her mother, Julia Ellen Nickerson, was a music teacher, a violinist, and a cellist; her father was a bandleader and violinist; and two brothers became performers. At nine, Nickerson played piano in the women's orchestra her father conducted, and in her teens she taught at his studio.

Nickerson's father encouraged and supported her early aptitude, and arranged for her to be sent to Oberlin Conservatory. There she studied piano, organ, composi-

tion, voice, history, and theory, graduating with a bachelor's degree in music and membership in Pi Kappa Lambda, the national music honor society. It was at Oberlin that Nickerson returned to her roots and began to compose Creole songs like "Suzanne, Bel Femme" and "Mam'selle Zi Zi." She quickly became interested in preserving the artless simplicity of Creole music, and made conservation a lifelong goal.

After graduation, Nickerson spent a brief period teaching at her father's school in New Orleans before launching her performing career in Southern cities. With authenticity in mind, she began wearing a Creole costume for stage performances of Creole music, performing under the name "The Louisiana Lady." Although she successfully combined performing and teaching, Nickerson made a decision to leave the stage for an academic career in 1926. After two unsuccessful attempts to hire her, Howard University finally got the answer it

hoped for when she joined the faculty at the age of thirty-eight.

Howard was the right place for her conservation efforts. She saw the survival of Creole music as endangered by general indifference. Like the spiritual, which had gone unrecorded for many years, it was an art form mostly passed down by ear. Nickerson won a Rosenwald Fellowship to transcribe songs from this indigenous form of American music, and completed a master's thesis on the strength of this research.

> *Nickerson's aim was to preserve the artless simplicity of Creole music.*

In her long and illustrious career at Howard, Nickerson gained a reputation as a demanding professor. She never entirely gave up performing, which was another way of preserving Creole music by passing it on to appreciative new listeners. She finally retired from active involvement with the Howard faculty in 1962, taking the title of professor emerita. She maintained her affiliation with the university, and died at its hospital of pneumonia at age ninety-six.

TO FIND OUT MORE . . .

- Anderson, Ruth E. *Contemporary American Composers: A Biographical Dictionary.* Boston: G.K. Hall, 1976.

- Smith, Jessie Carey, ed. *Notable Black American Women.* Detroit, MI: Gale Research Inc., 1992.

- Southern, Eileen. *Biographical Dictionry of Afro-American and African Musicians.* Westport, CT: Greenwood Press, 1982.

Elizabeth Olds, 1896–1991

Elizabeth Olds is best known for her powerful, socially conscious lithographs. Lithography allows the artist to produce an almost unlimited number of prints of any one image, an idea that perfectly fit Olds's democratic vision of art as something for all people to enjoy.

Elizabeth Olds was born in Minneapolis and began to attend the city's School of Art when she was twenty-two. After two years of training there, she won a scholarship to study at the influential Art Students' League in New York. She eagerly made the long trip and stayed in New York for three years, absorbing the influence of Ash Can painters like her teacher, George Luks, who painted gritty, sympathetic scenes of urban life in poor neighborhoods.

Her three years in New York marked the beginning of Olds's decade-long search for her own form of expression. She traveled to Europe in 1925, and the next year became the first woman to win a Guggenheim Fellowship to study painting in Europe. She traveled abroad for four years, observing other artists' innovations, and fi-nally decided that she had to root her work in her American background. She returned to the States in 1929.

Olds found her medium in Depression-era Omaha, Nebraska. Her lithographs of the grisly everyday realities of Omaha's stockyards—the heavy labor, the routine slaughterings—earned her critical acclaim and a silver medal from the Kansas City Art Institute. Her quest complete, she returned to New York in 1935 to work for the Federal Art Project's graphics division.

During this period, Olds focused on mass-producing art to keep it open to the widest possible audience. Most of her works were lithographs, and most displayed a deep political sympathy for the working man. Her 1939 lithograph, *1939 A.D.*, delivered a warning to the complacent fat cat: In it, capitalists are driven from the Stock Exchange by the workers. In her *Scrap Steel* (1935–1939), Olds emphasizes the enormous cast-off shapes that dominate the foreground and dwarf the men toiling to erect a building in the background.

To help make art more accessible, Olds

and a handful of like-minded artists established the FAP's Silk Screen Unit in 1938. She also began to reach out to a small magazine-reading public with her political illustrations for *The New Masses*, a radical magazine. She continued her magazine work into the current decade with illustrations for *The New Republic* and *Fortune* magazines, and also began to write and illustrate children's books. She died in 1991 at the age of ninety-five.

> *Olds's democratic vision of art held that is was something for all people to enjoy.*

TO FIND OUT MORE . . .

- Marling, Karal Ann. *7 American Women: The Depression Decade.* Poughkeepsie, NY: Vassar College Art Gallery and A.I.R. Gallery (NY), 1976.

- Rubenstein, Charlotte Streifer. *American Women Artists: From Early Indian Times to the Present.* New York: Avon, 1982.

- Olds's papers are in the Schlesinger Library at Radcliffe College.

Betty Parsons, 1900–1982

L ike **Gertrude Whitney, Katherine Sophie Dreier**, and **Hilla Rebay**, Betty Parsons is better remembered for her contributions to promoting art than for her works of art. Her self-named gallery was so influential in establishing some of the abstract artists of the 1940s that she has been called the "midwife of the New York School."

Betty Parsons grew up privileged and talented in New York City. She was offered a spot on the U.S. Olympic tennis team, but chose instead to pursue a career in art. She was married and divorced young, but kept her husband's name. The couple obtained their divorce in Paris around 1923, and Parsons stayed on to study sculpture and work for the next ten years.

In Paris, Parsons moved in intellectual circles. She befriended such artistic and literary luminaries as Gertrude Stein, Alexander Calder, and Man Ray, and had her first one-woman show at the age of twenty-seven. Two years later the stock market crash wiped her out, and she was forced to return to the United States in 1933. After three years spent teaching in Santa Barbara, California, Parsons moved back to New York City.

In the late 1930s and early 1940s, Parsons achieved success with her shows of watercolors at the Midtown Gallery. Meanwhile, she learned about the gallery side of the art business by working in Mrs. Cornelius Sullivan's gallery. From 1941 until 1945, she took increasingly responsible gallery jobs, and in 1946 she opened her own gallery.

Shows at the Betty Parsons Gallery were coveted by New York abstractionists. She gave her artists total freedom, letting them design the gallery space for their own exhibitions. Parsons never showed her own work at her gallery, but had regular exhibitions at other galleries into the 1960s. Her own work moved from traditional watercolors in the 1930s to thickly painted abstract works in the forties, fifties, and sixties, and finally returned to sculpture in the 1970s.

Raised an aristocrat, Parsons was the perfect intermediary between her wealthy patrons and her often inaccessible artists.

Her good opinion could mean the difference between success and failure for artists (see **Lee Krasner)**, and she helped many artists—including **Perle Fine**, Jackson Pollock, **Anne Ryan**, Mark Rothko, and **Irene Rice Pereira** become well known.

Late in her career, Parsons moved to a Long Island studio overlooking the sea from a tall cliff. She continued to produce abstract paintings and sculpture late into her seventies, and died in her eighty-second year.

> *Betty Parsons was offered a spot on the U.S. Olympic tennis team, but chose instead to pursue a career in art.*

TO FIND OUT MORE . . .

- Alloway, Lawrence, and Robertson, Bryan. *Paintings, Gouaches, and Sculpture, 1955–1968.* London: Whitechapel Gallery, 1968.

- Hall, Lee. *Betty Parsons: Artist, Dealer, Collector.* New York: H.N. Abrams, 1991.

- Rubenstein, Charlotte Streifer. *American Women Artists: From Early Indian Times to the Present.* New York: Avon, 1982.

Irene Rice Pereira, 1907–1971

. .

Abstract painter Irene Rice Pereira was a dramatic, passionate painter. An observer and friend, John I.H. Baur, once wrote that she painted in "a kind of creative hysteria; she weeps and sings and draws—violently and with both hands." Her art and poetry, however, (she was Poet Laureate of the Philippines) are anything but hysterical. Pereira developed a distinctive, ethereal style. She suggests many planes of harmonic space, using layers of rippled glass and translucent parchment in one distinctive group of works.

Born in Chelsea, Massachusetts, Irene Rice moved several times as a child. Hilda Rice was an amateur artist, and two of her daughters, Irene and her sister Juanita, became painters. When Emmanuel Rice died in 1922, the fifteen-year-old Irene began to take commercial courses instead of academic ones, and soon took a job as a secretary to help support her family.

Despite this hardship, Rice's dreams remained intact. She put herself on a stringent schedule, working during the day and taking night courses in art and literature at NYU and the Art Students' League. At twenty-one, she married the first of three husbands, the commercial painter Humberto Pereira. Two years later she took a solo trip to Paris, where she was inspired by the Purist movement but disappointed by her traditional classes. She left after a month to travel through Italy and North Africa.

In the enormous sandy vistas of the Sahara Desert, she felt she had a vision of infinity. On her return to New York, she began to try to express this notion in her paintings. In many of these, there seems to be a pale glow at the center of the image. She is able to make it seem as if there is light radiating softly from some space deep within the work, even in flat geometric paintings. In *Green Depth*, some squared forms seem to yearn past the viewer, while others retreat into an obscured glow. The

painting, while wholly abstract, nevertheless has a very emotional feel to it.

By 1938 Pereira's painting was increasingly experimental. Not satisfied with expressing three-dimensional space with illusion, she began to layer transparent materials over each other to demonstrate depth. Although these innovations were propelling her artistic career to new success, her personal life suffered. In 1938 she divorced Humberto Pereira; in 1941 her dear sister Dorothy died. Cancer took a breast from her in 1943, but her need to paint during her recovery was so powerful that she became ambidextrous.

She married her second husband, George Brown, in 1942. Brown, an engineer, shared her interest in experimenting with various materials, and the marriage lasted for a decade. During this time Pereira was quite successful; several of her paintings were bought by major museums, and she was included in landmark group shows like the Museum of Modern Art's "Fourteen Americans" in 1946. After she and Brown parted ways in 1950, however, a shift in taste in modern art made her somewhat of an outsider.

Pereira's interests turned to poetry and writing, and she married the Irish poet George Reavey and began to write prolifically. Her ten books of poems and metaphysical essays were internationally recognized; she was awarded an honorary Ph.D. by the Free University of Asia and was made Poet Laureate of the Philippines. She never did return to the art world, but after her divorce from Reavey in 1959, moved to Marbella, Spain, where she spent her last years privately painting in the clear Mediterranean light. She died there at the age of sixty-four.

> *John I.H. Baur, once wrote that she painted in "a kind of creative hysteria; she weeps and sings and draws— violently and with both hands."*

TO FIND OUT MORE . . .

- Heller, Nancy G. *Women Artists: An Illustrated History*. New York: Abbeville Press, 1987.

- Munsterberg, Hugo. *A History of Women Artists*. New York: Clarkson Potter, 1975.

- Rubenstein, Charlotte Streifer. *American Women Artists: From Early Indian Times to the Present*. New York: Avon, 1982.

- Sicherman, Barbara, and Carol Hurd Green, eds. *Notable American Women: The Modern Period. A Biographical Dictionary*. Cambridge, MA: The Belknap Press of Harvard University Press, 1980.

Florence Beatrice Smith Price, 1888–1953

The Chicago Symphony's performance of Florence Price's Symphony in E Minor in 1933 marked the first time that a major American orchestra had played a symphony composed by a black woman. This achievement is especially notable since the symphony is identifiably ethnic—Price was inspired by West African juba rhythms.

Florence Smith's parents were educated people who placed emphasis on academic achievement. Both parents worked: her father, James H. Smith, was a dentist; her mother, Florence Gulliver Smith, an elementary school teacher and trained musician. Their daughter attended segregated schools in her hometown of Little Rock, Arkansas, where she was consistently at the top of her class. She was also composing music by age eleven.

At fourteen Smith moved to Boston to study piano and organ at the New England Conservatory. She graduated at eighteen and returned to Little Rock, where she taught at Shorter College until 1910. From 1910 until 1912, she taught at Clark University in Atlanta, and in 1912 she married Little Rock lawyer Thomas J. Price. They lived in Little Rock until 1927, when they moved to Chicago.

For the first twenty years of her marriage, Florence Price juggled the demands of work and family. While her children were small, she taught privately and entered a series of composition contests. She began to win prizes for her work in the late 1920s, including first prize for composition in the Wanamaker Prize competition for Symphony in E Major. Publicity from the prize attracted the attention of Chicago Symphony conductor Frederick Stock, and in 1933 he conducted the symphony at the Century of Progress Exposition in Chicago.

Price's style combined the old with the new. Her ethnic influences, which included African-American spirituals and African rhythms, were the innovative elements in her composition, which otherwise heark-

ened stylistically back to the tastes of her turn-of-the-century training. They were remarkably popular with a mainstream audience. Her many different works were successfully published—spirituals, symphonic pieces, organ music, and songs.

In 1940 Price became a member of the American Society of Composers, Authors and Publishers, which gave her work wider distribution and popularity. Her *Three Negro Dances* became part of the repertory of the United States Marine Band, and many of her symphonic works were performed by the orchestras of Detroit, Chicago, and Pittsburgh. Marian Anderson sang several of her spiritual songs.

After Price's husband died in 1942, she continued to compose into her sixties. She was still active when she died at the age of sixty-five.

> *Her ethnic influences, which included African-American spirituals and African rhythms, were the innovative elements in her composition, which otherwise hearkened stylistically back to the tastes of her turn-of-the-century training.*

TO FIND OUT MORE . . .

- Cuney Hare, Maud. *Negro Musicians and Their Music.* 1936.

- Sicherman, Barbara, and Carol Hurd Green, eds. *Notable American Women: The Modern Period. A Biographical Dictionary.* Cambridge, MA: The Belknap Press of Harvard University Press, 1980.

- Smith, Jessie Carey, ed. *Notable Black American Women.* Detroit, MI: Gale Research Inc., 1992.

- Southern, Eileen. *The Music of Black Americans: A History.* 1971.

Elizabeth Prophet, 1890–1960

. .

Sculptor Elizabeth Prophet's career was a long struggle with poverty. Her work earned her prizes, but never much of a living. Despite her hardships, she wrote in her diary, "I am a fighter, determined and non-retreating. I only stop when I drop."

Nancy Elizabeth Prophet was the child of an African American mother and an African American/Native American father. At twenty-four she enrolled at the Rhode Island School of Design (RISD) in Providence. While a student there she married Brown University student Francis Ford, ten years her senior. The marriage later dissolved, and Prophet once showed her feelings about him by listing herself as a widow.

At RISD, Prophet studied sculpture but focused more on drawing, painting, and portraiture. From her graduation in 1918 until 1922, she struggled futilely to make a living with her portraits. Old-fashioned American prejudice blocked her in a local exhibition, when a gallery agreed to show her work only if she did not attend the opening. Insulted, Prophet withdrew her work. In hopes of finding a more congenial atmosphere, she moved to France in the summer of 1922.

When she arrived, she spent part of her $380 nest egg on a studio in Paris, and set to work on her sculpture. Before the first piece was quite finished, however, she was broke and starving, stealing food from dogs. Within a year she was on the move in search of cheaper lodgings, continuing all the while to sculpt. In 1924, she fed herself by selling batik until a two-thousand-franc windfall from a sympathetic patron allowed her to start work on a longtime goal—a life-size statue, *Volonté*. She smashed the sculpture in a fit of frustration at her lack of progress in 1926.

Her work was much hampered by her shaky health and the interference of her drunken husband, who showed up in December 1925 with a bunch of roses, then

proceeded to pass out on her sofa. Prophet finally sent him back to America in 1929, paying his way with money she could hardly spare. Her hunger was a very real companion in her Paris years; her diary is full of her struggles with starvation. In 1925 she was hospitalized for malnutrition. The doctors, who thought that the emaciated artist must be a junkie, warned her to stay away from drugs. She returned to her work within three weeks.

In the late twenties she enjoyed moderate success with her busts, which were shown in several exhibitions. She also found a friend and patron in W.E.B. Du Bois. Du Bois hosted her during her yearlong visit to America to promote her art in 1929. The visit resulted in the placement of several of her pieces with patrons and museums, but she earned little money and had to return to France with only five hundred dollars.

French patrons supported her rather well in the early thirties, and in 1932 the Whitney Museum bought her best-known sculpture, a cherrywood head of a Masai warrior titled *Congolaise* (1930). By 1934, however, money had once again run out, and Prophet was subsisting on tea and marmalade when she finally decided to accept the offer of Spelman College in Atlanta and

> *"I am a fighter, determined and non-retreating. I only stop when I drop."*

return to America to work for pay.

At Spelman she was frustrated by the limited materials and her makeshift studio in the school's power plant, and gained a reputation for eccentricity. Her habit of covering her work with black cloths—she was deeply critical of her own work—became a much whispered-about habit. She left Spelman after ten years of service in 1944.

In the last two decades of her life, Prophet slid into obscurity. She returned to Providence, Rhode Island, where she worked as a domestic servant for twenty years. Her sculpture was fitfully shown in and around Providence, but she never regained her following, and when she died her last employer paid her funeral expenses to keep her from a pauper's grave. Sadly, most of her works are unaccounted for, because she never drew up a will.

TO FIND OUT MORE . . .

- Dover, Cedric. *American Negro Art*. Greenwich, CT: New York Graphic Society, 1960.

- Smith, Jessie Carey, ed. *Notable Black American Women*. Detroit, MI: Gale Research Inc., 1992.

- *Who's Who in American Art*. New York: Bowker, 1941.

Gertrude Pridgett (Ma Rainey) Rainey, 1886–1939

Ma Rainey was one of the great singers who popularized the blues in its heyday in the 1920s. Her act with her husband, Will (Pa) Rainey and their adopted son, Danny, started her on a life of touring the southern and midwest states, which lasted until the Depression cut her career short. Her voice, sadly, is remembered but not well represented on the scratchy recordings that were made over six decades ago.

Ma Rainey was born Gertrude Pridgett in Columbus, Georgia, and baptized at the First African Baptist Church. When she was only ten years old, her father died and her mother took a job with the Central Railway of Georgia. Gertrude performed as a young girl. Her first recorded public appearance was at age fourteen, in *Bunch of Black Berries* (a local talent revue) at the Springer Opera House.

She continued to sing, often in local tent shows, until a minstrel show came through Columbus when she was about seventeen years old. Will Rainey, a comedy singer with the show, married her in February of 1904, and the two began to tour together in minstrel shows, circuses, tent shows, and African-American variety shows. They developed a routine together and began to call themselves "Ma" and "Pa" Rainey, the "Assassinators of the Blues." They also adopted a son, Danny, who joined their act as the "world's greatest juvenile stepper."

The marriage and the act eventually split up, but Rainey kept her stage name. As her popularity grew, she began to sing as a featured performer, often under the name "Madame Gertrude Rainey." She still sang in the early teens in variety shows that featured her along with jugglers, comedians, and vaudeville and minstrel acts. But the blues became more and more popular in the late teens and early twenties, and Rainey's popularity grew with it. She used her earnings to buy a home for her family

in Columbus, and invested in two theaters, the Lyric in her hometown and the Airdome in Rome, Georgia.

Between 1912 and 1916, Rainey sang with another blues pioneer, **Bessie Smith**, on the traveling show circuit. Smith's career eventually eclipsed Rainey's, partly, perhaps, because her recordings are both more numerous and in better shape than Rainey's. But blues legend links the two greats, in one account, as lovers; others say that Rainey was the much-younger Smith's mentor. Whatever the status of their personal relationship, it seems clear that the two artists influenced both each other and the sound of blues music.

Rainey's first known public appearance was at age fourteen in Bunch of Black Berries (a talent revue) at the Springer Opera House in Columbus, Georgia.

From about 1909 to 1931, the Theatre Owners Booking Association (TOBA) organized the African-American entertainment circuit in the South and the Midwest. The organization, run by whites, was regarded as a mixed blessing by the performers themselves, some of whom renamed TOBA "Tough on Black Asses."

For Rainey, the organization was a career-booster in the early twenties. Blues music was popular, and Rainey made ninety-two recordings for her expanding audience, mostly in Chicago. Some representative songs: "Blame it on the Blues," "See, See Rider," "Lawd Send Me a Man Blues," and "Walking Blues." Her voice (even without the staticky sound of the recordings) had a husky, gritty sound that was, in the words of gospel composer/singer Thomas Dorsey, "the real thing."

When the stock market crashed, blues music went out of style and Rainey's offers dried up. She returned to her Columbus home in 1935 to run her theaters and see her family. Her mother and sister both died that year, and Rainey died four years. She was fifty-three.

TO FIND OUT MORE . . .

- Lieb, Sandra R. *Mother of the Blues: A Study of Ma Rainey*. Amherst, MA: University of Massachusetts Press, 1981.

- Macksey, Joan, and Kenneth Macksey. *The Book of Women's Achievements*. New York: Stein and Day, 1975.

- Smith, Jessie Carey, ed. *Notable Black American Women*. Detroit, MI: Gale Research Inc., 1992.

- Stewart—Baxter, Derrick. *Ma Rainey and the Classic Blues Singers*. New York: Stein and Day, 1970.

Anne Ryan, 1889–1954.

ollage artist and painter Anne Ryan was a late starter. She began to paint when she was nearly fifty years old, and to work on the collages for which she is best remembered when she was nearly sixty. Her small-scale works were carefully composed of bits of paper, sometimes specially made to provide contrast and texture, and sometimes of "found objects" like tickets or postage stamps. Her new-found creativity was only limited by her death, which sadly came less than a decade after she had discovered her metiér.

Anne Ryan was born in Hoboken, New Jersey, the oldest child and only daughter of a wealthy Irish Catholic couple, Elizabeth Soran Ryan and John Ryan. Her father was a banker and amateur poet who died when Anne was only thirteen. She attended the Academy of St. Elizabeth's Convent and went on to St. Elizabeth's College, but left in 1911 before earning a degree in order to marry William J. McFadden, then a law student.

Anne and William McFadden had three children together, but the marriage was undermined by Anne's dissatisfaction with her role as wife and mother. They separated in 1923, and Anne Ryan took back her maiden name. She made a radical shift, living the life of a free spirit and a writer in New York's Greenwich Village. After two years spent writing on the Spanish island of Majorca and visiting Paris with her older children, Ryan returned permanently to Greenwich Village, bringing her younger son.

Around the age of fifty, Ryan discovered painting. Her Greenwich Village friends helped and encouraged her, and in 1941, she had her first one-woman show of oil paintings. In 1948 she saw an exhibition of the collages of German artist Kurt Schwitters and began the series of small-scale assemblages of paper that gained her wider recognition.

Her early collages, like Schwitters's, made use of "found objects"—candy wrappers, towels, postage stamps. Soon, however, she turned to chunkily textured cloths and papers, including handmade papers by Douglas Howell. Sometimes she deliberately wore out material so that it would acquire

the texture she wanted. She used these scraps to assemble cubist-inspired abstract compositions of rough blocks. She used both color and texture to interest the eye, juxtaposing a single bright color with a series of neutrals, or pebbled paper with rough burlap. The collages achieve a kind of balance among their differing elements.

Ryan had only six years to work on her collages, operating out of the Greenwich Village home she shared with her daughter. After suffering a stroke in the spring of 1954, she moved to her son's house in Morristown, New Jersey, where she died just two months short of her sixty-fifth birthday.

> *Ryan discovered painting at the age of fifty.*

TO FIND OUT MORE ...

- Rubenstein, Charlotte Streifer. *American Women Artists: From Early Indian Times to the Present.* New York: Avon, 1982.

- Ryan, Anne. *Anne Ryan: Collages, 1948–1954: October 13 to November 7, 1979.* Essay by Eric Gibson. New York: Andre Emmerich Gallery, 1979. (Exhibition catalog.)

- Sicherman, Barbara, and Carol Hurd Green, eds. *Notable American Women: The Modern Period. A Biographical Dictionary.* Cambridge, MA: The Belknap Press of Harvard University Press, 1980.

- Ryan's papers are at the Archives of American Art, Washington, D.C.

Ruth St. Denis, 1879–1968

With her husband, Ted Shawn, the dancer and choreographer Ruth St. Denis founded Denishawn, the company that popularized modern dance in the United States. Her creative spirit chafed against the restrictions that inevitably came with public success, and she was never as happy wrestling with the desires of her public as she had been as a struggling dancer. Her epitaph testifies to the true passion of her life on the stage: "The gods have meant/That I should dance,/and by the gods/I will!"

Ruth had a colorful childhood. Her mother, Ruth Emma Hull Dennis, graduated from medical school and suffered a nervous breakdown. While still recuperating, she met her husband-to-be, Thomas Denis, near Perth Amboy, New Jersey. When they met, the amateur inventor was married to another woman, whom he divorced in order to marry his pregnant new bride. In somewhat less than nine months, Ruth was born.

Her father was often unemployed, and often drank; the quarrels were oppressive to the sensitive girl, who responded to her own scandalous existence by very carefully observing social dictates (and later, vigilantly avoiding unwanted pregnancies). She achieved a more immediate sort of escape by learning to dance. At fifteen she went to New York with her mother to audition, and during the week of January 29, 1894, she had her New York Stage debut, as a "skirt dancer" at Worth's Museum.

Inauspicious as this start may have been, Dennis was hooked. She was able to support herself and her parents—then separated—by dancing in variety revues and roof garden concerts over the next ten years. She began to develop her own ideas about choreography during this period. Inspired by an ad for Egyptian Deities (a brand of cigarette), she experimented with Oriental styles of dancing—an inspiration for her later solo style. She changed her stage name to Ruth St. Denis and launched her solo career with *Radha*, performed for a mostly male audience in a "smokers' concert."

After building her reputation with a three-year solo tour of Europe, St. Denis met and married ex-divinity student and as-

piring dancer Ted Shawn. In 1915 they moved to Los Angeles to found their dance school and company. Denishawn's students included such later influential choreographers as Martha Graham, Doris Humphrey, and Charles Weidman. St. Denis continued to dance as a soloist, still acting the grand lady of the stage. And Denishawn flourished, its performances becoming more and more popular.

Although St. Denis starred in many of Denishawn's productions, she felt cramped by her enthusiastic audiences' expectations. Furthermore, in the late 1920s the founders' marriage was coming apart, shaken by their quarrels over infidelities, his interest in men, her fear of pregnancy, and professional differences. They separated in 1931 but were able to rebuild an enduring friendship.

> *"The gods have meant/That I should dance,/and by the gods/I will!"*

In the later years of her career, St. Denis moved to Hollywood, where she continued to perform until as late as 1964 as a well-loved icon of modern dance. She lived to be eighty-nine years old.

TO FIND OUT MORE . . .

- Shelton, Suzanne. *Divine Dancer: A Biography of Ruth S. Denis.* Garden City, NY: Doubleday, 1981.

- Sherman, Jane. *The Drama of Denishawn Dance.* Middletown, CT: Wesleyan University Press, 1979.

- Sicherman, Barbara, and Carol Hurd Green, eds. *Notable American Women: The Modern Period. A Biographical Dictionary.* Cambridge, MA: The Belknap Press of Harvard University Press, 1980.

Olga Samaroff 1882–1948

Concert pianist, philanthropist, and teacher Olga Samaroff funded her own stage debut in New York City in an enormous financial gamble. Long after she had established herself as a pianist, she remembered what it was like to be an impoverished unknown, and devoted her energies to teaching, nurturing, and supporting young musicians. She also saw a need for music to be accessible to the general public, and wrote books and taught courses designed to open up music to nonmusicians.

Lucy Mary Olga Agnes Hickenlooper was born in 1882 to a Catholic family in San Antonio, Texas. She attended school in a Galveston, Texas convent, and her grandmother taught her piano. Both her grandmother and composer Edward MacDowell, who had heard the talented girl play, encouraged her to study in Europe. Her parents were reluctant—as far as they were concerned, women should not pursue careers unless financially necessary—but in the end, they supported her. At age fourteen Olga left for Paris with her grandmother.

A year later, she was the first American female to win a scholarship to study at the Paris Conservatoire. She boarded at another convent, where she continued her academic studies. She trained in piano with Élie M. Delaborde for two years at the Conservatoire, then studied in Berlin with Ernst Jedliczka and Ernest Hutcheson. A marriage in 1900 to Russian engineer Boris Loutzky did not last; in 1904 they obtained a divorce and a papal annulment. Olga returned to the United States that year.

It was notoriously difficult to break through in American music in 1905; most musicians built their reputations in Europe before attempting the American stage. Although she was low on money, especially since the divorce, Olga Loutzky took a major chance to establish a name for herself. She hired the New York Symphony Orchestra, including prominent conductor Walter Damrosch, for her debut at Carnegie Hall in January of 1905. Good reviews earned her a spate of performances around New York, and she found herself well established by the time of her appearance with the Boston Symphony Orchestra in 1906.

By 1909 she was being hailed as one of the world's foremost pianists. Her position as an acclaimed pianist was secure when, in 1911, she married composer Leopold Stokowski, popularly known as the maestro in Disney's *Fantasia*. They had a daughter, Sonya, soon after the marriage, and Olga resumed concert performances after a short break in 1913. Over the next ten years, her marriage fell apart, and the couple was divorced in 1923. In 1925, Olga was sidelined by an arm injury.

Despite these seeming misfortunes, the injury was the trigger Samaroff needed to quit performing, which she found oppressive, and begin teaching, which she enjoyed immensely. She worked at the Julliard Graduate School of Music from 1925 until her death in 1948. She was an exceptional teacher who nurtured students, taking them into her home or on trips to Bavaria. She did not discriminate among those who would go on to brilliant careers on stage and those who would become teachers.

In 1928 she established the Schubert Memorial, Inc., which funded splashy debuts for young American artists who needed them, in memory of her own daring debut. In 1929 she became the head of the

> **Samaroff was the first American woman to win a scholarship at the Paris Conservatoire.**

Philadelphia Conservatory of Music's piano department. While shuttling weekly between New York and Philadelphia, she developed music appreciation courses for laymen and taught in New York, Washington, and Philadelphia. She wrote a text for the course and later taught it on television and radio.

Samaroff was active in all areas of music for all of her life. she was the music critic of the New York *Evening Post* in the late twenties, and during the Depression was one of the group that founded the Musicians' Emergency Fund. After her death in New York at age sixty-five, her students banded together to establish a fund in her name to house music students.

TO FIND OUT MORE . . .

- Samaroff, Olga. *An American Musician's Story*. New York: Norton, 1939.
- Sicherman, Barbara, and Carol Hurd Green, eds. *Notable American Women: The Modern Period. A Biographical Dictionary*. Cambridge, MA: The Belknap Press of Harvard University Press, 1980.

Augusta Savage, 1900–1962

This talented sculptor had to overcome the disadvantage of her poverty and the hostility of racist art dealers to become a leading figure in the advancement of African-American art. She taught in Harlem and fought to get recognition for other African-American artists. She is best known for her striking portrait bust of N.A.A.C.P. founder W.E.B. DuBois.

Augusta Savage was born in 1900 in Green Cove, Florida. She was the seventh of fourteen children, and the family often had a hard time making ends meet. Her father, a strict Methodist minister, objected to her impractical interest in sculpture, but Savage was able to pursue it in high school, where she taught other students clay modeling.

On her graduation she broke away from home, enrolling in 1921 at Cooper Union in New York to study sculpture. Broke, she narrowly avoided being evicted from her apartment when her teachers talked the board of trustees into awarding her a scolarship.

The next year Savage found herself at the center of a controversy when she tried to apply for admission to summer art school at the Palace of Fontainebleau, near Paris. Before she even completed her application, she was rejected by the school, which seems to have thought her presence might drive white students away. Savage publicly criticized the school in interviews and letters. Columbia anthropology professor Franz Boas and the Ethical Culture Society's Alfred Martin argued her case.

In the end the protests did Savage little good; the school held its ground, and dealers and museums ignored her work. She spent nearly a decade supporting her work with menial jobs in factories and laundries. Then, in 1930, she won her chance to go to Paris. A Julius Rosenwald Fellowship made it possible for Savage to study at the Académie de la Grande Chaumière, working with sculptor Félix Bueneteaux. Her two years in France gave her the legitimacy she needed in the art world.

In 1932 she established her own school in Harlem, the Savage School of Arts and Crafts. She won a Carnegie Foundation grant to provide tuition for young students

and taught a generation of New York African-American artists, including Ernest Crichlow and Norman Lewis. She also founded and acted as first director for the Harlem Art Center, agitating to staff it with African-American artists.

Much of her own work does not survive; she devoted more of her time to her cause than to preserving her own sculpture. One lost work was *Lift Every Voice and Sing*, commissioned in 1939 for the New York World's Fair. Cast in plaster, it remains only in photographs, but its power is evident even so. Twelve figures rise up out of the frame of a harp, shoulders squared and heads lifted in song. It is an arresting paean to African-American music. Her bust of W.E.B. DuBois is in the 135th Street branch of the New York Public Library.

> *Savage's application to summer art school at the Palace of Fontainebleau was rejected before she submitted it.*

TO FIND OUT MORE . . .

- Bearden, Romare, and Henderson, Harry. *Six Black Masters of American Art.* Garden City, NY: Zenith Books/Doubleday, 1972.

- Rubenstein, Charlotte Streifer. *American Women Artists: From Early Indian Times to the Present.* New York: Avon, 1982.

- Schomburg Center for Research in Black Culture. *Augusta Savage and the Art Schools of Harlem.* Essay by Deidre L. Bibby. New York: The New York Public Library, 1988.

- Savage's papers are in the Schlesinger Library at Radcliffe College.

Concetta Scaravaglione, 1900–1975

· ·

The talented Italian-American sculptor Concetta Scaravaglione literally worked her way into the New York art world of the 1930s. As a teenager she took a horrible factory job to support herself in her costly art classes when she lost a position at the National Academy of Design to cutbacks. Her sculpture is based on curving lines and warm energy. She passed on her love of art in a fifteen-year teaching career at Sarah Lawrence College, Vassar College, New York University, and Black Mountain College.

Scaravaglione drew her earliest inspiration from the Lower East Side Italian neighborhood where she grew up. The crowded, vibrant neighborhood gave her an appreciation of the human body in its many forms and movements. Her parents, immigrants from southern Italy, found their youngest child's interest in art impractical, but allowed her to take free classes at the National Academy of Design. When funding for the classes disappeared, Scaravaglione went looking for a job.

The perfume factory that hired her to fill bottles infused her with its stench. She constantly reeked of cheap perfume; even baths couldn't remove the smell. She was embarrassed to be in close quarters with other people. But the job allowed her to continue her precious art, and she eventually saved up enough to quit the factory.

By the late 1920s she was exhibiting at the Whitney Museum and the Museum of Modern Art; in the thirties she won commissions in Washington, D.C. *Railway Mail Carrier* (1935) was cast in aluminum for the Federal Post Office Building, and *Agriculture* (1937) was a carved limestone bas-relief on the Federal Trade Commission Building.

Her 1938 *Girl With Gazelle* won her national acclaim, appearing on the covers of Newsweek and Art Digest. After the thirties, her work became more abstract and experi-

mental, and she used newer materials like welded metal in her simplified shapes.

TO FIND OUT MORE . . .

- Rubenstein, Charlotte Streifer. *American Women Artists: From Early Indian Times to the Present.* New York: Avon, 1982.

- *The Sculpture of Concetta Scaravaglione.* Richmond, VA: Virginia Museum of Fine Arts, 1941. (Exhibition catalog.)

> *Scaravaglione's work is based on curving lines and warm energy.*

Philippa Duke Schuyler, 1931–1967

The offspring of her parents' experiment in interracial breeding—they believed that their Caucasian/African-American marriage would produce a superior child—pianist and composer Philippa Schuyler certainly lived up to their expectations. She was a child prodigy who inspired comparisons with the young Mozart and charmed audiences of all races. The strain on her, however, was enormous. She left race-obsessed America but still wrestled with issues of identity. Schuyler often "passed" as white, and at one point changed her name to Montero and claimed Spanish heritage. Her premature death in a helicopter crash at the age of thirty-six was her only release from a lifelong search for identity.

Josephine Cogdell moved from the white world of Greenwich Village to Harlem to marry fellow journalist George Schuyler. Besides their intense attraction to one another, they shared the conviction that their child would benefit from her hybrid blood.

The force of their conviction, perhaps, propelled their daughter to become a child prodigy: She began writing at two and a half and composing at four. At five she was playing Mozart for audiences. Josephine Schuyler, an overpowering force in her daughter's life, kept her on a restrictive diet that eliminated sodas, alcohol, sugar, meat, cooked foods, and most fat. She also became the dominating force in Philippa Schuyler's professional life.

At ten Schuyler was made a member of the National Association of Composers and Conductors. Critics compared her to the young Mozart, and she was celebrated by both the African-American community and the white press. Her father's influence behind the scenes in the press fueled her acclaim. As she grew into a beautiful young woman, however, American audiences became uncomfortable with her. White America began to reject her, and there was little for a classical composer and pianist in the

African-American music world in the late 1940s. Humiliated, Schuyler fled abroad.

She was rather conditionally celebrated in Europe as an "exotic beauty." Restless and uncomfortable with the constant labeling of her racial identity, she roamed Latin America, Africa, Asia, and Europe. She played before Queen Elizabeth and Haile Selassie. Despite her European success, American audiences relegated her to performing only in African-American circles. Unhappy at having only half of her parentage accepted, she never returned permanently to the United States.

Schuyler was a child prodigy who inspired comparisons with the young Mozart.

In the early sixties she began to supplement her income with articles and books based mostly on her experience abroad. She also changed her name to Felipa Monterro, with the hope that a Latin American pianist and composer would be better received than an African-American one. She had soon revised her history to include a European childhood and social work in Africa. She was able to join a lecture tour under this identity, but her reviews as a pianist were not good enough to merit much of a career in white America.

In May of 1967 Schuyler was in Vietnam, acting as a performer for American troops and a missionary for young children. On May 8 she was advised by a clairvoyant that "her malefic period would be over and she would emerge form the mouth of the Dragon." Buoyed by this news, she wrote a hopeful letter to her mother. The next day she was killed in a helicopter crash.

TO FIND OUT MORE . . .

- Schuyler, Philippa. *Adventures in Black and White.* New York: R. Speller, 1960.

- Smith, Jessie Carey, ed. *Notable Black American Women.* Detroit, MI: Gale Research Inc., 1992.

- Schuyler's papers are at the Schomburg Center.

Esther Mae Scott (Mother Scott), 1893–1979

L ike her rough contemporary **Alberta Hunter**, Esther Mae Scott had a more successful career as a blues artist when blues made a comeback in the late 1950s. Her performances in the 1960s and 1970s were enormously popular in Washington, D.C., where she played with fellow blues guitarist **Libba Cotten**.

Scott was the seventh of fourteen children in a family of poor sharecroppers. She was born in Bovina, Mississippi, on the Polk Plantation, where she began working by the age of five. She was not paid for her labor until age nine, when she earned the child's wage of a quarter a day. All the basics were in short supply for the large family—clothes, food, medical care, and heat in the winter. Scott remembered eating picklepoke (pickled horsemeat used for cooking vegetables) and berries scrounged from the woods. All the plantation workers worked from sunrise to sunset, and there was little time for school for working children.

Music came with work; Scott picked up songs from the other plantation laborers. "Singing looked like it'd make the day shorter for you," Scott later explained. She also picked up some experience playing the guitar, mandolin, banjo and piano on the plantation, learning from relatives and friends. Other less conventional instruments were also a part of plantation music: sardine-can "violins," empty jugs, brooms for bass. At the age of fourteen, Scott left home to become a vaudeville performer.

Scott's mother disapproved of her choice, but Scott still brought home her first paycheck, arguing "I get so tired of seeing you eat the same thing." She earned a dollar a day shilling hair pomade and liniment and performing as a singer, dancer, and guitarist. She knew that the show was a rip-off, stripping many of its more gullible viewers of their last spare cent, but the pay was a powerful lure. She also picked up valuable stage experience, learning to play a multitude of charac-

ters and adding spirituals and blues songs to her growing repertoire.

After only two years on the circuit, Scott quit to take a job as a maid and nurse for the wealthy Klaus family of Vicksburg, Mississippi. During the twenty-seven years she spent working for them, she met other musicians like Leadbelly, whom she remembered as a "performer from the heart," and her idol **Bessie Smith**. After the Klauses let her go without severance pay in 1938, Scott found another position as a maid and nurse in Baltimore, a position she kept for twenty years. In 1958 she moved to Washington, D.C., to renew her performing career.

> *"Singing looked like it'd make the day shorter for you."*

At first Scott only played for church services and at weddings, for no pay. Club engagements rebuilt her reputation, and soon she was a regular performer at folk festivals and revivals. Her standards included an emotional rendition of "He's Got the Whole World in His Hands" and "When the Saints Go Marching In." At seventy-eight she also recorded a version of Bessie Smith's "Gulf Coast Blues" on her first and only album, *Moma Ain't Nobody's Fool* (1971).

Despite her deteriorating health, Scott kept her generous spirit in her old age. She once entertained the other patients when she was hospitalized for eye surgery. Her death in 1979 capped a long career spent bringing joy to others.

> *An old lady sat under a tree,*
> *Sewing as long as her eyes could see.*
> *She pulled her work and she*
> * smoothed it right*
> *And she said Dear work goodnight*
> * goodnight.*

— From her alternate ending to "Goodnight Ladies, I'm Bound to Leave You Now"

TO FIND OUT MORE . . .

- Barlow, William. *"Looking Up at Down": The Emergence of Blues Culture.* Philadelphia: Temple University Press, 1989.
- Black Women Oral History Project, interview with Esther Mae Scott. Cambridge, MA: Schlesinger Library, Radcliffe College, 1977.
- Smith, Jessie Carey, ed. *Notable Black American Women.* Detroit, MI: Gale Research Inc., 1992.

Netta Dewee Frazer Scudder (Janet Scudder), 1869–1940

J anet Scudder was one of the group of women sculptors who worked with the sculptor Leonardo Taft and were called the "white rabbits." The name came from an offhand comment his chief architect had made when Taft told him to hire some women among the assistants. Scudder quoted the architect as saying that he would hire "anyone who could do the work . . . white rabbits if they will help out." Scudder encountered plenty of skepticism, but broke through on her own with her popular small garden sculptures, which were snapped up by museums and wealthy patrons like John D. Rockefeller.

Scudder's Indiana childhood was not a happy one. Her father, left with seven small children when his wife died, remarried a woman who turned out to be Scudder's own personal evil stepmother. Scudder was a rebellious child and a tomboy, and she grew up with that independent streak undiminished. She also fell in love with the illus-

trations in some old poetry volumes, risking her life to save them from a fire.

A drawing instructor recognized Scudder's talent and encouraged her father to consider sending her to art school. In 1887 she enrolled at the Cincinnati Art Academy, where she quickly found her niche in sculpture, studying wood carving and clay sculpture. The wooden mantlepieces she carved at sixty dollars apiece helped to pay her tuition. Both the confidence gained at Cincinnati from her instructors' encouragement and her own personal toughness would be much needed in the difficult years to come.

Scudder's father and brother both died while she was at school, and in her hunt for work over the next several years, she suffered many setbacks and indignities. She was pushed out of her job as a woodcarver at a Chicago factory because the union blocked women carvers. Much later, in Paris, a woman model shrieked at her in French when Scudder showed up in a life

class. Another assistant to her mentor Frederick MacMonnies, jealous over Scudder's excellent work, told her that MacMonnies was dissatisfied with her work. Scudder left, finding out only later that MacMonnies had considered her his best assistant and was disappointed by her departure.

A stint as one of Lorado Taft's assistants for the enormous projects he was preparing for the Chicago World's Fair led to the assistantship with Macmonnies in Paris. Both experiences gave her some needed practical experience. When she left Macmonnies's studio under a cloud of mutual misunderstanding, she moved to New York City, where she struggled with poverty, discrimination, and obscurity. An architect fabricated a commission in an attempt to seduce her. She finally broke through when a friend helped her obtain a commission to design the seal for the New York Bar Association.

She moved back to Paris around the turn of the century, where she became internationally noted for her popular playful figures. Her 1901 *Frog Fountain*, a three foot high bronze piece, is an early example of the pieces that made her famous. A small nude boy with a pudgy belly dances as

> As a child, Scudder risked her life in a fire to save some old poetry volumes that contained illustrations she loved.

three frogs spray water from their mouths. She later won significant commissions like *Feminina Victrix* (1915), a figure for a Washington, D.C., monument to the suffrage movement that was never installed.

Scudder shuttled back between Paris and New York, but she adopted France as her country for World War I, serving in the Red Cross. For her service, France made her a Chevalier of the Legion of Honor in 1925. In 1920 the American National Academy of Art elected her an associate member. She returned for good to the United States when World War II broke out, and died at age seventy-eight in her Rockport, Massachusetts home.

TO FIND OUT MORE . . .

- Rubenstein, Charlotte Streifer. *American Women Artists: From Early Indian Times to the Present.* New York: Avon, 1982.

- Scudder, Janet. *Modeling My Life.* New York: Harcourt, Brace & Co., 1925.

- Taft, Lorado. *The History of American Sculpture.* Rev. ed. New York: MacMillan, 1924.

Ruth Crawford Seeger, 1901–1953

Ruth Crawford Seeger was one of America's most promising classical composers, the first woman composer to win a Guggenheim fellowship. After her marriage to Charles Seeger, she worked to preserve over six thousand American folk songs—an enormous contribution to musical history.

Ruth Crawford was born in East Liverpool, Ohio, in 1901. Her father was a Methodist minister. She studied piano as a girl and was such a quick student that by age 17, she found a position teaching piano at the School of Musical Art in Jacksonville, Florida. She spent three years there before moving to Chicago to study seriously at the American Conservatory. She trained in several disciplines, including piano, counterpoint, orchestration, and composition.

The Guggenheim Fellowship, which Crawford won in 1930, made it possible for her to study and develop her style in Paris and Berlin. Her *Three Songs* for oboe, piano, percussion and contralto was chosen to represent the United States at a 1933 international festival in Amsterdam. She spent a year in New York absorbing new ideas and composing. A summer at the MacDowell colony in Petersborough, New Hampshire, a peaceful artists' retreat, further polished her style.

In 1931 she married Charles Seeger, a musicologist who then headed the Music Division of the Pan American Union. He brought three children from an earlier marriage with him. One of them, his then twelve-year old son Pete Seeger, grew up to become the nation's most prominent folk singer, touring with Woody Guthrie and joining the anti-Vietnam movement. Two more of the four children Ruth and Charles Seeger had together, Peggy and Michael, also became folk singers.

Ruth Seeger continued to compose for some years after her marriage, producing works of startling originality that still sound

new sixty years after their composition. *Three Songs* is a complex piece, despite its rather stark use of its single voice and three instruments. Other much-praised compositions include *String Quartet* (1931), *Orchestral Composition* (1941), and another *Three Songs* (1932) to words by poet Carl Sandburg. Slowly, however, her interest in folk songs took up more and more of her time.

Seeger spent almost twenty years working to preserve and pass on American folk songs. She transcribed over six thousand recordings from the Library of Congress and wrote more than three hundred piano accompaniments to some of them. She brought folk songs to children in three books of enduring popularity, *Folk Songs for Children, Animal Folksongs for Children,* and *American Folksongs for Christmas*, all published by Doubleday. Her own children were the test audience for the material. These publications made her an authority on the use of folk songs in teaching, and she often gave lectures for groups of educators. Her children Mike and Peggy recorded 2 double album sets of the folk songs she collected.

In 1952, a year before her death, Seeger began to compose seriously again. Her *Suite for Wind Quintet* (1952) is the most often-performed piece from this period. She died on November 18, 1953.

> *Seeger, an enormously talented classical composer, brought her considerable skills to folk music when she married a musicologist.*

TO FIND OUT MORE . . .

- LePage, Jane Weiner. *Women Composers, Conductors and Musicians of the Twentieth Century.* Metuchen, NJ: The Scarecrow Press, Inc., 1980

Henrietta Shore, 1880–1963

Painter Henrietta Shore produced works that have been described as "abstracted realism." In her stylized human figures or her close studies of seashells, her vision transforms her subject into something new. Her work has been compared to Georgia O'Keeffe's for its tendency to zoom in close to her subject to find a new view.

Henrietta Shore was born in Toronto, Canada, but moved to New York City to study at the bohemian Art Students League. She spent years studying in New York and, later, at the Heatherly Art School in London. In 1913 she became a pioneer in West Coast art when she moved to Los Angeles and helped to establish the Los Angeles Society of Modern Artists. She established herself in California with some early successes. At the 1915 Pan-American Exposition in San Diego, her work won a silver medal. Three years later, she and Helena Dunlap had a two-woman exhibition at the Los Angeles County Museum.

Back in New York in 1921, Shore finally became an American citizen. She worked to develop her personal style in the early twen-ties, experimenting with nonobjective painting before settling on her trademark abstracted realism. Professional breakthroughs came in the mid- and late twenties. The Worcester Art Museum in Massachusetts gave a retrospective of her work, reviewed favorably in *Arts* magazine.

In 1924 Shore was among the twenty-five artists chosen to represent American art in Paris. The next year she became one of the founding members of the New York Society of Women Artists, of which **Marguerite Zorach** became the president. On a trip to Mexico, José Orozco and Jean Charlot sat for portraits by her.

Shore returned to Los Angeles, where in 1927 she became close with photographer Edward Weston. He was deeply struck by her close studies of shells, and began to work on a series of photographs based on her vision. His photographic versions of her paintings were heavily influential among American photographers.

In 1936 she was hired by the Treasury Relief Art Project to work on a series of six murals near Carmel, California. Some of the

murals cannot now be seen—one, at the Monterey Post Office, was covered up in 1966. The four done in the half-moon of the lunettes of the Santa Cruz Post Office, however, survive. In *Cabbage Culture* (1936), Shore's stylized workers hunch over the vegetables, which seem to stretch out to an infinite horizon of cabbages. The worker in the foreground seems especially hemmed in by the post office's sloping ceiling, which curves over his bent back.

In her later years, Shore withdrew to her home in Carmel. The town honored her with an exhibition after her death given by the Carmel Art Association.

> *Her work has been compared to Georgia O'Keeffe's for its tendency to zoom in close to her subject to find a new view.*

TO FIND OUT MORE . . .

- Armitage, Merle, Edward Weston, and Reginald Poland. *Henrietta Shore.* New York: E. Weyhe, 1933.

- Rubenstein, Charlotte Streifer. *American Women Artists: From Early Indian Times to the Present.* New York: Avon, 1982.

Bessie Smith, 1894–1937

I n her short life, Bessie Smith changed the history of the blues. She became one of the most successful blues performers of the 1920s and 1930s, eclipsing the career of her supposed mentor, **Ma Rainey**. The ten years she spent recording left us with a precious archive of her innovations and placed her at the pinnacle of blues in America. As Ralph Ellison put it in his book *Shadow and Act*, "Bessie Smith might have been a 'blues queen' to the society at large, but within the tighter Negro community where the blues were part of a larger way of life . . . she was a priestess."

Smith was orphaned at nine when her mother died; her father had died when she was still an infant. She grew up in Chattanooga, Tennessee, where her older sister supported her own child as well as her younger siblings by taking in laundry. In her early teens she fled Chattanooga for the vaudeville circuit, where she met Ma Rainey and her husband, Will ("Pa") Rainey. Rainey's flashy style doubtless impressed the aspiring performer, and her rough singing style is clearly identifiable in Smith's earliest recordings, made thirteen years after they met.

Smith began taking jobs performing for the Theatre Owners Booking Association (TOBA). By 1920 she was producing her own shows at the 81 theater in Atlanta, named for its address (81 Decatur Street). She had enough pull to insist on her own noncommercially plump chorus line, which theater owners disliked but were forced to accept—Smith wouldn't perform without them. Meanwhile, she struggled to obtain a recording contract.

In 1921 Bessie Smith signed with Columbia Records. The first of her Columbia records, "Downhearted Blues," sold an unprecedented 750,000 in just a few months. Flushed with success, the twenty-seven-year-old Smith married Jack McGee, who became her manager. The marriage lasted six years. Meanwhile, Smith became a full-fledged star, drawing round-the-block lines for her performances. Her seventy-five-cent records, when in short supply, often sold for as much as five dollars.

Smith's special talent lay in the way she

interpreted even the blandest pop lyrics. Her voice could slide with an improvisational ease that was actually the result of long practice and tight control. Her stage presence, too, was imposing—she was a large woman who carried herself with unruffled dignity. Offstage, she often drank and was sometimes volatile—much has been made of other performers' recollections of her temper. Still her grand presence onstage inspired a whole raft of musical descendants, including **Mahalia Jackson**, **Mildred Bailey**, and **Dinah Washington**. From "Downhearted Blues" in 1923 until "Do Your Duty" in 1933, Smith's recordings remain as a testament to her mastery.

Her great popularity kept her career afloat even after TOBA went belly-up during the Depression. Compared to the tough times most other performers were weathering, things were going fairly well for Smith in the late 1930s. Another marriage, to sophisticate Richard Morgan in 1929, was a stabilizing force in her life—Morgan was a better manager than McGee had been—and Smith had been able to line up some prospective recording deals. In 1937, however,

As Ralph Ellison put it in his book Shadow and Act, "Bessie Smith might have been a 'blues queen' to the society at large, but within the tighter Negro community where the blues were part of a larger way of life ... she was a priestess."

her plans were cut short when Morgan crashed the Packard they were driving to Darling, Mississippi, on Route 61. She died ten days later of her injuries in the segregated hospital in Clarksdale, Mississippi—contrary to the much-perpetuated legend that she bled to death in the foyer of a white Memphis hospital.

TO FIND OUT MORE ...

- Sicherman, Barbara, and Carol Hurd Green, eds. *Notable American Women: The Modern Period. A Biographical Dictionary.* Cambridge, MA: The Belknap Press of Harvard University Press, 1980.

- Harris, Sheldon. *Blues Who's Who.* New Rochelle, NY: Arlington House, 1979.

- Lieb, Sandra. *Mother of the Blues: A Study of Ma Rainey.* Amherst: University of Massachusetts Press, 1981.

- Smith, Jessie Carey, ed. *Notable Black American Women.* Detroit, MI: Gale Research Inc., 1992.

- Southern, Eileen. *Biographical Dictionary of Afro-American and African Musicians.* Westport, CT: Greenwood Press, 1982.

Jessie Willcox Smith, 1863–1935

Illustrator Jessie Willcox Smith is best remembered for her timeless illustrations of Charles Kingsley's classic children's book, *The Water Babies*. She lived with three other well-known women artists and assorted family members in a series of communal homes in and around Philadelphia for fourteen years.

Jessie Smith lived most of her life within a few hours of Philadelphia. She had none of the urgency or drive of the stereotypical artist; in fact, she had already begun a career in teaching young children when she discovered her talent. At her cousin's request, she was acting as a chaperone while the cousin tried to teach a male friend to draw. The student could not have been pleased to see that Smith, also a novice, had more talent than he did, for he soon stopped trying. Smith, on the other hand, had found a new career.

The Philadelphia School of Design for Women accepted Smith as a student, which led in 1885 to her studying at the Philadelphia Academy. The famous painter Thomas Eakins was one of her teachers, and the Academy was quite prestigious, but Smith found that her peers there took themselves terribly seriously.

Illustration classes at Drexel Institute, which Smith started in 1894, suited her much better. Her teacher there, Howard Pyle, took a much lighter view of art. He urged his students to picture their drawings in their minds first, insisting that the actual drawing would come intuitively from a clear idea. Smith made friends with a younger classmate, Elizabeth Green, who joined the class that year. In 1897 painter Violet Oakley entered Pyle's class. The age difference between the three classmates was significant—at thirty-four, Smith was older than her friends, both in their mid-twenties—but it did not stop them from becoming lifelong friends.

Meanwhile, Smith was becoming a

modest commercial success. Before her work at Drexel, she had illustrated commercial advertisements. In 1897 she and Oakley illustrated an edition of Henry Wadsworth Longfellow's *Evangeline.* Editors found her style appealingly feminine—perfect for the magazine *Good Housekeeping*, for which she later illustrated over two hundred covers. Her idealized, cherubic images of children seemed to strike a popular note of sweet harmony.

Smith, Oakley and Green found their own harmony in a shared Philadelphia studio apartment, for which they each paid six dollars per month. The trio would become the core of a group of friends and relatives that lived happily together over the next fourteen years. In 1902 the group moved to the Red Rose Inn, joined there by a few of their parents and close friend Henrietta Cozens. Their careers began to take off; that year Oakley was awarded a huge commission for eighteen murals for the Governor's Reception Room in the new state capitol building at Harrisburg.

In 1905 the group, adding a few more relatives to its number, moved to grassy, spacious Chestnut Hill, Pennsylvania. Cozens, Oakley, Green, and Smith named their new home "Cogslea" (after the first letters of their last names and the old English word *lea*, meaning "meadow"), and stayed happily there until Green left to marry Huger Elliott, an architecture professor at the University of Pennsylvania.

When Green left in 1911, Smith left too, settling with her brother, and aunt, and Cozens only a mile away from Oakley. She dubbed her new home "Cogshill," since it sat uphill of Cogslea, and lived out the rest of her long and successful career there. She was seventy-two when she died.

> *Smith's idealized, cherubic images of children struck a note with the public.*

TO FIND OUT MORE . . .

- Rubenstein, Charlotte Streifer. *American Women Artists: From Early Indian Times to the Present.* New York: Avon, 1982.

- Schnessel, S. Michael. *Jessie Willcox Smith.* New York: Thomas Y. Crowell, n.d.

Florine Stettheimer, 1871–1944

Florine Stettheimer was an extremely private painter. When her first exhibition was poorly received, she stopped showing and selling her work. "Letting other people have your paintings," she stated, "was like letting them wear your clothes." Taking a closer look at her paintings, one can see that she had a point: They are full of private jokes and personal references that few outside her immediate circle of friends might have understood. Even without an understanding of all the relationships in the paintings, however, Stettheimer's wit comes through.

The three youngest Stettheimer sisters, Florine, Carrie, and Ettie, were very close. Their father left the family when they were young children, but they were financially secure enough that their genteel upbringing in Rochester, New York remained undisturbed. They all pursued scholarly or artistic occupations: Ettie wrote novels, Florine painted, and Carrie worked for twenty-five years on an intricate dollhouse with a scaled-down art gallery, complete with reproductions of works of art executed by the artists themselves.

After touring Europe for several years, the "Stetties," as their friends called them, settled in New York City. Their salon was extremely popular with the luminaries of the art/social scene, including Gaston Lachaise, Alfred Steiglitz, and Marcel Duchamp. Her only exhibition, a one-woman show in 1916 at Knoedler's, was a flop. Not one of her paintings sold. She retreated into her circle of friends, where she gave only private shows thenceforth. Despite friends' efforts to publicize her work, she perhaps intentionally rebuffed museums by insisting that any exhibition of her work involve the redecorating of the gallery space to look like her own home.

Her paintings are fascinating to look at and full of rich detail. In her 1944 satire of/homage to the art world, *Cathedrals of Art*, the focus is the entrance to the main

Manhattan museums, the Metropolitan Museum of Art, the Museum of Modern Art, and the Whitney Museum. A fussy, mustachioed figure stands at one side, holding up little flags that say "stop" and "go" in either hand. Each museum is lampooned gently. At the Museum of Modern Art, for instance, half-clothed women from a Picasso painting romp wildly through the halls. Outside the museums, an infant, Art, is born in a flash of photojournalists' cameras as interested art dealers look on.

Stettheimer's figures are not painted in naturalistic proportion, and the perspective in her paintings is deliberately flat, like a child's drawing, so that she can pack more detail into them. She skewers comfortable Manhattan shoppers in *Spring Sale at Bendel's*, in which women frantically wrestle over sale items and try them on over their own clothes. The body of one matron in green has turned into a nearly straight horizontal line in her grab for some choice item, interrupted only by the bulge of a rather large posterior.

Stettheimer periodically sighed to friends that she would bury her paintings with her when she died. Luckily, she willed them instead to her sister Ettie, the novelist.

> *"Letting other people have your paintings was like letting them wear your clothes."*

Stettheimer had long been a cult figure to a very select group of Manhattanites, but after her death her paintings became available to the public as Ettie released them. Her first posthumous exhibition was in 1946 at the Museum of Modern Art.

TO FIND OUT MORE . . .

- Fine, Elsa Honig. *Women and Art.* Montclair, NJ: Allanheld, Osmun & Co, 1978

- Harris, Ann Sutherland, and Nochlin, Linda. *Women Artists: 1550–1950.* New York: Alfred A. Knopf, 1976.

- Heller, Nancy G. *Women Artists: An Illustrated History.* New York: Abbeville Press, 1987.

- Rubenstein, Charlotte Streifer. *American Women Artists: From Early Indian Times to the Present.* New York: Avon, 1982.

Helen Tamiris, 1902–1966

Dancer and choreographer Helen Tamiris always believed in making a statement. Her stage name was chosen from a line from a poem: "Thou art Tamiris, the ruthless queen who banishes all obstacles." As a kind of irresistible monarch of her art, she dictated that dance should have something to say.

The youngest of Isor and Rose Becker's five children, Helen grew up on New York's lively Lower East Side. The Beckers, Russian Jewish immigrants, had artistically inclined children. One brother became a musician, another a painter, a third a sculptor. Helen knew early on that she wanted to dance. She studied ballet at the Henry Street Settlement House, and later defied her father's wishes in order to audition for the Metropolitan Opera Ballet School. She won a scholarship to train there under Rosina Gallí, prima ballerina.

Helen Becker joined the Metropolitan's opera company in 1920, after graduating from high school. During her three years there, she continued to study dance, both ballet and modern (then called "natural" dancing). After leaving the Met in 1923, she was the second soloist in a company touring South America. They went broke in Bogotá. Undaunted, Becker went back to the States to perform in nightclubs and revues, taking the name of the Persian Queen in the poem. As "Tamiris," she danced the role of the Red Queen in *Alice in Wonderland* and a "Chinese" number at the Music Box Revue in New York. The cast of the show included Fanny Brice, the subject of the 1964 musical *Funny Girl*.

In 1927 she moved from the relative stability of the revue cast to perform her own choreography on the concert stage. For her first show, Tamiris did everything: she was producer, choreographer, costume designer, and soloist. She danced twelve original pieces, including *The Queen Walks in the Garden*, to no music, *1927*, to music by George Gershwin, and *Subconscious*, in which she appeared (as one reviewer put it) "for one long and devastating moment" in the nude. Her style was, from the beginning, outspoken.

A year after her creative debut, Tamiris

spent a year developing her ideas in Europe, performing in Paris, Berlin, and Salzburg. In 1929, she returned to New York to join forces with Martha Graham and Doris Humphrey to form the experimental Dance Repertory Theatre. She was becoming an important force in the creation of modern dance. Throughout this period she worked on her guiding concept of dance as social comment.

In 1935 Tamiris successfully lobbied for dance to be recognized as an independent art form by the newly founded Federal Theatre Project. The Dance Project, which ran from 1936 to 1939, when all of the Federal Project's groups lost their funding, was a fertile think tank for Tamiris. Now performing under the stage name "Helen Tamiris," she produced some of her trademark pieces with this group. Some of the best-known include *How Long, Brethren?* (1937), inspired by a group of African-American songs of protest, and 1939's *Adelante*, about the civil war in Spain.

After several years dividing her time between performing and teaching, and a marriage to a former student (Daniel Nagrin, in 1946), Tamiris turned to Broadway. She had two early flops before her major hit, *Up in Central Park*, ran for over five hundred showings and was made into a movie. Her *Showboat* revival and *Annie Get Your Gun*, in which Nagrin performed the role of the Wild Horse, further cemented her reputation as a choreographer who could "see a show whole."

Tamiris continued her Broadway work into the 1950s. In 1960 she founded a short-lived company with her husband. It split up when their marriage did, in 1964. A year after the split, Tamiris checked into New York's Jewish Memorial Hospital, suffering from cancer. When she died in 1968, her will left one-third of all her assets to found the Tamiris Foundation, designed to benefit Tamiris's lifelong passion, modern dance.

> *In 1927's* **Subconscious**, *Tamiris appeared "for one long and devastating moment" (in the words of one reviewer) in the nude.*

TO FIND OUT MORE . . .

- Schlundt, Christena L. *Tamiris: A Chronicle of Her Dance Career, 1927–1955.* New York: New York Public Library, 1972.

- Sicherman, Barbara, and Carol Hurd Green, eds. *Notable American Women: The Modern Period. A Biographical Dictionary.* Cambridge, MA: The Belknap Press of Harvard University Press, 1980.

Katherine Lynn Sage Tanguy, 1893–1963 (Kay Sage)

The surrealist painter Kay Sage had a remarkable life of dramatic highs and tragic lows. She was a brilliant, multilingual young woman who passed her college boards at age fourteen. A visionary painter, she was happily married for fifteen years to another, equally talented surrealist painter, Yves Tanguy. In 1955, however, her beloved husband died and she retreated into depression. Only three years later, she lost much of her eyesight in a double cataract operation. She never fully recovered from this double blow, and committed suicide at seventy.

Katherine Lynn Sage took after her rather unusual mother as a child. She found life with her father, a New York state senator, stifling, preferring to travel Europe with her mother after her parents divorced. She attended the prestigious Brearley and Foxcroft schools and dabbled in art classes.

When she was twenty-five, Sage moved to Italy to recover from a disastrous affair with an older married man. She taught herself to paint there, preferring her own judgment to others' criticism. Her 1925 marriage to the Italian Prince Ranieri de San Faustino ended in divorce in 1935, and Sage moved to Paris to take up her painting again.

In Paris, Sage spent five happy years among other surrealist painters, including Yves Tanguy. They were married in 1940 and moved to Woodbury, Connecticut. They kept in touch with friends still in Paris, helping many of them to get out of a city that was increasingly traumatized by World War II. Much of Sage's most striking work was done in the period of her marriage to Tanguy. Her landscapes of dream-images are painted in minute detail and muted colors, lending the unreal images a wierd feeling of solidity. In the foreground of *I Saw Three Cities* (1944), an upright beam is wrapped in flowing white, which seems to stream horizontally off of the top of the beam. Cream-colored, sharply delineated geomet-

ric structures fill the pale background.

Other paintings, like *The Instant* (1949) and *Tomorrow is Never* (1955), employ unfinished or half-destroyed architectural forms on a misty landscape. There is a kind of drifting loneliness in her visions. Her poem "Tower" expresses it well: "I have built a tower on despair/You hear nothing in it, there is nothing to see . . . " She was a private person even before her husband's death turned her into a real recluse. During the years after his death, she had to struggle with the demands of his estate as well as her own growing depression. She first attempted suicide in 1959, but was resuscitated. In 1963 she used a gun to shoot herself in the heart.

> *"I have built a tower on despair/You hear nothing in it, there is nothing to see . . . "*

Sage's work was long overshadowed by her husband's, a problem common to women artists, even those as eminent as **Eva Hesse**, **Lee Krasner**, and Elaine deKooning. Like many other women artists of the 1940s and 1950s, her work came to be better appreciated in the 1970s.

TO FIND OUT MORE . . .

- Fine, Elsa Honig. *Women & Art: A History of Women Painters and Sculptors from the Renaissance to the 20th Century.* Montclair, NJ: Allanheld, Osmun & Co and Abner Schram Ltd., 1978.

- Harris, Ann Sutherland, and Nochlin, Linda. *Women Artists: 1550-1950.* New York: Alfred A. Knopf, 1976.

- Heller, Nancy G. *Women Artists: An Illustrated History.* New York: Abbeville Press, 1987.

- Rubenstein, Charlotte Streifer. *American Women Artists: From Early Indian Times to the Present.* New York: Avon, 1982.

Sister Rosetta Tharpe, 1915–1973

For over fifty years, gospel performer Rosetta Tharpe sang and played the guitar to audiences in churches, New York clubs, revues, European tours, and jazz festivals. She was able to bridge the gap between gospel and other African-American forms of musical expression: Jazz, blues and swing all influenced her delivery of such classic spirituals as "Precious Lord" and "Down by the Riverside." Her popularizing of religious music alienated her from the Holiness Church in which she had been raised, and she was forced to change her affiliation to Baptist.

Rosetta Nubin was born in Cotton Plant, Arkansas. Her mother, Katie Bell Nubin, was a singer and evangelist in the Holiness Church. Katie Nubin took her only daughter—then five years old—to debut as "Little Sister," singing before an audience of one thousand in Chicago. Katie and Rosetta Nubin settled in Chicago that year, and Rosetta began touring tent revivals the next year.

Soon she could accompany herself on the guitar, making her mother's mandolin backup unnecessary. Still, her mother kept her company as she toured widely for the Holiness Church from age six to twenty-two.

When Nubin was twenty-three, she became the first gospel singer to sign a contract with a major recording company. Her version of "Rock Me" and a *Life* magazine article on her singing with Cab Calloway in the Cotton Club Revue in New York propelled her into the spotlight. Gospel gained momentum in the forties and fifties with the emergence of other gospel stars like **Mahalia Jackson** and Willie Mae Ford Smith, and Nubin—now married to Holiness Church elder Pastor Thorpe, whose name she kept with altered spelling after their divorce—became more widely popular. She brought her gospel stylings and flashy stage manner to New York City, where she performed at the Apollo and at the ritziest downtown clubs.

Sister Rosetta Tharpe played rhythmic, syncopated guitar and sang with bluesy inflections and twists. She also adopted an exotic stage costume, including a reddish wig and a feather boa. Her flamboyant style and secularization of religious songs were much frowned upon by her church, and she found herself rejected by her faith as her popularity grew. Saddened, Tharpe joined the Baptist Church and continued to perform in mostly secular settings.

> *When Nubin was twenty-three, she became the first gospel singer to sign a contract with a major recording company.*

The last years of Tharpe's life were marked by a series of personal tragedies. Her mother died in 1969, and in 1970 Tharpe suffered a debilitating stroke that resulted in the amputation of her leg. Her friend Mahalia Jackson died in 1972. Despite these misfortunes, Tharpe continued to perform in 1972 and 1973, and was preparing to begin a recording session when she suffered a fatal stroke in 1973.

TO FIND OUT MORE . . .

- Broughton, Viv. *Black Gospel: An Illustrated History of the Gospel Sound.* New York: Blandford Press, 1985.

- Smith, Jessie Carey, ed. *Notable Black American Women.* Detroit, MI: Gale Research Inc., 1992.

- Southern, Eileen. *Biographical Dictionary of Afro-American and African Musicians.* Westport, CT: Greenwood Press, 1982.

Alma Thomas, 1892–1978

It was Alma Thomas herself who best described the abstract paintings that brought her to national attention around 1970. "They are . . . all little dabs of paint that spread out very free." Thomas's lyrical patches of color suggest rather than represent their subjects in paintings like *Reflections of a Brilliant Sunset Shimmying in a Lake*, *Wind Tossing Late Autumn Leaves*, and *Wind Dancing with Spring Flowers*.

Thomas was born in Columbus, Georgia. She spent idyllic early childhood summers on her grandfather's plantation in Fort Mitchum, Alabama, where she remembered admiring beautiful sunsets, abundant wildflowers, and the plantation's animals, which included peacocks. It was here that Thomas remembered her first experiments with color, molding small cups and plates out of riverbank clay of different hues.

The Thomases moved to Washington, D.C. when Alma was fifteen. At Armstrong High, Alma fell in love with the art room. "It was like entering heaven," she later told interviewer Eleanor Munro. Her determination to become a professional led her to train to become a teacher, however, and she spent most of her life teaching in the Washington, D.C. public school system.

Her interest in art—particularly sculpture—never faded, and while she taught she continued to look for ways to fit her art into her life. In the early twenties she attended Howard University, where she joined mentor James Vernon Herring's recently formed art department. She was its first graduate in 1924. While continuing to spend most of her time teaching ("thirty-five years in the same room," she told Munro), she also squeezed in a master's degree from Teachers College at Columbia University in 1934. In the 1950s Thomas took painting classes at American University in Washington.

The paintings Thomas did before 1964 were realistic and were occasionally shown in exhibitions of African-American art. They drew respect but little excitement from critics. It wasn't until after she had retired from teaching that she had a creative breakthrough. It was 1964, and she was recovering from a debilitating attack of arthritis. The arthritis was so painful that she could

not then walk or paint. Her alma mater, Howard University, offered to show a retrospective of her paintings. Not only did she agree to the exhibition, she regained enough energy to contribute a series of new works to the show.

She found new inspiration in the colors that she found through her window. The shifting patterns made by a holly tree that stood in front of the window inspired her, and she began to paint her beautiful abstractions of color and light. Sometimes patches of color, sometimes calligraphic figures, they all suggest movement and her comment: "Every morning since then, the wind has given me new colors through the windowpanes."

In 1972 the Whitney Museum in New York City gave an important exhibition of her work that helped to establish her as a major artist. Earlier curators had automatically grouped her with other African-American artists, an artificial classification that had little to do with her subject matter. After her breakthrough she was placed instead with the Color Field movement. In light of her work and her indomitable spirit, any classification seems artificial. "Nobody taught me how to paint," she told inter-

Thomas's lyrical patches of color suggest rather than represent their subjects.

viewer Munro. "I had to do it myself. . . . I am a painter. I am an American."

TO FIND OUT MORE . . .

- Foresta, Merry A. *A Life in Art: Alma Thomas, 1891–1961–1978.* Washington, D.C.: The Smithsonian Institution Press, 1981.

- Munro, Eleanor. *Originals: American Women Artists.* New York: Simon & Schuster, 1979.

- Rubenstein, Charlotte Streifer. *American Women Artists: From Early Indian Times to the Present.* New York: Avon, 1982.

Helen Francesca Traubel, 1899–1972

I n the 1940s, soprano Helen Traubel was the darling of the American operagoing public as the greatest American Wagnerian singer in decades. In the 1950s she brought her oversized, ebullient personality to wider audiences through television performances. Her cross-media performances eventually brought her operatic training to a popular audience, extending the boundaries of a traditional opera singer.

Traubel was born to an eminent German-American family in St. Louis. At seventeen she began her formal voice training with Louise Vetta-Karst, who became her mentor and close friend. After her sophomore year in high school, Traubel quit to focus exclusively on singing. She progressed rapidly but held herself back, preferring to perfect her instrument before starting a career on stage.

At twenty-three Traubel was married to her first husband, automobile salesman Louis Franklin Carpenter. The marriage

soon failed. At twenty-five Traubel introduced her voice to the American public in her debut with the St. Louis Symphony Orchestra. Two years later the Metropolitan Opera in New York offered her a contract, but Traubel did not yet feel ready. She continued to study devotedly and sing in St Louis for another twelve years until she felt ready for the New York stage.

In 1937 Traubel debuted with her future stage partner, Laurence Melchior, and her future rival, Norwegian soprano Kirsten Flagstad. Unlike the cutthroat intensity of many rivalries, their competition was always friendly. In the 1950–1951 season, Flagstad sang at the Met with the understanding that she and Traubel would split the Wagner roles. "I will not push her aside," Flagstad told Rudolf Bing, The Met's manager. A year after her New York debut, Traubel married William L. Bass, who took over the role of her manager.

After two years of rave reviews per-

forming on other New York stages, Traubel joined the Met's company with her spectacular 1939 performance of Sieglinde in Wagner's *Die Walküre*. She reigned triumphantly through the forties with Melchior as the queen and king of Wagnerian opera in America. But Wagner, the Met, and New York eventually proved too narrow for her, and in the late forties and early fifties she turned to an international touring schedule and the first of her appearances on television.

She injected a popular flavor into the Met by wearing designer gowns in place of the armor traditionally worn by Wagnerian heroine Brünnhilde. Performances for the USO during World War II had whetted her appetite for a wider audience, and when Metropolitan Opera director Rudolf Bing objected to the time she spent performing in nightclubs, she called him a snob and quit.

Television performances with Ed Sullivan, Jimmy Durante, and Red Skelton had already won her a wide following, and she was able to embark upon a successful career in film. She applied her powerful voice to musicals like *Deep in My Heart* (1954) and a Rodgers and Hammerstein show, *Pipe Dream* (1955). She continued to perform into her late sixties until her death in Santa Monica, California, at the age of seventy-three.

> *Traubel was the greatest American Wagnerian singer in decades.*

TO FIND OUT MORE . . .

- Sicherman, Barbara, and Carol Hurd Green, eds. *Notable American Women: The Modern Period. A Biographical Dictionary.* Cambridge, MA: The Belknap Press of Harvard University Press, 1980.

- Traubel, Helen, and Richard Hubler. *Saint Louis Woman.* New York: Duell, Sloan and Pearce, 1959.

Baroness Hilla Rebay von Ehrenweisen, 1890–1967

L ike **Gertrude Vanderbildt Whitney**, the Baroness Hildegard Anna Augusta Elisabeth Rebay probably had a bigger impact on American art through her contributions to an important New York museum than through her own art. She guided millionaire mining magnate Solomon R. Guggenheim's forays into collecting modern art, and in 1937 became the director of his newly established museum. In her own work she was a pioneer of abstract painting, producing nonrepresentational paintings as early as 1916. She continued to paint throughout her career, but after 1937 her attention was primarily on her great museum.

Rebay was born in Strasbourg, Alsace. She trained in Paris, Munich and the Düsseldorf Academy, but by age twenty-four had broken away from more conventional traditions. She exhibited with cutting-edge experimental groups like the Salon des Indépendants in Paris and the German Krater and the November Gruppe. In 1917,

she showed her paintings at the Berlin gallery Der Sturm with such distinguished contemporaries as Marc Chagall, Vasily Kandinsky, Paul Klee, Robert Delaunay, and Rudolf Bauer. Later, she would heavily influence American art by championing these same painters to Guggenheim.

In 1927 Rebay moved to New York City. There she befriended Solomon Guggenheim and painted his portrait. His art collection at the time leaned towards a comfortable canon of well-established artists. Rebay took him in hand, guiding him toward more adventurous choices like her old Berlin co-exhibitors. In fact, she was later criticized for what was seen as excessive loyalty to Bauer's work, which was considered mediocre by many critics. With her advice, Guggenheim's collection soon overflowed his Plaza Hotel apartment, and Rebay began to supervise the works from an office in Carnegie Hall. In 1937 the collection had grown large enough to fill a small museum.

With this goal in mind, a foundation was incorporated that same year. In 1939 Rebay directed the opening of the Solomon R. Guggenheim Museum of Nonobjective Painting on 54th Street in Manhattan. She served as its director for the next twelve years, meanwhile becoming a powerful guiding force in the shaping of American art. In 1948 the museum moved to temporary quarters on Fifth Avenue, where the permanent building was being built. Eight years after her resignation as director, the collection finally moved into Frank Lloyd Wright's stunning spiral-shaped building.

Rebay was in her own mind a figure of almost mythical proportions. One artist friend of Rebay's reported that she believed that she had magical powers. She was much criticized for her authoritarian demeanor and her offhand use of her power, but she also helped out many artists when they had little money and less recognition. She got Jackson Pollock jobs as a janitor, a carpenter and a guard in museums, and often doled out money for supplies for struggling young artists.

During World War II, Rebay was attacked by the very artist she'd gotten the most grief for trying to help, Rudolf Bauer.

Von Ehrenweisen was a pioneer of abstract painting, producing nonrepresentational paintings as early as 1916.

Jealous of her success, he spread rumors that she was a German spy. An investigation cleared her, but Rebay was deeply wounded.

Rebay's last exhibit as an artist was in 1962, five years before her death at age seventy-seven.

TO FIND OUT MORE . . .

- Lulcach, Joan M. *Hilla Rebay: In Search of the Spirit in Art.* New York: G. Braziller, 1983.

- Rubenstein, Charlotte Streifer. *American Women Artists: From Early Indian Times to the Present.* New York: Avon, 1982.

- Sicherman, Barbara, and Carol Hurd Green, eds. *Notable American Women: The Modern Period. A Biographical Dictionary.* Cambridge, MA: The Belknap Press of Harvard University Press, 1980.

Bessie Potter Onahotema Vonnoh, 1872–1955

Bessie Vonnoh, like **Janet Scudder** and **Julia Bracken Wendt**, was one of the so-called "White Rabbits"— women who studied under the sculptor Lorado Taft. Like Scudder, she sculpted small bronze pieces. Her sculpture, however, reflects a professional and personal life much more serene than Scudder's. She settled on a lovely serene style, sculpting groups of happy, peaceful figures that seem to reassure their audience that all is well with the world.

Bessie Potter was born in St. Louis, Missouri. She was only twenty years old when she was hired by Lorado Taft to work—thrillingly, for pay—to prepare for the 1893 World's Fair. When Potter and the other women assistants were given their first month's pay, they celebrated by carpeting the floor with the cash. Taft's busy studio yielded a generation of women sculptors, including Scudder, Wendt, Caroline Brooks MacNeil, and Enid Yandell.

Potter was in good company.

Potter worked with the rest of the group to prepare several of Taft's large-scale pieces to be shown at the Exposition, but they did not reflect her own style—in fact, she had not yet developed one. It was at the fair, Taft later wrote, that she was first inspired by the work of Prince Paul Troubetskoy to sculpt groups of figures. According to Taft, she began "doing Troubetskoys" after the fair.

Taft was a supportive mentor to Potter; when some critics found her style derivative, Taft defended her, asserting that Potter's style was original. To further develop her work, Potter briefly went to Paris in 1895, and on her return, sculpted her charming and much-reproduced *The Young Mother*. The small statue was exhibited in 1976 as part of the Whitney Museum's Bicentennial sculpture show, and a copy is on display at the Metropolitan Museum of Art.

Like many artists, Potter married an-

other artist, the painter Robert Vonnoh, in 1899. She continued to sculpt through the 1930s, and put on a one-woman show at the Brooklyn Museum in 1913. She exhibited small bronzes like *Daydreams*, in which a young woman cradles her sister's head on her lap next to the book she has been reading. The gentle sweep of their garments and their contemplative expressions radiate peace.

In later years Bessie Vonnoh turned to larger pieces, including a portrait of James S. Sherman that resides in the U.S. Capitol. She died at age eighty-three.

> *Vonnoh's style reflects a happy, serene outlook on life.*

TO FIND OUT MORE . . .

- Armstrong, Thomas, et al. *200 Years of American Sculpture.* New York: Whitney Museum of American Art and David R. Godine, Publisher, 1976.

- Craven, Wayne. *Sculpture in America.* New York: Thomas Y. Crowell, 1968.

- Rubenstein, Charlotte Streifer. *American Women Artists: From Early Indian Times to the Present.* New York: Avon, 1982.

- Scudder, Janet. *Modeling My Life.* New York: Harcourt, Brace & Co., 1925.

- Taft, Lorado. *History of American Sculpture.* New York: Rev. ed. New York: Macmillan, 1924.

Beulah Belle (Sippie) Wallace, 1898–1976

Blues singer and pianist Sippie Wallace suffered the loss of her dearest friends and relatives near the end of her period of popularity in the 1920s. She shrugged off her woes, however, telling a 1975 interviewer, "Even little dogs have the blues, even little birds . . . even little bees, even everything has it." Wallace sang through her troubles and survived them, enjoying a revival in the 1970s when the blues resurfaced after a four-decade hiatus.

Beulah Belle Thomas (nicknamed Sippie) was one of thirteen children born to domestic workers George and Fanny Thomas in Houston, Texas. Raised in a strictly religious setting, Sippie's first performances were at Shiloh Baptist, the family's church. Older sister Lillie taught her how to sing. Her older brother George, also musically inclined, helped her to write her own songs. Her lyrics and his music combined in original blues songs like "Adam and Eve Had the Blues" and, later, "Shorty George."

At fifteen she followed George to New Orleans. She had a brief but heartbreaking marriage to Frank Seals, who was evidently not faithful to her. At twenty she returned to Houston to live with her siblings when her parents died. The lure of fame soon drew her to tent shows in Houston, where she served as a stage assistant and maid to Madam Dante, a snakedancer. Meanwhile she built a reputation as a singer, and was soon performing under her own name in tent shows across Texas.

In the early twenties Thomas joined her brother George, then a successful composer, in Chicago. She brought along her beloved thirteen-year-old brother Hersal, a piano prodigy. Together the three siblings became recording sensations, with the runaway hits "Shorty George" and "Up the Country Blues." Sippie's first recording sold a then-phenomenal 100,000 copies. In her early twenties Thomas had a talent for mournful, offbeat phrasing and strong emotion.

Sippie Thomas's second husband, gambler Matthew Wallace, was the cause of financial woes for her in the mid-twenties. Sippie Thomas released "Jack O' Diamond Blues," about his errant ways, in 1926; the recording featured backup by Louis Armstrong. Meanwhile she had moved to Detroit with Matthew and Hersal, who had become a popular performer in his own right. A series of tragic deaths took Wallace's closest siblings in the late 1920s: her older sister Lillie died at home in 1925; in 1926 Hersal was struck down at age sixteen by food poisoning; and George was killed by a Chicago streetcar.

> Sippie's first recording sold a then-phenomenal 100,000 copies.

Rocked by her losses, Wallace took a two-year break from performing in 1927–1929. On her return in 1929, she accompanied herself on piano in Victor Records' version of "Mighty Tight Woman." Hersal had played the piano on her recording for Okeh Records in 1926. The Depression shut down Wallace's career in the 1930s, and for the next forty years, her children, her church, and her husband became her main concerns.

Revival recordings in 1945 and 1959 proved that her voice had not weakened with age, and at 1968 she was convinced to try the European circuit. Her new versions of "Mighty Tight Blues" and "Shorty George" garnered strong reviews, and when the blues became popular in the United States in the early seventies, Wallace was ready. In 1977 she sang at New York City's Lincoln Center.

A new song, "Women Be Wise, Don't Advertise Your Man," became a staple of her repertoire. It was one of the last she performed at a Copenhagen appearance months before her death at the age of eighty-eight.

TO FIND OUT MORE . . .

- Harrison, Daphne Duval. *Black Pearls: Blues Queens of the 1920s.* New Brunswick, NJ: Rutgers University Press, 1988.
- Smith, Jessie Carey, ed. *Notable Black American Women.* Detroit, MI: Gale Research Inc., 1992.

Dinah Washington, 1924–1963

· ·

Blues singer Dinah Washington only lived to age thirty-nine, but those thirty-nine years were amazingly eventful. She was married seven times (two other marriages were rumored but never occurred) and had two children. She was a mercurial star, often feuding with fellow musicians. She died of an accidental overdose of diet pills and perscription drugs. Her voice was one of the most remarkable in the history of the blues, at will smooth or crisp, and her beautiful enunciation brought the full wit—or poignancy—of the lyrics home.

She was born Ruth Lee Jones in Tuscaloosa, Alabama, to Alice Williams and Ollie Jones. At four she moved with her family to the South Side of Chicago. Her mother, a very religious woman, taught her piano and gospel singing at St. Luke's Baptist Church. Through her singing at the church, she met gospel singers **Mahalia Jackson** and Roberta Martin and became

a member of the first all-woman gospel group, the Sallie Martin Colored Ladies' Quartet.

As a teenager, she became interested in popular music and spent the next few years swinging back and forth between gospel and singing in clubs. The club work earned her some money, and her reputation grew. She sang at the Garrick Stage Lounge with her idol, Billie Holiday. The manager there is said to be the man who suggested she take a stage name, and in 1943 Jones began touring under the name Dinah Washington.

She sang at the Apollo Theatre in Harlem and cut records in New York and Los Angeles in the forties, building a reputation as "Queen of the Blues." She took pride in handpicking a small group of backup artists for tours and records; Quincy Jones was one of these protegés. She recorded popular songs and blues, moving easily from standards like "Harbor Lights" to "Fast

Movin' Mama." She could adjust her style to fit any song. She was capable of wryly delivering "Dentist's Song" ("You Thrill Me When You Drill Me"), or, as sax player Charles Davis remembered, "[She] could make a whole band cry."

Washington always kept in close touch with her family despite her whirlwind life. She set up both parents in new homes (they had separated) and spent holidays with her mother. By this time, her mother and stepfather had ten children at home, and Washington's constant contributions to their support added to the necessity of her earning more money through her performances. She always managed her stage appearances, demanding ample attention to her hair and wardrobe.

By some accounts Washington was contentious, always fighting with one colleague or another. One story has her smashing a musician's saxophone; another has her receiving candy filled with ground glass.

> *One of Washington's protegés was the young Quincy Jones.*

TO FIND OUT MORE . . .

- Harris, Sheldon. *Blues Who's Who: A Biographical Dictionary of Blues Singers.* New Rochelle, NY: Arlington House, 1979.

- Haskins, James. *Queen of the Blues: A Biography of Dinah Washington.* New York: William Morrow, 1987.

- Smith, Jessie Carey, ed. *Notable Black American Women.* Detroit, MI: Gale Research Inc., 1992.

Julia Bracken Wendt, 1871–1942

. .

Sculptor Julia Wendt was half of a prominent artistic couple. She may have been best known for her portraits, carved in relief, of celebrated men of the nineteenth century. Her husband, William Wendt, has often been called "the painter-laureate of California." Together, they were prominent in the Laguna Beach art colony on the southern California coast.

Wendt was the twelfth child born to Irish-Catholic parents in Apple River, Illinois. At seventeen she struck out on her own as one of Lorado Taft's female assistants, the so-called "White Rabbits." She studied with Taft in Chicago for six years, in the company of other emerging women sculptors like **Bessie Potter Vonnoh** and **Janet Scudder**.

Toward the end of her time with Taft, Julia had begun to make a name for herself in Chicago as an independent artist. She won a commission for a sculpture at the Illinois pavilion at the Chicago World's Fair in

1893. A bronze cast of her sculpture, *Illinois Welcoming the Nations* (1893), was placed in the state capitol in Springfield, Illinois.

Wendt left Chicago after her marriage, in 1906, to painter William Wendt. The couple moved to Los Angeles to begin with, but eventually moved to Laguna Beach, where they had a house with an ocean view, and soon gained respect among the art community. In 1911 Wendt accepted a commission to create a "heroic three-figure allegory" to be installed in the rotunda at the Los Angeles County museum.

She chose to represent History, Science, and Art as goddesses draped in folds of cloth, whose upraised hands hold an electrically lit globe that casts its glow on the other works of art scattered about the rotunda. *The Three Graces: History, Science and Art* (completed 1914) was well received by the new museum and its patrons.

It was not so well treated after Wendt's death. In the fifties, a large circular display

of minerals constructed around *The Three Graces* obscured it completely from view. The sculpture remained hidden for years, only coming back to view when the Museum's mineral display was moved to its own room in 1980. Unencumbered, it dominates the rotunda. The eleven-foot high bronze figures on a stone pedestal stand head and shoulders above the second floor, which overlooks the central space via a circular balcony.

Many of Wendt's other works were portraits and memorials of eminent figures. In 1913, Canada commissioned her to create a King Edward Peace Memorial, which was installed in Saskatoon. Her home state, Illinois, has both her 1893 *Illinois Welcoming the Nations* and a statue of James Monroe (1900) in the state Capitol building in Springfield. Wendt also did a series of relief carvings of notables from the previous century, including Abraham Lincoln, Ralph Waldo Emerson, William Morris, and Leo Tolstoy.

> *Wendt was perhaps best known for her portraits, carved in relief, of celebrated men of the nineteenth century.*

TO FIND OUT MORE ...

- Moure, Nancy, et. al. *Southern California Artists: 1890-1940.* Laguna Beach, CA: Laguna Beach Museum of Art, 1979. Exhibition catalog.

- Rubenstein, Charlotte Streifer. *American Women Artists: From Early Indian Times to the Present.* New York: Avon, 1982.

- Taft, Lorado. *The History of American Sculpture.* Rev. ed. New York: MacMillan, 1924.

Gertrude Vanderbildt Whitney, 1875–1942

Sculptor Gertrude Vanderbildt Whitney never had to struggle with the most common problem of artists—poverty—but she sometimes had trouble getting people to take her seriously. At first friends simply humored the young heiress, but her monuments proved to be distinctive and striking in their own right. Her contributions to art as a patron were immense; her Whitney Museum of American Art is now arguably the leading collection of American art. The reserved sculptor had a rather difficult personal life, and in 1934 she was hounded by newspaper reporters who covered the trial for the custody of her niece, Gloria Vanderbildt. Whitney won custody of the girl, who grew up to be a well-known fashion designer, but the trial contributed to her declining health.

Cornelius Vanderbildt II, Gertrude's father, was one of America's wealthiest men, at the reins of a profitable railroad empire. Gertrude's childhood among her family's art collection sparked a lifelong passion for art, which she first demonstrated in her sketches and watercolors. At twenty-one, she married another wealthy young heir, Harry Payne Whitney. The couple had three children, and moved between their homes on Fifth Avenue in Manhattan and Long Island.

Whitney began to study sculpture intensely, working under monument sculptors James Earl Fraser in Manhattan and Andrew O'Connor in Paris. She was deeply struck by the work of Auguste Rodin, who briefly taught her in Paris, and absorbed his influence into her style. Taken aback by the skepticism with which her work was received—the Whitneys were seen as *patrons*, not artists—Whitney exhibited under a pseudonym for several years and began to work in a small studio in downtown Manhattan, in the midst of other artists.

When her *Paganism Immortal* (1910) was lauded by the National Academy, Whitney finally began using her own name. She

THE REMARKABLE LIVES OF

became a distinguished, conservative sculptor of public monuments. Her fifteen-foot *Titanic Memorial* (1931) features a glorious, somewhat androgynous male figure whose outstretched arms suggest a cross. He leans forward, as if about to swan-dive off of his pedestal. The statue is installed in Washington, D.C.

Experiences in a hospital she funded and ran in France during World War I inspired another monument, her 1922 Washington Heights War Memorial, in which one soldier heroically supports two sagging, wounded comrades. Her figures have a somewhat stylized look to them—the folds of the *Titanic Memorial*'s gown are smoothed planes.

Whitney's studio became a gallery for many of her struggling contemporaries around 1910. In 1914 she hired an assistant, Juliana Force, and in 1918 expanded the studio to form first the Whitney Studio Club and then the Whitney Studio Galleries. Whitney herself bought many of the works shown there, forming the core of the collection that became the Whitney Museum. When the Metropolitan Museum turned down her offer to build a new wing for them to house her collection, she simply built her own museum, which opened in 1931.

In 1932 she published a novel under a pseudonym. Her new success was soured, however, when the custody trial for her niece attracted quite a bit of unwelcome, unfriendly attention. Her museum came under fire in the trial; the opposing lawyer tried to prove that the art in the collection was obscene and reflected poorly on her capabilities as a mother. The pressure of so much negative scrutiny wore on her, and Whitney died several years after the trial, at age sixty-seven.

The reserved sculptor had a rather difficult personal life, and in 1934 she was hounded by newspaper reporters who covered the trial for the custody of her niece, Gloria Vanderbildt.

TO FIND OUT MORE . . .

- Armstrong, Thomas, et al. *200 Years of American Sculpture*. New York: Whitney Museum of American Art and David R. Godine, Publisher, 1976.

- Friedman, B.H. *Gertrude Vanderbilt Whitney: A Biography*. Garden City, NY: Doubleday, 1978.

- Harris, Ann Sutherland, and Nochlin, Linda. *Women Artists: 1550–1950*. New York: Alfred A. Knopf, 1976.

- Heller, Nancy G. *Women Artists: An Illustrated History*. New York: Abbeville Press, 1987.

- Rubenstein, Charlotte Streifer. *American Women Artists: From Early Indian Times to the Present*. New York: Avon, 1982.

Charmion von Wiegand, 1899–1993

A bstract painter and collage artist Charmion von Wiegand spent the first twenty-six years of her life trying to live by the expectations of her family. Like her fellow collage artist **Anne Ryan**, however, she found her picture-perfect life as a society wife confining, and decided to do what she really loved—painting. She became a totally original painter, combining the influences of Buddhist and abstract art, most particularly that of mentor Piet Mondrian. Von Wiegand's collages often incorporated Chinese brush characters that she painted herself.

Born to genteel parents in Chigago, von Wiegand was raised in San Francisco. Her early artistic influences included the bright colors and lights she saw in Chinatown, where she loved to watch the dragon parades and fireworks displays. Her father's adherence to theosophy, a religious sect that incorporated aspects of Buddhism, also shaped her early consciousness. She at-

tended prestigous Barnard College for women and married an acceptably affluent man.

In her late twenties she found herself completely unhappy with her position as a society wife in Darien, Connecticut. She underwent psychoanalysis and began to paint in 1926, and soon divorced her husband. Declining any financial help from him, she worked as a journalist and continued to paint in her spare time. In 1932 she married magazine editor Joseph Freman, and was soon working as a writer for art magazines. In her research for articles, she became interested in abstract art.

In a 1941 interview with Piet Mondrian, von Wiegand's own background in theosophy clicked with Mondrian's philosophy of order and harmony in art. Mondrian became a good friend and artistic mentor to her, and she began to experiment with nonobjective painting. In the 1940s she worked her way through different modes of expres-

sion before settling on her informal collages of paper and cloth, juxtaposing symbols and solids. In 1948 she was one of the organizers of Kurt Schwitters's exhibition of collages (see **Anne Ryan**).

Von Wiegand learned to paint Chinese characters in ink, and began to use them in her collages. In the late 1940s she began to study Tibetan Buddhist art, finding inspiration for her own work in religious symbolism. In works like *Dark Journey* (1958), the sweep of her brushstrokes play against careful arrangements of vertical and horizontal rectangular shapes, moving around and sometimes through the boundaries formed by the shapes. The collage is "signed" with a large printed "W" inside a larger "C," which dominates the right side of the collage.

> *In the late 1940s von Wiegand began to study Tibetan Buddhist art, finding inspiration for her own work in religious symbolism.*

Von Wiegand continued to study, write, and produce collages into her eighties, broadening her knowledge with trips to India in the 1970s. She died at the age of ninety-four.

TO FIND OUT MORE...

- Hill, May Brawley. *Three American Purists: Mason, Miles, von Wiegand.* Springfield, MA: Museum of Fine Arts, 1975. Exhibition catalogue.

- Rubenstein, Charlotte Streifer. *American Women Artists: From Early Indian Times to the Present.* New York: Avon, 1982.

- Wescher, Herta. *Collage.* New York: Harry N. Abrams, 1968.

Mary Lou Williams, 1910–1981

J azz composer, pianist and arranger Mary Lou Williams got her introduction to music before she learned to walk. Her mother, an amateur pianist, often sat the baby Mary on her lap when she played ragtime and spirituals. Before her third birthday, Mary could pick out tunes on the keyboard herself. The child prodigy grew up to be an influential figure in the jazz world. Her groundbreaking arrangements and innovative style helped shape the development of bebop and the Kansas City big band style.

Mary's Pittsburgh childhood was a happy one. Her family loved to hear the little girl play. Each relatives' request for his or her own favorite kind of music made her adept at many different styles: Irish tunes for a favorite uncle, classical for her grandfather, and ragtime, boogie woogie, and blues for her stepfather, Fletcher T. Burley. It was Burley who bought her a player piano for home performances. Mary's mother taught her to learn by ear, a technique which encouraged her to develop a style all her own. Before she was ten, the "Little Piano Girl" was playing for Pittsburgh's wealthy families.

Her first real professional experience came at twelve, when she toured as a pianist with the Buzz and Harris Revue. She spent her high school years splitting her time between school and tours. She picked up pointers from Fats Waller, Willie the Lion Smith, and Jelly Roll Morton. On one tour, she met John Williams, a saxophone player and band leader. She married him when she was sixteen. She spent three years in his band, the Seymour and Jeanette Show, first as a pianist and later as the leader of an offshoot, the Jeanette James Synco Jazzers. She made her first recordings with this band in Tennessee, cutting records for Paramount, Gennett, and Champion.

In 1929 Mary Williams followed John Williams to Oklahoma City, where both

worked in an innovative band, Andy Kirk and the Twelve Clouds of Joy. She became the group's principal pianist and arranger. Her innovative arrangements caught on quickly; soon she was creating arrangements for other popular and cutting-edge performers like Louis Armstrong, Cab Calloway, Duke Ellington and Benny Goodman. This was the great era of the Southwest Territory Big Band Sound, and Mary Williams' arrangements figured significantly in its development.

In 1942 Williams, having split up with her first husband, married the trumpeter "Shorty" Baker, and moved with him to New York to join Duke Ellington's band. The marriage only lasted a year, but Williams stayed in the city, working the nightclubs and developing her new bebop pieces. She became a mainstay of the New York group of bebop musicians first led by Dizzy Gillespie and Charlie Parker. Williams soon had her own radio show, the "Mary Lou Williams Piano Workshop." She became a prolific composer, producing influential pieces like "In the Land of Oo-Blah-Dee" and "Lonely Moments." She composed her *Zodiac Suite* in 1945, introducing it to her radio show audience one movement at a time. She rear-

> *Williams could pick out tones on the keyboard before her third birthday.*

ranged the suite for eighteen instruments. It made its orchestral debut in 1946 with the New York Philharmonic.

A brief, exhausting stint in Europe in the early fifties led Williams (who had now been performing for forty years) to take a three-year break from music. She converted to Catholicism and established the Bel Canto Foundation, a substance abuse program for musicians. She returned to jazz in 1957, founding Mary Records, the first record company established by a woman. She continued to compose and perform into her late sixties, gathering awards and honors along the way. She died in her seventy-first year.

TO FIND OUT MORE . . .

- Dahl, Linda. *Stormy Weather: The Music and Lives of a Century of Jazzwomen.* New York: Pantheon, 1984.
- Lyons, Len. *The Great Jazz Pianists: Speaking of Their Lives and Music.* New York: Quill, 1983.
- Smith, Jessie Carey, ed. *Notable Black American Women.* Detroit, MI: Gale Research Inc., 1992.

Marguerite Thompson Zorach, 1887–1968

Painter Marguerite Zorach was one of a handful of artists who pioneered American work with a Fauvist influence. The *Fauves*, or "wild beasts," were regarded as mildly lunatic for their wild, unrestrained use of bright color. Zorach's work was seen as too radical for its day, and she was unable to win funding for her painting. After a period of intense, innovative painting, she married, had children, and faded from public notice until an art historian found her early paintings after her death in 1968.

Marguerite Thompson was raised in a genteel Fresno, California, family. As a child she had private French, German, and music lessons with her sister. She had a penchant for drawing at an early age, filling notebooks with her visions. Marguerite's cosmopolitan aunt Addie, a childhood friend of Gertrude Stein, knew talent when she saw it and invited her twenty-year-old niece to stay with her in Paris.

Marguerite Thompson proved a bit of a shock to her aunt. She was greatly impressed with the work of a group of painters, including Matisse, whom the critics had dubbed the *Fauves*. She began to incorporate their ideas into her own paintings, creating boldly outlined forms filled in with brilliant colors.

It was not her boisterous painting that really unsettled Marguerite's aunt, however, but her Paris romance with a young Lithuanian Jewish/American artist, William Zorach. Aunt Addie announced that she was going on a world tour with her niece and would not accept no for an answer. Marguerite used the scenery in Palestine, Egypt, Japan, and India for artistic inspiration and continued to write William Zorach.

Predictably, her family in Fresno was even more alarmed by her unladylike painting than her aunt had been. Marguerite finally escaped the demands of her social family and married William in 1912. Ironically, her most creative paintings were done

in the years she spent shocking her family; after she married Zorach, she painted for only three more years before the birth of their first child, Tessim. One of her most impressive works was painted in 1912 after a camping trip in the Sierras. *Man Among the Redwoods* features huge fuchsia trees outlined thickly in dark purple dwarfing the tiny figure below. Somehow, the almost neon tones of pink and orange don't look wrong here— they only emphasize the grandeur of the California redwoods.

> **Zorach's works were pioneering examples of the American Fauvist movement.**

Not that Zorach opposed her work—on the contrary, he was a great admirer of it. Their careers simply followed opposite paths. Her creative peak came early on, and her painting required more uninterrupted time than she had as a mother. He, on the other hand, struggled for a while before becoming a very successful sculptor.

The Zorachs had a long lean period while William worked to find his metier. Meanwhile, Marguerite turned her artistic energies to needlework, a medium that she could put down when her children needed attention. William experimented with it as well, and the couple produced a collaborative tapestry in 1918, *Marine Islander.* Sadly, Zorach's needleworks were not seen as a legitimate art form until after her death in 1968.

Around 1970 the art historian Roberta Tarbell was researching William Zorach's work when she saw Marguerite's early paintings, which had spent over five decades rolled up and packed away (still more had been thrown away long since). She recognized them as pioneering examples of the American Fauvist movement.

TO FIND OUT MORE . . .

- Fine, Elsa Honig. *Women and Art.* Montclair, NJ: Allanheld, Osmun & Co, 1978.

- Harris, Ann Sutherland, and Nochlin, Linda. *Women Artists: 1550-1950.* New York: Alfred A. Knopf, 1976.

- Heller, Nancy G. *Women Artists: An Illustrated History.* New York: Abbeville Press, 1987.

- Hoffman, Marilyn Friedman. *Marguerite and William Zorach: The Cubist Years, 1915–1918.* Manchester, NH: Currier Gallery of Art. Dist. by University Press of New England, 1987. (Exhibition catalog.)

- Rubenstein, Charlotte Streifer. *American Women Artists: From Early Indian Times to the Present.* New York: Avon, 1982.

Index by Occupation

Architects
Marion Lucy Mahoney Griffin
Julia Morgan

**Archivists of indigenous
American music**
Natalie Curtis (Native American)
Camille Nickerson (Creole)
Ruth Crawford Seeger (folk)

Blues performers
Alberta Hunter
Gertrude Pridgett ("Ma") Rainey
Esther Mae ("Mother") Scott
Bessie Smith
Beulah Belle ("Sippie") Wallace
Dinah Washington

Choral directors
Emma Azalia Smith Hackley
Eva Jessye

Classical composers
Amy Marcy Cheney Beach
Mabel Wheeler Daniels
Florence Beatrice Smith Price
Ruth Crawford Seeger

Collage artists
Perle Fine
Anne Ryan
Charmion von Wiegand

Concert singers
Marian Anderson
Emma Hayden Eames
Emma Azalia Smith Hackley
Matilda Sissieretta Joyner Jones

Concert pianists
Amy Marcy Cheney Beach
Hazel Lucille Harrison
Natalie Hinderas
Ethel Leginska
Marian Griswold Nevins MacDowell
Olga Samaroff
Philippa Schuyler

Conductor
Ethel Leginska

Filmmaker
Maya Deren

Beatrice Romaine Goddard Brooks
Rosalind Bengelsdorf Browne
Emily Carr
Minna Wright Citron
Katherine Sophie Dreier
Perle Fine
Ruth Gikow
Gertrude Glass Greene
Marion Greenwood
Frida Kahlo
Lee Krasner
Jenne Magafan
Alice Trumbull Mason
Alice Neel
Betty Parsons
Irene Rice Pereira
Baroness Hilla Rebay von Ehrenweisen
Anne Ryan
Katherine Lynn Sage Tanguy
Henrietta Shore
Florine Stettheimer
Alma Thomas
Charmion von Wiegand
Marguerite Thompson Zorach

Patrons
Katherine Sophie Dreier
Marian Griswold Nevins Macdowell
Betty Parsons
Baroness Hilla Rebay von Ehrenweisen
Gertrude Vanderbildt Whitney

Photographers
Diane Nemerov Arbus
Imogen Cunningham
Frances Benjamin Johnston
Gertrude Stanton Käsebier
Dorothea Lange
Lisette Model

Sculptors
Mary Abastenia St. Leger Eberle
Meta Vaux Warrick Fuller
Dorothea Schwarcz Greenbaum
Gertrude Glass Greene
Eva Hesse
Malvina Cornell Hoffman
Anna Vaughn Hyatt Huntington
Adelade Johnson
Evelyn Beatrice Longman
Louise Nevelson
Elizabeth Prophet
Augusta Savage
Concetta Scaravaglione
Netta Dewee Frazer Scudder
Bessie Potter Onahotema Vonnoh
Julia Bracken Wendt
Gertrude Vanderbildt Whitney

Trapeze artist
Lillian Leitzel